Talking

to

High

Monks

in the

Snow

HarperCollins*Publishers*

Talking

to

High

Monks

in the

Snow

*An Asian American
Odyssey*

LYDIA YURI MINATOYA

Grateful acknowledgments are made to the following:

The Asia Society Galleries, 725 Park Avenue, New York, NY for permission to reprint a portion of their 1987 publication *The Chinese Scholar's Studio: Artistic Life in the Late Ming Period*, ©1987 by The Asia Society Galleries.

Longman, Inc., for the use of their 1978 publication, *American Kernal Lessons: Intermediate*, by Robert O'Neill, Roy Kingsbury, Tony Yeadon, and Edwin T. Cornelius.

HarperCollins books may be purchased for educational, business, or sales promotional use. For information, please call or write: Special Markets Department, HarperCollins Publishers, Inc., 10 East 53rd Street, New York, NY 10022. Telephone: (212) 207-7528; Fax: (212) 207-7222.

FIRST EDITION

Designed by Fritz Metsch

LIBRARY OF CONGRESS CATALOGING-IN-PUBLICATION DATA

Minatoya, Lydia Y. (Lydia Yuriko), 1950-
 Talking to high monks in the snow : an Asian American odyssey / Lydia Minatoya. – 1st ed.
 p. cm.
 ISBN 0-06-016809-9
 1. Minatoya, Lydia Y. (Lydia Yuriko), 1950- . 2. Minatoya, Lydia Y. (Lydia Yuriko), 1950-
–Homes and haunts–Japan. 3. Japanese Americans–Biography. 4. Japanese Americans–
Ethnic identity. I. Title.
E184.J3M46 1992
973'.0495602–dc20
 [B] 91-50450

92 93 94 95 96 MAC/RRD 10 9 8 7 6 5 4 3 2 1

TO MY MOTHER AND FATHER
WHERE THE STORIES ALL BEGAN

ACKNOWLEDGMENTS

My deepest thanks to the family and friends whom I describe within this book. They have been the high monks of my journey, sharing with me their insights and wisdom. To protect their confidence and privacy, I have altered names. I am grateful to my agent, Timothy Schaffner, and my editor, Terry Karten, for their enthusiastic support of this book. Special thanks to my husband for his continuing faith in the project and to Seiji and Emiko for the boundless joy they provide.

I would also like to thank the Seattle Arts Commission for an Individual Artist's Grant and the PEN American Center for the PEN/Jerard Award supporting the completion of this book.

....Cool breeze and beautiful moon. Vase of flowers. Tea, bamboo shoots, oranges and tangerines all in season....The host not being formal. Stretch under the sun....Research. Peace in the world. Talking to high monks in the snow....Getting up from sleep. Recovering from sickness. Freely displaying objects but slowly putting them away.

Chen Jiru
1558–1639
Fond Interests

I.
Albany,
New York

My Mother's Music

"I believe that the Japanese word for wife literally means honorable person remaining within," says my mother. "During the nineteen twenties, when I was a child in Japan, my seventeen-year-old cousin married into a wealthy family. Before her marriage, I would watch as she tripped gracefully through the village on her way to flower arrangement class. Kimono faintly rustling. Head bent in modesty. She was the most beautiful woman I had ever seen. After her marriage, she disappeared within her husband's house. She was not seen walking through the village again. Instead, she would send the clear, plucked notes of her okoto—her honorable Japanese harp—to scale the high courtyard wall. I used to pause to listen. In late spring, showers of petals from swollen cherry blossoms within her courtyard would rain onto the pavement. I would breathe the fragrant air and imagine her kneeling at her okoto, alone in a serene shadowy room. It seemed so romantic, I could hardly bear it." My mother laughs and shakes her head at her childhood excess. After a moment she speaks. "Courtyard walls, built to keep typhoons out, also marked the boundaries of a well-bred wife. Because of this, in others ways, the Japanese always have taught their daughters to soar."

"And you?"

"When I was eleven years old, my father gave me okoto."

During the 1950s, in our four-room flat on the south side of Albany, New York, my mother would play her okoto. Sometimes on Sunday afternoons when the jubilant gospel singing had faded from the AME Zion Church across the alley, my mother would kneel over a long body of gleaming wood, like a physician intent on reviving a beautiful patient, and pinch eerie evocative chords from the trembling strings of her okoto.

"Misa-chan, Yuri-chan," she would call to my sister and me, "would you like to try?"

"*Hai*, Okaa-chan"—yes sweet honorable mother—we would murmur, as if stirred from a trance.

"I was a motherless child," says Okaa-chan, when I have grown to adolescence. "My father gave me okoto to teach me to cherish my womanhood."

"Your womanhood?"

My mother plucks a chord in demonstration. "The notes are delicate yet there is resonance. Listen. You will learn about time-lessness and strength. Listen. You will understand how, despite sorrow, heart and spirit can fly."

An American daughter, I cannot understand the teachings of my mother's okoto. Instead, I listen to the music of her words.

A formal, family photograph is the only memento my mother has of her mother. In 1919, an immigrant family poses in a Los Angeles studio and waits for a moment to be captured that will document success and confidence in America; a moment that can be sent to anxious relatives in Japan. A chubby infant, pop-eyed with curiosity, my mother sits squirming on her father's lap. My forty-five-year-old grandfather levels a patrician stare into the camera. By his side, wearing matching sailor suits, his sons aged three and

five stand self-conscious with pride and excitement. My grand-mother stands behind her husband's chair. In her early twenties, she owns a subdued prettiness and an even gaze.

My seven-year-old aunt is not in the picture. She has been sent to Japan to be raised as a proper ojo-san—the fine daughter of a distinguished family. Within the next year, her mother, brothers, and baby sister will join her. Five years later, my grandmother will be banished from the family. The circumstances of her banishment will remain a family secret for over forty years.

"Your grandmother loved to read," says Okaa-chan. The year is 1969. Okaa-chan and I sit in the kitchen, drinking tea at a table my father has made by attaching legs to a salvaged piece of Formi-ca. It is after midnight; the house lies sleeping. "She was a roman-tic, an adventurer. In Japan, she caused scandal when she bought a set of encyclopedia."

"A scandal?"

"You must understand these were country people. A young wife wasting her time on reading, spending her money on frivolous facts, people must have thought, What nonsense! My honorable older brothers recall that each day she would read to us from the encyclopedia. She would tell us about science and foreign coun-tries. I think she liked to dream about possibilities." Okaa-chan tilts her head and looks into the distance. "I was too young to remember this but it is a nice memory, neh Yuri-chan?"

"But why was she sent away? Why did your father divorce her?" Direct, assertive, American, I break into my mother's reflection and pull her back to the story I want to hear.

"Saa neh," Okaa-chan wonders. "Ojii-chan—your honorable grandfather—lived in America maybe ten to fifteen years before he went back to Japan and married. Our family is descended from samurai. We thought of ourselves as aristocracy; and Ojii-chan needed a wife from another samurai family."

"And the divorce?" I persist.

LYDIA MINATOYA

"Perhaps my father was naïve about people."

"What do you mean?"

"When he brought my mother to Los Angeles, Ojii-chan owned a pool hall. It was very popular with young Filipino workers. It was against the law for them to bring family to America. They were lonely and restless; and pool halls helped to kill times. My mother worked by Ojii-chan's side, and being young and pretty she was good for business. When work was done, father would leave us alone. My mother had read all the European, great romantic novels. She was much younger than Ojii-chan. She was lonely, and she fell in love with a young Filipino who could read and speak Japanese. He courted her by bringing books."

"She had a love affair!"

"They were very sincere." Okaa-chan is quick to correct any impression that her mother had been a libertine. "The man wanted my father to divorce my mother so she could remarry. Ojii-chan started moving us from house to house, trying to hide Mother, but her lover keeps locating us."

"Why didn't she just take you children and run away with him?"

"You must understand, my mother was from a good family. She would not consider taking her children from a respectable family into a disgraceful situation. She would not think of taking her husband's children from him. Romance is a private peril. Others should not suffer." Okaa-chan pours herself some more green tea. Its aroma is faintly acrid. "Perhaps Ojii-chan finally thought, This is embarrassing nuisance. He sent us all back to Mother's parents in Japan."

"But why did Ojii-chan wait five years to divorce your mother?"

Okaa-chan sighs. "That was a cruel mistake, *neh?* Ojii-chan was a highly honorable man but often he did not understand how his action would affect others. If he had divorced my mother when he first found out, in America, then she could have married her lover." Okaa-chan is silent again. Perhaps she is saddened to recall a flaw in the only parent she clearly can remember. "Ojii-chan

6

divorced as an afterthought. He may have wondered: Why am I supporting this woman? Why is her family raising my children? He broke a promise to my mother's parents."

"A promise?"

"When Ojii-chan sent my mother back to her parents, they begged him not to divorce her. It was a small village. If Ojii-chan and Mother divorced, her parents would have no choice but to send their daughter from their house."

"And so, when they divorced ..."

"My mother's ancestral home was adjacent to Ojii-chan's ancestral home. There had been warm feelings and intermarriages between the homes for centuries. With the divorce, relations had to be severed."

Okaa-chan is silent for a long time.

"After the divorce, my mother's parents would come to edge of Ojii-chan's ancestral home," she finally says. "My grandmother would be carrying a plate of sweets and she would call to her grandchildren. They only wanted to see us, to give us some candies. We would long to run to them but we knew it was forbidden. Instead, we would turn and run into the house to hide."

I stand and move to the sink and stove, heating more water, helplessly wanting to give Okaa-chan a cup of tea to compensate for losing her grandmother's sweets.

"Did you know beforehand? Did you know the divorce was coming?"

"Oh, no, I was maybe five years old, little more than toddler. But looking back, there are certain memories."

Okaa-chan is quiet as she moves back within her memories. "One day, mother took us to a photographer's studio for a formal portrait. I was excited and I turned to call my mother's attention to something. She was wiping away tears with her kimono sleeve. I never before had seen her cry and thought, Why in the middle of such a grand adventure?" Okaa-chan pauses. "I suppose that happened just before Ojii-chan had us sent from her house."

There is a longer pause.

"How I wish I could have a copy of that picture," she says.

In the quiet, I notice that the sky is lightening outside the kitchen window; birds are beginning to stir. Finally, Okaa-chan resumes her story.

"My clearest memory is this. I am sleeping beneath billowing mosquito netting with my sister and brothers. Suddenly I am awakened. It is a summer night and the rice paper screens are open. In the courtyard are the sounds of crickets and the glows of fireflies. My mother is standing, holding two candles inside white paper lanterns. They make pretty shadows. I am still sleepy as Mother leads us across the courtyard. Our wooden geta scrape along the footpath. It is damp and cool with dew. Mother holds one lantern. Eldest brother holds the other. As we get to Ojii-chan's ancestral home, Mother embraces us. Ojii-chan's sister stands waiting. '*Itte!*' Mother commands. Go!"

The second hand sweeps noiselessly around the kitchen clock. From somewhere in the darkened house, my sister coughs and turns in her bed. After a long time, Okaa-chan speaks. "I never saw my mother again."

When my mother is fifty-one, she takes me to the Japanese village where she spent fourteen years of her girlhood.

"I want to tell you about my regret," Okaa-chan says suddenly as we recline on the cool straw mats. In this house where Okaa-chan spent her childhood, the late afternoon air feels sultry and unpredictable. A typhoon has been forecast.

"After I graduated from the Charlotte School of Costume Design in Los Angeles"—my mother always uses the full title of her alma mater; as if the formal labor of carefully pronouncing all those multiple syllables affords her more time to savor her pride—"your Ojii-chan wanted to return to Japan. I accompanied him and became a fashion designer at a large department store. One day I

received a letter, from Manchuria, addressed to me through the store. It was from my mother."

"What did you do?"

"I was only twenty years old. It is such a young age. My mother was little older than twenty when she was sent away." Okaa-chan sighs. "I excitedly showed my mother's letter to my father. May I write back? I begged him. I knew nothing of the anger that can be between husband and wife."

"Did Ojii-chan scold you?"

"No. He took my mother's letter from me. He told me not to write back. We never spoke of the letter again." Okaa-chan pauses. "My greatest regret, Yuri-chan, is that I obeyed. I did not write to my poor mother. I do not have her letter. She never wrote to me again."

In the restless, August afternoon, Okaa-chan strokes my hair. I am moved and discomforted by her confession. I am twenty years old.

"Tell us how you and Daddy met!" my sister and I would beg Okaa-chan when we were children. The idea of our parents courting seemed both romantic and silly, and we would become giddy and giggly at the telling.

"During the war, your daddy's daddy and my family were in the same relocation camp—Heart Mountain, Wyoming," Okaa-chan invariably would begin. "Your daddy was in Chicago, at the University of Illinois and your daddy's daddy was very worried about him."

"Why?"

"Because he was thirty-three years old, unmarried, and far from family." Okaa-chan would smile in recollection. "Your daddy's daddy was the sweetest man. Since I am here in camp, Daddy's daddy thought, I will make most of it. I will find my son a good bride."

"You were the good bride!" I would giggle from behind my hands.

"But first there were other steps," Misa would interrupt. Being older and more orderly, Misa's job was to make certain that the whole story was told in the correct sequence.

"Yes," Okaa-chan would oblige us. "Daddy's daddy decided that his son should marry a Kibei—Japanese born in America and raised in Japan. As you know, your daddy has a temper and sometimes can be stubborn."

Misa and I would chortle knowingly.

"Daddy's daddy thought, If Katsuji marries a Nisei—a Japanese born and raised in America—or a non-Japanese, there will be too much commotion in the household. So Daddy's daddy began to ask all his friends."

"Do you know of any nice Kibei girl for my boy, Katsuji, to marry?" Misa and I would chorus. We knew this part by heart.

"Daddy's daddy was a widower in his late sixties. He was separated from all seven of his sons. The bride search made his life in camp more meaningful."

"Tell us about the haiku man."

"Well, Ojii-chan liked to write. He belonged to a haiku poetry group. One of Ojii-chan's haiku poetry friends knew Daddy's daddy. When the haiku friend heard Daddy's daddy ask—"

"Do you know of any nice Kibei girl for my boy, Katsuji, to marry?"

"The haiku friend said, 'Oh, yes. I know the finest Kibei girl. She is an ojo-san—a proper daughter from a fine household—and she even comes from same prefecture in Japan.'"

"And you were that finest Kibei girl!" I triumphantly would shout, overeager for the happy culmination of the story.

"Tell us about Daddy's visit," Misa would urge, savoring the tale.

"When war ended, your daddy came to Heart Mountain to visit his daddy. He planned to stay two weeks. The first week of the visit was agony for Daddy's daddy. He wanted your daddy to agree to

meet the Kibei girl, but all your daddy did was eat ravenously and sleep late! Finally, about six days before he was to return to Chicago, your daddy accompanied the haiku man to our barracks and was introduced to my father and me."

"Daddy broke a date for you," Misa reminds Okaa-chan.

"Well, not really, that would have been rude," Okaa-chan explains. "The next evening, your daddy had agreed to play bridge with a young Nisei woman. She had been married to a Hakujin—a white man—but he had divorced her in the midst of wartime hysteria. She was very nice girl."

"But not the girl for Daddy!" Misa and I would gloat at Okaa-chan's victories over shortening time and a nice Nisei woman.

"Instead of playing bridge, your daddy again came to our barracks. This time, the haiku friend did not accompany him. By the end of the week, when Daddy went back to Chicago, our marriage had been arranged. Just before he left, there was an engagement party." Okaa-chan laughs affectionately, "Your daddy and I were still strangers: shy and dazed. The most happiest person at party was your daddy's sweet daddy!"

In the fall of 1945, Okaa-chan and Daddy's Sweet Daddy took a train to Chicago, where my parents were to be married. In formal recognition of the new familial network, Ojii-chan accompanied them to the train station. There in the desert, amidst the howling, whipping winds, Okaa-chan's father stood on the train platform. He held his hat in his right hand; his arms hung straight at his sides. He stood bowing deeply from the waist, long after the other well-wishers had drifted from the platform. He stood bowing, until the train carrying his child and her new father had vanished into the horizon.

In romance, my father's timing was lucky. Until only a few months before she met him, Okaa-chan had been spoken for.

Her engagement had begun on an early autumn morning in

1940. She and Ojii-chan were boarding an ocean liner docked in the busy international harbor of Yokohama. They were returning to Los Angeles after a sojourn of two years in Japan.

Sunlight sliced the crisp sea air. Ships sounded. Everywhere was the commotion of loading. My mother wore high heels and a slim, pinch-waisted suit she had designed herself. My grandfather was regal in pinstripes.

Also boarding was a sophisticated woman in her late twenties, sailing off with her second husband. She and my grandfather began to converse. It seems that, distantly, their great family houses were linked. The woman's brother—a college educated, handsome young baseball idol in the glittering city of Tokyo—was there to bid his sister adieu. He pushed back the brim of his new fedora— the better to see my twenty-year-old Okaa-chan—and immediately fell in love.

And so, in time, a marriage was arranged. Between a bilingual fashion designer, from the city of motion pictures, and a Japanese baseball star. Truly, it was to be a marriage of the twentieth century, of a shining new age at its height. But then came the war and everything changed and wedding plans fell into dust.

When my sister and I were children, we viewed Okaa-chan's wartime Relocation simply as the provident event that enabled her to meet our father. As we grew older, Misa and I began to ask Okaa-chan about the war years themselves.

"Like every American of that era," Okaa-chan says, "I will never forget December seventh, nineteen forty-one. Ojii-chan, my eldest brother, and I were visiting an auntie in San Pedro, California. Ojii-chan had just returned from visiting Japan. It had been the last Kobe-San Francisco sailing, before war. We were laughing and talking when the telephone rang."

Okaa-chan pauses, searching for a way to describe that moment. "Sometimes you catch, out of the corner of your eye, a view of

someone's posture suddenly change, just a little," she says, "something so small, and you know that everything has gone terribly wrong."

"Who was it on the telephone?" Misa and I ask.

"Someone from Japanese American community perhaps. My auntie said nothing. She carefully put the receiver back on the telephone, turned like a sleepwalker to the radio, and switched it on. When she faced us, the sight of Auntie's anguished face and the sound of the news came at the same moment."

"Then what happened? What did you do?"

"San Pedro is a harbor." Okaa-chan recalls, "there was immediate panic about Japanese American fishermen. The federal government issued an order blockading all roads leading out of the city. No Japanese were allowed to leave the city and anyone doing anything suspicious was to be arrested and detained indefinitely. Auntie got word from friends that government agents were going from house to house, arresting the leaders of Japanese culture clubs."

"Weren't you terribly frightened?"

"I was paralyzed with fear. Ojii-chan was Issei—born in Japan and not allowed to become American citizen. He had just come from Japan; he was considered a community elder. He was an old man, in his seventies. I was afraid if he was arrested, we never would see him again."

"What did you do?"

"I did nothing. I was too frightened. Onii-san—my honorable older brother—decided that we had to return to Los Angeles. Onii-san wrote to the Los Angeles county clerk's office. He asked for notarized copies of his and my birth certificates. They would be proof of our American citizenship. He selected a time when the military police were likely to be too busy with traffic to search each car. He made our father lie down in the back of car and completely covered him with clothes. It had been one week since that horrible moment when Auntie had turned on the radio. That moment had

never ended; it had only grown worse. When we approached the military police station, my brother calmly handed over our identifications paper. The guard looked at us closely; he leaned through the window and stared at the pile of clothes. I wondered if the clothes were moving. I waited for the guard to stiffen, for him to aim his rifle, for him to drag Father from the hiding place. He stepped back and waved us through."

I am a psychologist. People often ask me, "How did wartime Relocation affect Japanese Americans?" Relocation was a wall that my mother's music could not scale.

When asked about her feelings and thoughts during her three years in Relocation Camp, Okaa-chan has little to say. Her memory, usually so rich with character and mood and nuance, becomes oddly unyielding.

"How long did you have to get ready, what did you take?" My sister and I try to encourage her with questions.

"Oh," Okaa-chan stops and thinks. She shakes her head impatiently, as if trying to shake a dormant memory into wakefulness. "Let's see, maybe two weeks? We could bring what we could carry. Everything else had to be sold or given away." Okaa-chan trails off and looks at us with worry. She is disappointed by her memory and afraid that we will be disappointed with her.

When Okaa-chan speaks of her years in Relocation Camp, her voice is hesitant. Often it fades: confused and apologetic. Her recollections are strangely lifeless. In this way, the Wyoming desert, with its cruel extremes, with its aching cold and killing heat, still holds my mother against her will.

My Father's Career

 My father is a retired research scientist. He swells and glows when describing the processes of the universe. The laboratory could not contain his enthusiasm. He was a magnet for scientific flotsam. Scraps of litmus and discarded electroencephalograms would spill from the depths of his pockets.

I was six years old when Father showed us mercury. In the slanting sunlight of a summer's eve, we huddled on the back porch, tiptoed and peering. Father poured a heavy silver liquid into the top of a cardboard shoe box. The liquid poured in beads. Scentless, soundless, shimmering beads. They rolled languorously as the box top was tilted this way and that. Father poked the beads with a pencil point and they dented into soft round commas. He told us about atomic weights and mercury poisoning, and the beautiful beads quivered with mystery and power. My mother hovered close and anxious—torn between convictions. Expose children to science. Protect children from hazard.

When Father went away to scientific conferences, he would send me the postcards issued by his hotel. An arrow would be drawn to a tiny hotel window, far above the pavement and the trees. "This is where Daddy is staying," he would write. I would study the postcard for a very long while. In time, the curtains in the tiny window would part and I would feel my father's presence:

standing by the window, looking out, and searching for my face.

Once, Father spent a week at a conference with a man named Ponchec. Ponchec was idiosyncratic. Each night, before retiring, Ponchec would drink a bottle of Coca-Cola. He would settle upon his twin bed—stretching his legs along its length, plumping pillows behind his back—and would paw through his battered briefcase with the cheerful anticipation of a child examining his Halloween bag of treats. From his briefcase would emerge a sheaf of papers and a small grocer sack containing two bottles of Coca-Cola. "Shall we review the day's sessions?" he would ask with a shy and shining hopefulness. He would extend a cola across the nightstand.

Each evening, the appearance of those slender, sea green bottles signified the commencement of an academic dialogue, as surely as a gavel's fall convenes a courtroom.

My father laughed and shook his head when he told us about Ponchec. "That old rascal got me into a habit," he said with mock exasperation. For the next two months, while reading his professional journals, my father nightly drank one bottle of Coca-Cola. It was his toast to the spirit of scientific fraternity.

"The first thing I saw in America was a tengu—a treacherous long-nosed demon," says my father. He is recalling the day in 1922 when he immigrated to the United States. "A huge creature with red fur upon its face. It had the pale skin of a ghost and eyes so light they seemed to be transparent."

"What was it?" I shiver. I am ten years old.

"It was a monster posing as an immigration inspector."

"What did you do?"

"I searched for my parents. I expected to meet them at the dock in Seattle. I looked and looked and my fear grew. I had not seen my parents in five years. I began to realize that I could not remember what they looked like."

"Did the tengu trick you with clever speeches?" I inquire. I am familiar with tengu and their dangerous occult arts.

"It could not speak," recalls my father. "Only a strange rumbling came from the depths of its throat. I was confused. I had never encountered a tengu before. Perhaps it was not even a tengu, perhaps it was the unimaginable baku, come to feed upon my dreams!"

I give a little shudder. "Then what?"

"I begged the monster to spare my life. I was carrying a package that contained all the papers I would need. I thrust it at the tengu-baku and started to cry." My father pauses and chuckles. "Actually, the immigration officer was a very nice man."

"What happened? Did your parents recognize you?" But Father's storytelling cannot be rushed.

"As I stood shivering before the giant devil, it smiled and patted me on the head. It rummaged through its clothing and handed me a stick. I sobbed and stared. The tengu-baku pantomimed putting the stick in its mouth. It smiled again. Very gradually, my crying subsided. Very hesitantly, I raised the stick to my mouth and touched it to my tongue." Father's tale pauses tantalizingly.

"And?"

"And immediately I knew I had been tricked. The stick was hot. It singed my mouth; I could taste the sweetness of poison. I hurled the stick to the ground and wept inconsolably." Father tugs gently on my braided hair. "Later," he smiles, "I learned the name of the stick was peppermint."

"And your parents?" I giggle at Father's naïveté.

"Your grandfather had traveled hundreds of miles to meet my boat in Seattle," says Father. "Your grandfather had been born in a tiny fishing village, way back in the 1870s. In America, he worked for the railroad company; but he came from a different world. A smaller, slower world. He was not comfortable living in the industrial age. He never grew to trust the power and speed of trains. Rid-

ing them made him weak with anxiety and it took all his courage to meet me."

"Did he bring you presents?" Presents are never far from my mind.

"In a way. The first thing that your grandfather did was to buy me American clothing. It was an immigrant ritual. Near the landing area was a shopping district especially for the new arrivals. In it was a clothing exchange store. Masses of Japanese poured off the boat and into that store. They entered in kimono and exited in Western clothes. I left wearing a navy blue sailor suit with knickers. I had knee-high socks and a little white sailor cap. My father led me down the street and bought me a juicy hot dog. I was bursting with pride. I knew I had become an American."

Braving another train ride, Grandfather took my father home to a little wooden house in the east Washington desert. A wheezing windmill pulled water from deep below the parched soil. Grandmother willed the survival of vegetables, chickens, and flowers. Try as she might, she could never coax them to flourish.

"Where we lived, an odd thing used to happen," says my father, his brow wrinkling in the effort to recapture the image. "Twice a year, a Yakima Indian and his grandson would appear. They would come walking across the desert landscape: two blurred figures growing into an old man and a boy. They would come bearing a gift—an alderwood smoked salmon. To me, it always seemed a miracle, like the kings arriving in Bethlehem or a mirage from some desert delirium. 'Kiku, Kiku, Kikumatsu!' they called in Japanese. 'Chrysanthemum, Chrysanthemum, Chrysanthemum-pine.' From their throats came my father's name: low and singing, like the voices of birds, like the saying of a prayer."

"Where did they come from? Why did they come?"

"They walked from the Columbia River. Each summer the Indians gathered driftwood, timbers washed ashore from overloaded

logging barges. But winters were harsh and driftwood limited. Your grandfather gathered railroad ties to keep their babies warm."

"And the fish?"

"The salmons were thanksgiving. When the flickering figures appeared calling, 'Kiku, Kiku, Kikumatsu,' we all would rush outside. Your grandfather was very happy to hear the Kiku call. It was like the first sip of water in the morning of the new year: a sign of Buddha's goodness. It meant the Indians had survived."

Because there were no schools in that part of the desert, my father and his older brother Kaoru moved to a town down the line. They lived in a cabin in an area settled by Mexican railroad workers. There my father learned to speak English and to eat jalapeño peppers. On weekends, Father and Kaoru visited their parents—pumping a flat-bedded cart along the railroad tracks and straining for the distant keening that announced an approaching train. At the first faint lowing, they would scramble to drag their cart from the tracks. Then they would wait, with heads bowed, before a fury of dust and thunder.

My father was a willful boy. He grew sullen working on the track. He withered in the desert sun. Whenever he could, he slipped from the harness of his chores and stole away to read. When Father reached the eighth grade, he decided he would go to college.

And so it happened, that Father moved farther down the line, still farther from his parents' house in the desert. He went to Portland, where public schools fed public colleges. He became a schoolboy, a child servant, in the home of a prosperous automobile distributor. For room and board, Father cooked and cleaned and tended the cool long lawn that sloped away from the big house like a dowager's ample evening skirt.

And slowly, my father began to idolize his employers. A boy who had lived most of his life separated from his parents, he began

to imagine a deep well of parental warmth behind the smallest of gestures.

"Early one morning, when I was taking out the trash, I spied a glimpse of supple leather," says my father with nostalgia. "A brief-case lay buried beneath the coffee grinds. Golden letters—the initials of my employer—were embossed on the front. I wanted that briefcase so much, but to take it without asking would be stealing."

My father gazes out the window and sees a distant dawning. He feels the cold and dew-drenched morning, the soft and supple treasure.

"All day, I waited for my employer. I waited for him to return from work, to fix and drink his martini. I served his dinner and my hands shook with impatience. All the time, my mind was on the briefcase. Finally, with a racing heart, I asked if I could use it for my schoolbooks." Father pauses. "My employer was confused, 'Speak clearly, boy!' he cried. I gestured for him to wait. I raced to the end of the long driveway. The briefcase was still there. When I got back to the parlor, my employer was smoking a Havana cigar. The aroma rose rich and woody. I held up the briefcase. I did not say a word. 'Oh, that,' laughed my employer. 'Just take it. It's yours.'"

Fifty years later, recalling this kindness, my father's eyes mist with tears.

My father loved his work. He came home from the lab talking excitedly about his experiments. He paced the kitchen as he spoke, displaying annoyance when my mother could not test him with sufficiently penetrating questions. As he had been a good student and a good servant, my father was a good employee. He developed patents. He was loyal. Late at night and on weekends, he and my mother translated correspondence for his company's international office. From Japanese to English. From English to Japanese. Careful not to lose the nuances within every writer's voice.

Three years before his retirement, my father learned that he was

being paid the same salary as his laboratory assistant. His doctorate was earning the wages of a high school diploma.

"Your personnel file has been badly mismanaged by my predecessors," said the supervisor of personnel, "a fact that is most regrettable."

My sister and I were livid. "Sue them blind!" we raged.

But my father refused. He asked the company to base his pension on a more appropriate sum. The company agreed. I imagine they were relieved.

"You let them off too easily. You should have called the American Civil Liberties Union," my sister and I glowered. "You had a case. You could have won. Make the bastards pay."

My father's voice was calm. "For over thirty years, I have awoken each morning with an eagerness to go to my lab," he said. "I am proud to have had an opportunity to do the work I love."

"But they exploited you! It was racial discrimination!"

My father studied his American daughters. He gently smiled. "Before I could sue, I would have to review my life. I would have to doubt the wisdom of loyalty. I would have to call myself a victim and fill myself with bitterness." He searched our faces for signs of comprehension. "I cannot bear so great a loss."

He stood up and walked into the backyard. Through the kitchen window, we watched as he paused to inspect his roses. He stood proud and betrayed—an old man with white hair.

"A lion in winter," murmured my sister.

Albany, 1958

 The meter of my childhood was the rising and plunging of a sewing machine needle: rapid and smooth, like an endless distant drum roll. My mother hummed as she sewed. She guided the fabric this way and that.

In 1938, my mother had graduated from a school of costume design. Before she was sent to a Relocation Camp, she had her own boutique in Beverly Hills. It was her dream come true. At that time, her brother was working as a houseboy in a Beverly Hills mansion. One heat-shimmering day, the movie star Ginger Rogers had smiled at him. She had stopped him as he trudged to the bus stop and had given him a ride in her shiny new sports car. Down the sloping boulevard and toward the city of angels. It was before the war, a time and place when anything could happen, when the dream of America had never seemed finer.

The Albany of my childhood was a festive place, closer in spirit to the nineteenth century than to the twenty-first. Italian pushcart grocers crowded southern city blocks, crafting tiered architectural wonders from fresh produce and pungent sausages. The clamor of market day hung in the air mingling with garlic and yeast.

In that Albany, heavy-legged workhorses clopped along cobble-stones, delivering bread from German bakeries and milk from

Dutch dairies. A cable car ran along streets named for trees that once had grown there—chestnut, elm—or for birds that no longer were seen. We had an icebox instead of a refrigerator, and a short solid man who sang opera as he delivered the ice. My mother washed laundry against a wooden scrub board in a claw-footed bathtub. My sister hung it in the yard.

Each year in early April, an annual dinner-dance was sponsored by the pharmaceutical institute where my father worked as a researcher. A ballroom was rented in a downtown hotel. Musicians were hired to play big-band music. The dinner-dance was the only time when my mother would sew for herself. It was the one time when my parents went out, alone, together. I was a romantic child, dreamy and diffuse. For me, the dinner-dance was an annual event: looked forward to in long anticipation and back upon with nostalgia.

Each year, on a snowy weekday evening, Father would take us window shopping. The deserted downtown streets would be a magical glaze of snow-softened Christmas lights and shadowy shop displays. We would walk quietly, measuredly, as if in a museum. My mother would linger in front of the mannequins clad in evening apparel. My sister would glitter with questions. "How do they get that Santa's hand to wave? When will we get our tree?" I would follow along, drunk with wonder: tilting my face to the soft swirling sky, trying to taste snowflakes with the tip of my tongue.

Each year before the tape had desiccated on the backs of the New Year's cards and they had fallen, first into dizzying angles, and then to the floor, my mother would have decided on the design for her dinner-dance dress. Then there would be a trip to the fabric store. I would run my hands along graduated rainbows of thread spools. I would listen to their wobbling sound and watch their changing hues as they shimmered in the light.

As the dress took form, my parents would practice dancing.

"Slow, slow, quick, quick, slow," Father would mutter with determination as he trod unmincingly on Okaa-chan's feet and guided her into the walls.

"Next lady?" he gallantly would inquire. Misa and I would take turns, balancing on the tops of his shoes, as Father swept us around the room.

I always thought that Dinner-Dance Eve had some of the magic of Christmas. Every year, I would perch on the bathtub's edge. I would watch my father fix his tie. "See the nice dimple below the knot?" Father would turn from the mirror and bend to show me. "The dimple is very important." I solemnly would nod—the honored recipient of this arcane cultural wisdom.

Back in the bedroom, Okaa-chan would slide into her new dress. She would glance at her reflection with modest pleasure. When she moved, I could catch the light sweet scent of face powder.

When I was seven or eight, the window shopping and the dinner-dances stopped. The granite façades of the downtown stores were grimy with graffiti. Display windows were boarded with plywood. The elegant hotels had fallen into disrepair. No one danced to big-band music anymore.

As I grew older, my mother began to sew for wealthy women. The women lived in country homes where sunlight, reflected from swimming pools just beyond French doors, played across fine wood floors.

Once after a luncheon in the city, a woman came to our house for a fitting. Standing erect in the doorway, then bowing slightly, my mother met her formally.

"Won't you please come in? May I please take your coat?"

"Here you go. Try to put it somewhere clean."

Like an eagle, her words slipped regally down a great distance and struck with awful ease.

After the fitting, my father was ashamed and angry.

"Actually, I do not like this work," he stormed. "You do not have to do this; we do not need this kind of money." He waved his arms dismissively at Okaa-chan's sewing machine. "They come and look at our home with contempt. You kneel at their hems like a servant! *Mo dame desu yo!* It is no good, I tell you!"

Okaa-chan was intractable. Eloquent in anger, she blazed over the pronunciation of words that ordinarily would have left pondering pauses in her speech. "I do not care what they think of me, of our home. They cannot affect our value." My mother stepped in front of her sewing machine, as if to shield it from scorn. "My work gives me happiness." She squarely faced my father. "I do not care if you speak as Husband," she said daringly. "I am a Designer!"

"You are a seamstress," snorted my father.

The New House

We lived on a street that mirrored the social climate of the times. Two blocks north was the Park District. There, behind the broad bay windows of brownstones, existed the slightly shabby offices of struggling doctors and dentists. Within attics and basements dwelled students of law and medicine. On the southeast corner of the Park District, Mr. Rheingold owned a drugstore. He was a kindly man, most often found dispensing candy to the neighborhood children and academic exhortations to his growing sons.

South of the Park District, buildings turned to brick. Here lived the meat packers and deliverymen: the Polish and Irish families. At midblock, the houses suddenly dropped form four to three stories and narrowed from three to two windows. This juncture, of sudden diminishment, was where my family lived. To our north stood a larger house, once more grand. It was occupied by white families who had fallen upon misfortune: a widow who in 1898 had come as a bride, an elevator operator who in a work-related incident had lost his right hand, his polio-stricken wife.

To our south, where the houses shifted from brick to wood, lived the black families and a couple who was blind. To me, the blind couple seemed misplaced. White and white-collared, they should have lived to our north. But their pale, staring eyes left the neighborhood uneasy and, in any event, they cared little about their ranking in an ordering of melanin.

When Misa and I were children, we had a method for calculating the ages of our friends' mothers. "If Darlene is six years old, then her mother must be twenty-one," Misa would estimate. She could do the arithmetic in her head.

The formula Misa used involved adding fifteen years to the age of any given playmate. In our neighborhood, girls grew to adolescence, became pregnant, and left school. One, two, three.

When Misa turned ten, my parents began to talk together late at night. They wanted to move to a suburban neighborhood. They wanted to live in a district where daughters were expected to graduate from four-year colleges or universities. "Someday," Okaa-chan would say to Misa, as a lure, "someday you will receive matching set of Samsonite luggage. You will pack it with plaid, pleated skirts, and you will go away to college." Okaa-chan would hesitate; her knowledge of the coed experience would falter. Misa would shrug with indifference and continue to draw cartoons of pretty mice wearing pretty clothes. The opportunity to learn was more Okaa-chan's dream than hers.

Alarmed, Okaa-chan refocused her attention on the drafting of blueprints. She designed a simple house: three bedrooms, an attached garage, and a room with Japanese shoji screens. Father began to look for a lot. He based his search on the percentages of National Merit Scholars within a school district's graduating class. Evening after evening, he would wash our powder blue Chevrolet. We would put on our nice clothes. Then we would go to look at lots. When we arrived, the lots were never available. Someone had just purchased them; the prices had been raised. It was puzzling to me.

"Never mind," Father would say as he drove us home, "soon we will build our house."

"See the gardens Misa, Yuri-chan?" Okaa-chan would say. "Someday you will have one too."

"And a bicycle, and a dog?" I eagerly would ask.

"Moron," Misa angrily would hiss. "Don't you know when to shut up?"

"Takes one to know one," I happily would chant. At the age of six, I was the only one who loved those evening drives.

In a small town, on the eastern side of the Hudson River, my parents bought a lot. It was lushly wooded. Each weekend my father prepared a picnic lunch—Japanese rice balls and a can of sardines—and went to clear the trees. The lunches made him nostalgic.

"Your grandfather supervised a stretch of line along the Great Northern Railroad," he explained as he formed the rice balls. "During the Depression, the boxcars would roll by our house in the desert. They would make a lonesome sound." Father salted the rice balls to the rhythm of a rocking train. "Ka chun, ka chun, ka chun."

He paused a moment in recollection. "Hobos would be silhouetted along the tops of the cars like crows along a telephone line."

"Where were they going?"

"They crisscrossed the country endlessly. No work to do; no place to go. Your grandfather would feel sorry for them. He would leave cans of sardines and balls of rice down by the railroad tracks. The hobos would jump from the rolling cars and squat to eat the food. They would walk, wavering through a prism of desert heat, like zombies coming from another dimension. They would come toward our house, getting bigger as they came."

"Weren't you scared?"

"Up close, they lost their strangeness. I could see they were just tired men. They came to help with the chores and to tell their sad hobo tales."

One October dusk, when the new house was almost complete, our family went to see the lot. Misa and Okaa-chan explored the house. Father and I stood in the front yard.

"In the spring, myrtle will grow around the base of the dogwood tree over there," he said to me. "The tree will billow with blossoms."

I looked past the dogwood tree. Six or seven adults were approaching. I felt a chill.

Father glanced at the walkers. "The myrtle will be deep green," he continued, "with a sprinkling of small purple flowers."

The adults had reached the edge of our property. They stood there quite close, and jostled restlessly.

"When the dogwood has finished blooming, red berries will form," said my father. I slipped my hand in his.

"Hey you!"

"Good evening," Father turned his attention from me: slowly, deliberately, dangerously. "Is it I whom you wish to address?"

"We live in this neighborhood and it has always been a nice neighborhood."

The others rumbled in assent.

"We are clean, decent people and we don't intend to see our neighborhood's ruin!"

"I am sincerely glad to hear that," said my father. He spoke with careful calm. "We, too, are clean, decent people. We expect our neighbors to act in decent ways."

"We just came to welcome you," said the spokesman, suddenly shifting his style. "You might say we're a hospitality committee, here to help you understand our ways."

Once when I was five years old, a strange woman had given me a penny, had walked up to me in a department store when my mother was occupied with a purchase, had seized me by the hand and pressed hard. "And what do you say?" she had wheezed excitedly, her pallid face flushed in splotches and forced close to mine. "And what do you say?" The scene flooded back as I stood by my father's side. The pain of the penny biting into my palm, the horror of her excited face, the self-disgust when, once again, I heard myself whisper, "Thank you."

When we moved to the new house, I was nervous about my first day of school. I wanted to belong. My father misread my anxiety. "A bus will take you from the corner of the street to school," he carefully explained. "After school, a bus will bring you home."

On the first morning, I boarded the yellow bus. "How much is the fare, sir?" I asked.

"Don't talk to the driver, stay behind the white line," he growled.

I did not move. I was a city child. I knew there was no such thing as a free bus ride. "Do I pay at the end? Do I buy a book of coupons? Are there tokens?" I persisted.

The children on the bus began to giggle.

The school bus took us past pasturelands. Cows grazed in morning meadows. Outside of picture books, I had never even seen a cow. They were as exotic as elephants. "There are *cows* out there!" I screamed, pointing.

The children glanced at the cows with disinterest. Their interest had fastened on me.

In school, during recess, my classmates gathered around me.

"What religion are you?" asked a fair-haired, freckled boy. His hair smelled faintly of tonic, just like a grown-up man.

The other children stiffened. I knew that this was the test.

"Uhmmm...I'm Christian," I nervously said.

"Silly. *Everyone* is Christian!"

I was surprised. This had not been true in Albany.

"Well?"

"I guess I'm Protestant."

A girl with long auburn barrel curls tossed her head with impatience. "Everyone is Protestant!" she declared. Her voice dropped to a conspiratorial whisper. "Except Licia. She's Catholic." The children shot a quick glance at a shy, slender girl sitting alone by the window. That's Licia, I thought. As if disturbed by my identifying gaze, Licia shifted uneasily in her seat.

"So...what religion *are* you?" The freckled boy was growing testy.

"Methodist!" I blurted with the relief of sudden recollection.

The children relaxed. "Me too," smiled one. "I'm a Methodist too!"

I grinned. I knew that I had passed.

My classmates went home and told their parents that there was a new Methodist girl in school. The next few days went well. It must have been the teachers who spread the news that I was more than Methodist. By the end of the week, my classmates had learned of a new category: more taboo than being Catholic, more indicative of bad blood than being adopted. My classmates had learned about color.

Transformation

 Perhaps it begins with my naming. During her pregnancy, my mother was reading Dr. Spock. "Children need to belong," he cautioned. "An unusual name can make them the subject of ridicule." My father frowned when he heard this. He stole a worried glance at my sister. Burdened by her Japanese name, Misa played unsuspectingly on the kitchen floor.

The Japanese know full well the dangers of conspicuousness. "The nail that sticks out gets pounded down," cautions an old maxim. In America, Relocation was all the proof they needed.

And so it was, with great earnestness, my parents searched for a conventional name. They wanted me to have the full true promise of America.

"I will ask my colleague Froilan," said my father. "He is the smartest man I know."

"And he has poetic soul," said my mother, who cared about such things.

In due course, Father consulted Froilan. He gave Froilan his conditions for suitability.

"First, if possible, the full name should be alliterative," said my father. "Like Misa Minatoya." He closed his eyes and sang my sister's name. "Second, if not an alliteration, at least the name should have assonantal rhyme."

"Like Misa Minatoya?" said Froilan with a teasing grin.

"Exactly," my father intoned. He gave an emphatic nod. "Finally, most importantly, the name must be readily recognizable as conventional." He peered at Froilan with hope. "Do you have any suggestions or ideas?"

Froilan, whose own American child was named Ricardito, thought a while.

"We already have selected the name for a boy," offered my Father. "Eugene."

"Eugene?" wondered Froilan. "But it meets none of your conditions!"

"Eugene is a special case," said my father, "after Eugene, Oregon, and Eugene O'Neill. The beauty of the Pacific Northwest, the power of a great writer."

"I see," said Froilan, who did not but who realized that this naming business would be more complex than he had anticipated. "How about Maria?"

"Too common," said my father. "We want a *conventional* name, not a common one."

"Hmmm," said Froilan, wondering what the distinction was. He thought some more and then brightened. "Lydia!" he declared. He rhymed the name with media. "Lydia for *la bonita infanta!*"

And so I received my uncommon conventional name. It really did not provide the camouflage my parents had anticipated. I remained unalterably alien. For Dr. Spock had been addressing *American* families, and in those days, everyone knew all real American families were white.

Call it denial, but many Japanese Americans never quite understood that the promise of America was not truly meant for them. They lived in horse stalls at the Santa Anita racetrack and said the Pledge of Allegiance daily. They rode to Relocation Camps under armed guard, labeled with numbered tags, and sang "The Star-Spangled Banner." They lived in deserts or swamps, ludicrously

imprisoned—where would they run if they ever escaped—and formed garden clubs, and yearbook staffs, and citizen town meetings. They even elected beauty queens.

My mother practiced her okoto and was featured in a recital. She taught classes in fashion design and her students mounted a show. Into exile she had carried an okoto and a sewing machine. They were her past and her future. She believed in Art and Technology.

My mother's camp was the third most populous city in the entire state of Wyoming. Across the barren lands, behind barbed wire, bloomed these little oases of democracy. The older generation bore the humiliation with pride. "*Kodomo no tame ni,*" they said. For the sake of the children. They thought that if their dignity was great, then their children would be spared. Call it valor. Call it bathos. Perhaps it was closer to slapstick: a sweet and bitter lunacy.

Call it adaptive behavior. Coming from a land swept by savage typhoons, ravaged by earthquakes and volcanoes, the Japanese have evolved a view of the world: a cooperative, stoic, almost magical way of thinking. Get along, work hard, and never quite see the things that can bring you pain. Against the tyranny of nature, of feudal lords, of wartime hysteria, the charm works equally well.

And so my parents gave me an American name and hoped that I could pass. They nourished me with the American dream: Opportunity, Will, Transformation.

When I was four and my sister was eight, Misa regularly used me as a comic foil. She would bring her playmates home from school and query me as I sat amidst the milk bottles on the front steps.

"What do you want to be when you grow up?" she would say. She would nudge her audience into attentiveness.

"A mother kitty cat!" I would enthuse. Our cat had just delivered her first litter of kittens and I was enchanted by the rasping tongue and soft mewings of motherhood.

"And what makes you think you can become a cat?" Misa would

prompt, gesturing to her howling friends—wait for this; it gets bet-
ter yet.

"This is America," I stoutly would declare. "I can grow up to be
anything that I want!"

My faith was unshakable. I believed. Opportunity. Will. Trans-
formation.

When we lived in Albany, I always was the teachers' pet. "So tiny,
so precocious, so prettily dressed!" They thought I was a living doll
and this was fine with me.

My father knew that the effusive praise would die. He had been
through this with my sister. After five years of being a perfect dar-
ling, Misa had reached the age where students were tracked by
ability. Then, the anger started. Misa had tested into the advanced
track. It was impossible, the community declared. Misa was forbid-
den entry into advanced classes as long as there were white chil-
dren being placed below her. In her defense, before an angry rab-
ble, my father made a presentation to the Board of Education.

But I was too young to know of this. I knew only that my teach-
ers praised and petted me. They took me to other classes as an
example. "Watch now, as Lydia demonstrates attentive behavior,"
they would croon as I was led to an empty desk at the head of the
class. I had a routine. I would sit carefully, spreading my petticoat-
ed skirt neatly beneath me. I would pull my chair close to the desk,
crossing my swinging legs at my snowy white anklets. I would fold
my hands carefully on the desk before me and stare pensively at
the blackboard.

This routine won me few friends, The sixth-grade boys threw
rocks at me. They danced around me in a tight circle, pulling at
the corners of their eyes. "Ching Chong Chinaman," they chant-
ed. But teachers loved me. When I was in first grade, a third-grade
teacher went weeping to the principal. She begged to have me
skipped. She was leaving to get married and wanted her turn with
the dolly.

* * *

When we moved, the greatest shock was the knowledge that I had lost my charm. From the first, my teacher failed to notice me. But to me, it did not matter. I was in love. I watched her moods, her needs, her small vanities. I was determined to ingratiate.

Miss Hempstead was a shimmering vision with a small upturned nose and eyes that were kewpie doll blue. Slender as a sylph, she tripped around the classroom, all saucy in her high-heeled shoes. Whenever I looked at Miss Hempstead, I pitied the Albany teachers whom, formerly, I had adored. Poor old Miss Rosenberg. With a shiver of distaste, I recalled her loose fleshy arms, her mottled hands, the scent of lavender as she crushed me to her heavy breasts.

Miss Hempstead had a pet of her own. Her name was Linda Sherlock. I watched Linda closely and plotted Miss Hempstead's courtship. The key was the piano. Miss Hempstead played the piano. She fancied herself a musical star. She sang songs from Broadway revues and shaped her students' reactions. "Getting to know you," she would sing. We would smile at her in a staged manner and position ourselves obediently at her feet.

Miss Hempstead was famous for her ability to soothe. Each day at rest time, she played the piano and sang soporific songs. Linda Sherlock was the only child who succumbed. Routinely, Linda's head would bend and nod until she crumpled gracefully onto her folded arms. A tousled strand of blonde hair would fall across her forehead. Miss Hempstead would end her song, would gently lower the keyboard cover. She would turn toward the restive eyes of the class. "Isn't she sweetness itself!" Miss Hempstead would declare. It made me want to vomit.

I was growing weary. My studiousness, my attentiveness, my fastidious grooming and pert poise: all were failing me. I changed my tactics. I became a problem. Miss Hempstead sent me home with nasty notes in sealed envelopes: Lydia is a slow child, a noisy child, her presence is disruptive. My mother looked at me with surprise,

"*Nani desu ka?* Are you having problems with your teacher?" But I was tenacious. I pushed harder and harder, firmly caught in the obsessive need of the scorned.

One day I snapped. As Miss Hempstead began to sing her wretched lullabies, my head dropped to the desk with a powerful CRACK! It lolled there, briefly, then rolled toward the edge with a momentum that sent my entire body catapulting to the floor. Miss Hempstead's spine stretched slightly, like a cat that senses danger. Otherwise, she paid no heed. The linoleum floor was smooth and cool. It emitted a faint pleasant odor: a mixture of chalk dust and wax.

I began to snore heavily. The class sat electrified. There would be no drowsing today. The music went on and on. Finally, one boy could not stand it. "Miss Hempstead," he probed plaintively, "Lydia has fallen asleep on the floor!" Miss Hempstead did not turn. Her playing grew slightly strident but she did not falter.

I lay on the floor through rest time. I lay on the floor through math drill. I lay on the floor while my classmates scraped around me, pushing their sturdy little wooden desks into the configuration for reading circle. It was not until penmanship practice that I finally stretched and stirred. I rose like Sleeping Beauty and slipped back to my seat. I smiled enigmatically. A spell had been broken. I never again had a crush on a teacher.

Mothers and Daughters

My narcoleptic adventure earned me some ease. My classmates stopped tormenting me. They backed away and granted a grudging respect to my madness. Possibly, Linda Sherlock had made them sick as well.

I also gained a best friend, Jennie Lindstrom, who was as stringy and blonde as I was dense and dark. Like me, Jennie had a father who was a research scientist. Like me, she was somewhat of a pariah.

Exuberant, adventurous, reckless, Jennie's elbows and knees were a tangle of scars and scabs. I thought there was nothing she feared, but I was wrong. Her classmates knew differently. In kindergarten, they had learned. If cornered and taunted, Jennie could be driven to suck upon her thumb.

Jennie was teased about her mother, who was not a typical suburban mom. Mrs. Lindstrom smoked cigarettes. She never cooked. She sent her five children forth in scandalous disarray. They always were in need of a decent haircut.

Jennie liked to hang around my mother. Sometimes, I grew jealous. My head would be filled with some grand scheme, how we could rig a canoe from an old cardboard box, how we could add a new twist to our ongoing operetta, but Jennie would be engrossed in monitoring my mother's baking. Or I'd be wanting my mother's

attention, would be trying to show her how I could curl my tongue, and she would say, "What do you think Jennie would like for dinner tomorrow?" Jennie ate with us almost every night. She grew rosy and gained weight. Even her little brother started coming by our house.

Whenever I spent the night at Jennie's, dinner was "every man for himself." Jennie taught me to prepare her dietary staple: a tablespoon of butter rolled in granulated sugar. We liked it so much that we had it for breakfast too.

The Lindstrom kitchen would have made a social worker blanch. Open jars of peanut butter, cartons of curdling milk, were strewn across the counter. Every cabinet door was open and every cabinet was bare. A slab of crumb-encrusted butter lay lopsided and melting on a dinner plate—a cat sniffed daintily at its core. Cereal crunched beneath your feet and mixed with particles of kitty litter that had been carried in between the tabby's toes.

Dr. Lindstrom sought refuge in his pine-paneled study. A studious and somewhat distracted man, he spent most evenings sequestered with his paperwork. During these times, children were banished from his sight. I suspected it was a ruse. Once, I used the small half-bathroom adjacent to the study. Through the thin wall I could hear the whisperings of television. Dr. Lindstrom was watching *Bonanza*.

Mrs. Lindstrom had territories of her own. If you stood in the front hallway—amidst the rubble of abandoned boots, soggy mittens, scattered schoolbooks—you could see into the living room. It was an enchanted land, a pristine place of Persian carpets and eighteenth-century antiques. A grand piano gleamed by the window, not a fingerprint smudged its sides. A glass case housed Hummel figures. Even the cat knew to stay clear.

Usually, Jennie's mother was not at home. She toured the countryside in a battered station wagon, scouring cluttered curio shops for buried treasure. I liked her for her incongruity. She was an ele-

gant witty woman, forever traveling—unmarred—through the epi-
center of chaos.

One episode seems characteristic. Mrs. Lindstrom is speeding
along a rural road, furiously smoking cigarettes and punching
impatiently at radio channels. Jennie and I slide back and forth
across the front seat. We are startled into silence by her proximity.
Why are we here? Ordinarily her flights are solo.

The afternoon is darkening. The car climbs and dips. Crows
veer from our path. All the while, in half-frozen fields, trees hunch
and snow melts in unattractive patches.

Mrs. Lindstrom is humming. Her tune is completely unrelated
to the random snatches of songs and sales pitches that flash and
die in the dashboard. Her hazel eyes are glittering. They sweep the
landscape for garage sales, junk shops, anything of interest.

"Man oh man!" she suddenly exclaims. "Did you see that?"

I shift guiltily. I have seen nothing. I have been too mesmerized
by her nervous intelligence.

Ellen Lindstrom wheels into an abrupt U-turn. Our tail swings
wildly, on the verge of being left behind.

"They're slaughtering hogs back there. Come on, you're gonna
learn something!"

She is really excited. Her breath comes fast and shallow. It fogs
the windshield. I have seen her like this before. For Ellen Lind-
strom, passion comes quick and sudden. It lurks in the oddest
moments, overtaking in its intensity.

She jerks again at the steering wheel and rumbles into a
ramshackle farmyard. Gravel and dirt spray from her tires.

Two grizzled men watch her arrival. Bowlegged and bare-armed
in the raw March air, they stand braced against the assault of her
interest.

The driver's door swings open and Ellen unfolds. It is a graceful
movement, like the opening of a fan. Jennie and I climb out the
passenger side and stand shy and uncertain.

The men are strangely expressionless. Neither welcoming nor wary. They turn to resume their work.

"Can you show the girls what you're doing?" Mrs. Lindstrom is perfectly poised. Her brunette pageboy gleams in the late afternoon light.

The men glance at Jennie and me. Disheveled and dissimilar, we look like orphans.

It is a bizarre scene. So gruesome and matter-of-fact. A cauldron boils on a wood fire. From a huge tree, two hogs hang like lynched laundry. The men explain the process as they work. A throat is slit. Then a long slash along the belly. As if cracking a safe, they fiddle for a moment before the double doors of flesh swing wide. Inside, the intestines shine with ruby moistness.

As the hogs hang to dry, draining blood into the hard earth, the men explain how the skin is removed. Their movements are deft and knowing. Jennie stands dazed, lips parted, enrapt. But my gaze is pulled toward Jennie's mother.

Ellen Lindstrom leans against the car, watching. She bends to light a cigarette and her hair slips around her cupped hands, around her luminous face. She wears flannel slacks, a silky blouse. A car coat is draped casually around her shoulders. She takes a long draw, shakes her hair back and exhales in slow satisfaction. Seeing me, she grins and waves.

I am mesmerized. Mrs. Lindstrom stands in the midst of carnage: cool, classy, ironic. She looks like nobody's mother; she looks like young Betty Bacall.

Ellen Lindstrom knew no need to belong. She fit nowhere and believed she fit everywhere. She always felt at home. I thought I could learn from her. I thought I could absorb her easy confidence and shed my anxious ways. My differences dislocated me, made me simpering or sullen. In those days, I was vigilant for role models. I always was searching for clues.

The Good-
Impression Scale

During my graduate school training, we took a
battery of psychological tests. The point was to
practice interpretation on ourselves. Most tests had a scale named L.
L stood for lie. Sometimes it was called, more benignly, a good-
impression scale. If elevated beyond a certain point, the L scale sug-
gested that you were "faking good," trying to create an unrealistically
good impression. It rendered the entire test suspect.

It always galled me that my L scales came out so high. Not so
high as to be damning, but high enough to cause a smirk. Can't it
be that I'm *honestly* more conscientious, altruistic, and self-direct-
ed? I grumbled to myself. Doesn't *someone* have to be a stellar
human being?

In graduate school, we were sent into psychotherapy. The goal
was to achieve a client's perspective. For a year, I saw a psychiatric
social worker. Often she fell asleep as I spoke. I was a good student
and knew full well that, in theory at least, a sleeping therapist is a
therapist who is struggling with negative feelings toward the
client. I was appalled. I had shown my inner core and been judged
unlikable!

In truth, I hardly shared my inner core. I wanted to be admired

more than known. The superficiality of my concerns was boring, and as my therapist's boredom grew, so grew my superficiality. I was trapped. I dreaded going to sessions but dared not cancel. I did not want to be viewed as a "resistant" client.

And so I paid my money, drove to my therapist's elegant Chevy Chase home, looked at the hanging pictures of her beautiful accomplished family skiing at Sun Valley, and prattled endlessly. I was like a failing vaudevillian, pulling out every trick in desperate avoidance of the hook. Finally the whole thing began to be too reminiscent of trying to woo Miss Hempstead, and I quit.

At our final session, my psychotherapist told a story. Her parents had been German-Swiss immigrants. Tall, patrician, and decorous, my therapist had attended an Ivy League school. She had married a career diplomat. During her husband's second overseas posting, my therapist lived next door to a Japanese diplomatic family. My therapist's children were toddlers: rambunctious, destructive, and loud. As she raced through her ravaged garden, trying to keep her tots quiet and clean, my therapist would glance over the fence. The Japanese mother would be telling stories. *Her* garden was Zen-like and serene. *Her* children were immaculate and inquisitive. "That woman was everything my Swiss mother had told me to be," said my therapist, "and I hated her guts."

Change the scene slightly. Put my mother in that garden and put the garden in America. Or make it my father and put him in his laboratory. There they are: clean, honest, and reverent, diligent, docile, and perhaps a little dull. Evoking their neighbors' hate.

Of course, there is more to them. Of course, they have passions and dreams, follies and foibles. But these are private things, and they are in the garden, in the laboratory. They and their parents before them have come from a crowded land. There, you do not flaunt your individuality. My parents are Japanese. They have no idea of what it means to have a public personality.

* * *

Some Japanese tried to change. My Uncle Koji was a No No Boy. He was an engineer, a graduate of the University of California at Berkeley. In the workplace, he found his degree had little value. In time, he found himself in camp.

Camp was tedious, and when the Wartime Relocation Authority decided to provide internees with the opportunity to declare their patriotism, Uncle Koji was eager to comply. Loyalty was determined by responses to a long questionnaire; but the critical questions were numbers twenty-seven—"Are you willing to serve on combat duty wherever ordered?"—and twenty-eight—"Will you swear unqualified allegiance to the United States of America, defend the U.S. from all attack, forswear any allegiance to the Japanese emperor or any other foreign organization?" If you said Yes Yes, you were offered the opportunity of immediate enlistment. My uncle said No No.

"Actually, I was a No No No No Boy," he says. "That questionnaire made me so damn mad. 'If you met the emperor face-to-face, would you be willing to kill him?' The questions were ridiculous! I did not want to kill a soul. I knew the Constitution; I'd read my Henry David Thoreau. I decided to assert myself. I decided to say No No."

Uncle Koji was declared a menace and sent off to a maximum security detention camp. Koji's brother was the eldest son, imbued with a sense of familial responsibility. He said Yes Yes. It was believed that certification of loyalty would speed a family's release. Nothing much better happened to him. My mother watched the people she loved being carted off this way and that. She did not know what to think. Actually, the questions were ambiguously worded. She feared that by "Forswearing allegiance" she could be accused of having harbored allegiance in the first place.

The No No boys were branded, hated. Other detainees said that deference was the way. They said that the No No Boys were dangerous, that defiance could result in universal reprisals. When no good came of saying Yes Yes, the prophesy seemed to be true.

Call it learned helplessness. By the time the war had ended, my grandfather had retreated into cranky apathy. Nothing again could ever quite earn his praise. Ojii-san had lost everything: property, dignity, adequacy. He traveled back and forth between Japan and America, living with one family member, then another. After the war he left camp. But he never again found his home.

When I reached junior high school, I wanted to be a beatnik. I wanted to go away to college, to sit in coffeehouses, and to discuss Art and Meaninglessness. A cousin had visited from California. She was nineteen, beautiful, and discontent. We took her to New York City. She walked around Washington Square, drinking something called Tiger's Milk and talking about anomie. I wanted to be her someday.

We lived in an awkward town. South and east of Albany, it was one part affluent suburb, one part New England village, one part industrial river town, and one part upstate dairy country. There were no beatniks in our town.

In high school, my friends were pretty blonde girls who rode in convertible sports coupes. They had large, friendly family dogs. They had little brothers covered with freckles. Their attractive, successful parents spent summers at the club: tanning, flirting, and engaging in a fair amount of social drinking. Later, when their children were safely installed in good private colleges, a number would divorce.

I was oddly popular. Thanks to my father, I had an extensive biomedical vocabulary that I could manipulate in amusing ways. Thanks to my mother, I had a designer wardrobe of original home-made clothes. I was witty and well dressed. What more could a teenager crave?

I wanted *authority*. I was a sidekick to that bevy of beautiful girls, a foil for their fair, statuesque vitality. They were young women: studious, happy, seemingly blessed. I was that terrible,

painful thing—an adolescent: vacillating, vulnerable, and hostile.

I longed to be one thing or another, to blend and belong or to stand at a distance, boiling with racial rage, formidable and feared. But I was four feet eleven inches, eighty-five pounds, with a sweet, open, earnest face. I was hardly a figure to fear.

One summer during that period, our family flew to Los Angeles. All dressed up in our skin-tight chinos and our polished white sneakers, Misa and I sat on a curb in Nihonmachi—Japantown— and watched the Nisei parade. Men strode down the palm-lined street, rhythmically pounding on taiko drums. Women fluttered in their wake, wearing kimono and waving plastic cherry blossom branches.

We were accompanied by my Uncle Koji's children. They were touched by glamor. They attended Hollywood High and their classmates were remarkably beautiful. One had been cast in a major motion picture as the character Lolita.

We snacked on sushi and orange slurpies. We giggled and gossiped and bought souvenirs. Then the television cameras swept the crowd, and everything changed.

My cousins ducked as if threatened by enemy fire. They fell as if shot, flattening their faces in their laps, as I had learned to do in grade school air-raid drills. They hid from exposure like white-collar criminals caught in some scandalous indiscretion.

"Oh, no," they cried. "Suppose the kids at school see us. Suppose they think we're Japanese!"

There was a silence.

"Well, *aren't* we?" Misa finally asked.

My cousin Janice bristled. She drew herself up with dignity. It was the era of the Beatles and the Beach Boys. "Oh, no," she said most pointedly. "I am a *California* girl."

II.

Boston,

Massachusetts

 # A Young Professional

November, 1981. Saturday, dusk. I am living in Boston. The city is shrouded in clouds. In the waning light, a fine rain hangs, as invisible and certain as tears behind a widow's veil. High on Beacon Hill, a policeman patrols on horseback. His horse clop clops in small high steps, diagonally down the narrow lanes.

I am in the heart of the city, beneath the cold moist earth of the Boston Common, where the glare of the Park Street subway station slides icily along concrete and tile. I am watching an old man.

The old man sits alone on a bench, cradling a battered paper bag. The bag has a curious shape. Is it a bottle? I wonder. It seems too large. The bag top has been twisted along an expanse of neck. The bottom is bulbous. The old man peers inside. He smiles a secret smile. Then, he twists the bag closed.

People clip past, moving briskly toward some private future. The old man is invisible to them. He exists on some slower, dreamier plane. He peers into the bag again and squirms with anticipatory delight. As if to restrain himself, he fusses with the folding of a tattered overcoat. Finally, he cannot resist. He reaches into the bag and unveils its contents. It is a child's ukelele, with faded pink and blue paint.

The old man smiles shyly. He rests the ukelele against his cheek and gently plucks one string. Twang. The sound echoes once and is lost. After a moment, the old man tenderly slides the ukelele back into its bag. He stands and shuffles away.

Often a person interacts with a place and time in a manner that fails "to take." Occasionally, the result is a combustive moment when history is made—when revolutions and inventions and abominations are born. More frequently, the result is a drying and darkening, like a grafted bough that cannot thrive and fails to die, not a raging despair but a mild confusion upon waking. A "Where am I?" that lingers through the day. In time, it may create a timidity, or an anxiety, or a quiet sweet lunacy. In Boston, for two years, I lived at such a juncture.

Call it a youthful identity crisis. It was not a time of great trauma. I suffered no grave psychic or social wounds. But if it is true that when translated by the Chinese "crisis" becomes the words "danger" plus "opportunity," then it indeed was a crisis. For, eventually, its unsettling passage would lead me toward a greater fortune.

I moved to Boston in August 1981. I was very young and had in my possession: a brand-new tenure-track contract to teach graduate studies at a large university and a doctorate that was two weeks old. I had asked for—no, I had *negotiated*—a salary that was twice the sum of the graduate stipend I had been receiving. My latest issue of the *American Psychologist* had informed me that in the United States of America there were four women of Asian descent who were counseling psychologists. I was prepared to swell their august ranks.

The apartment that I leased hovered on the cusp of grandness. Two blocks east was the crest of Beacon Hill. There baronial mansions stood shoulder to shoulder in fraternal confidence—the clearly favored sons of an ungenerous god—looking down across the Capitol, Common, and finally back to England.

My apartment building nestled among a line of nineteenth-century tenements and boarding houses. The gas-lit cobblestoned alley was in a perpetual din. The tenements were being converted into luxury

housing; a hotel for elderly vagrant men was being renovated. Massive pieces of construction equipment sprawled across the street, sand-blasting the façades of buildings never built to be graceful until they could face the street with a stolid scrubbed prettiness.

The interiors of these buildings were being gutted. If you looked behind the scoured veneer, through the open windows, you could see huge chomping machines devouring walls and ceilings. It was like looking into the startled eyes of a decent housewife going mad.

Amidst the commotion, the elderly vagrant men wandered in mild confusion. They peered up at the buildings, with the nibbling fear of old men who no longer recognize their neighbors, and urinated on the polished stoops.

Like the neighborhood, my neighbors and I sought entry to a more gracious state of being. We awaited glorious, imminent metamorphoses. We lived in tiny, kitchenless, walk-up apartments with multiple dead bolt locks on our doors, with neither views nor light from our windows. Yet we were undaunted. We had hardwood floors and marble fireplaces. We had a foothold on Beacon Hill.

Larry and Tricia, my upstairs neighbors, were newlyweds. They were twenty-five years old. Larry was an insurance agent and Tricia was a substitute teacher. Both had grown up in an Irish working-class section of Boston; both were the first in their families to have attended college. They were proud to live so near to America's oldest, wealthiest families. Someday, they told me, they hoped to buy one of the luxury apartments that were emerging along the street.

The first year I lived in Boston, I frequently would wake to the sound of Larry singing in the shower. Tricia would be laughing and calling to him. Often I would hear them playing a game of make-believe. Larry was a puppy. Tricia was a kitten. "Woof, Woof," he would skid across the floor. "Meow," she would purr. Each evening, the young husband would rush home to his bride: whistling his way up four flights of stairs, jingling his keys, bearing his bicycle before him like a tribute.

One winter night, I woke to hear Tricia sobbing. "I know that I'm

changing. I know you're not happy, but what can I do?" Larry keened. "I'm making it; I'm moving up. I'm happy. I'm happy. I'm a happy, happy man."

They separated in April. On the narrow stairwell, I met the man who leased their former apartment. He was a thirty-four-year-old lawyer, in the midst of a divorce. He told me that he loved his new apartment: the marble fireplace, the fact that he could walk to work. "And do you know what?" he confided. "After my divorce settles, I think that I will buy one of the luxury condominiums coming up along the street."

During the 1950s, I was born in the United States of America. This event placed me among the ranks of a powerful cohort group—the postwar generation. Through the simple act of being born, in a country where majority rules, we were destined to wield inordinate influence on our society. We have grown, like infant emperors, watching our social environment continually re-create itself to mirror our changing whims.

In 1981 I was ambivalent about my new career, about my possibilities. Psychology and university teaching are "helping" professions requiring long years of training. They exert a simultaneous pull toward altruism and egotism, toward self-sacrifice and self-enhancement. Serve humanity and live well, I joked to myself. But it was an uneasy humor.

"I hate to sound like I'm manufacturing angst in the face of bounty," says Ann, "but what's more valuable to us—our life as it has been or as it could be?"

We are drinking tea on a Sunday afternoon in Ann and Danny's attic apartment. The apartment is furnished in homey comfort with hand-me-down furniture. Everything seemed to carry a family story: a desk given by Danny's father, crocheted cushions from a great-grandauntie, a shell-rimmed anniversary mirror made by a sister. Two plump cats doze at our feet.

"Real estate, stock portfolios, tax shelters," she lists in gloom, "lately, that's all I hear."

Ann is completing her doctorate in counseling. Danny is completing his medical internship. This year, they have earned approximately thirty thousand dollars. It is the first time in their five-year marriage that they jointly have earned over ten thousand dollars, and it seems a staggering sum. Yet they suddenly have realized its puniness when compared to the amounts they potentially could earn. The knowledge is unsettling.

"When we were in college, choosing our careers, I never thought that one day we would be preoccupied with nurturing our money, that we'd become gluttons for ownership," says Ann with a shiver.

"You two will never be gluttons for ownership," I chuckle.

On a postal clerk's salary, Danny's parents raised eleven children. Ann's father supported a family of seven by working in a chemical plant. Backed by their families' values, encouraged by the idealism of the early 1970s, Danny and Ann dreamed of a life devoted to family and public service. He wants to work in medical research. She wants to be a counselor for nontraditional students. "You know," she explains, "older adults, single mothers, ethnic minorities: the people who usually don't get a chance to go to college."

Now, however, Ann is working at a Seven Sisters college. Danny is interning with the sons of doctors. Their colleagues have referred them to tax accountants, stock brokers, real estate agents; and Ann and Danny are beginning to feel defensive about the simpleness of their dreams.

"I get the feeling that *real* professionals want the most visible, most prestigious jobs; that *committed* parents place earning money as their highest priority," says Ann. "We want to be realistic and responsible, but will we end up as people we no longer recognize or like?"

In her kitchen, Ann sits deep in thought. Her husband reads in the next room; her cats sleep by her feet. Her future shimmers before her. Suddenly she laughs.

"A prominent woman professional, whose first child is fifteen

months old, invited me to lunch," she recalls. "Danny and I are planning to start our family. Woman to woman, professional to professional, she wanted to help. 'Motherhood can be emotionally turbulent, in ways you never expected,' this woman confided. I waited to hear—oh, I don't know—maybe about the aching helplessness you feel the first time your baby suffers from a cold." Ann pauses and starts to giggle.

"So what did she say?"

"She told me about the frustrations of trying to locate designer-labeled infantwear."

Mirror, Mirror
on the Wall

 When I read Margaret Mead's autobiography, I was astounded by how matter-of-factly she stated that sometimes she did not like a culture. It seemed to lack ritual, or celebration, or tenderness. Sometimes there was nothing really wrong with the culture. It simply did not provide the fodder necessary to satisfy her personal or professional aims. When I lived in Boston, I assumed that a good social scientist should be able to create a sustaining day-to-day existence through the sheer power of discernment. There must be something here to satisfy you, I told myself. If only you would *observe* keenly enough; if you would just *perceive* with all your might.

In practically all my memories of Boston, it is winter. My spirit

hovered outside my body, observing from a dispassionate distance. Psychologists call this disassociation. It is considered a defense mechanism—a way to keep life in abeyance. It was a phenomenon that I welcomed.

Boston is not a lighthearted city, like Paris or New Orleans. It is not a mystical place, like Kyoto or Lhasa, where ancient spirits brush past you in the morning markets. It does not trumpet with the brash confidence of New York or Hong Kong. Bostonians refer to Boston as the Hub. It is an abbreviation for the Hub of the Universe.

"I'd attribute Boston's je ne sais quois to the weather and to the Puritans," laughs Ann. "Those Puritans were a strange and enduring bunch."

We are on a ferry bound for Provincetown, the tip of Cape Cod. We hope to see some whales on our voyage. We are in a playful mood.

"Recall the self-absorption in their industriousness, the weird vanity of their austerity. Imagine, if you can, the sheer terrifying gall of a people who could be so certain of the correctness of wearing black that they could despise the Pilgrims for wearing gray."

Ann recently has become steeped in Puritan lore. She has left the Seven Sisters college and is working in the heart of witch trial territory, providing mental health services on Boston's north shore.

At Ann's community agency, there is a legend. In the mid-1970s— when the agency first opened—a consultant was hired to deliver a training workshop. The consultant was a young African American woman. She wore her hair unstraightened in what was called an Afro. Now, at that time, community mental health centers were distrusted by the American public. After all, the centers dealt with crazy people and endorsed going into schools and telling *children* about sexual assault and drug usage. Additionally, African Americans were never seen in villages like Beverly, Prides Crossing, or Salem. They did not live there. They did not work there. They did not vacation there.

African Americans were people seen on television. So when the consultant was seen entering the community mental health center, why it was only natural that a telephone call would be placed to the village police. "The community mental health center is harboring a fugitive. Angela Davis has been sighted entering the premises." Legend has it that the word spread quickly. A village vigilante group was formed and dispatched. In the basement of the mental health center, the consultant was drawing a diagram on the chalkboard when the bull-horned message rang out. "The building has been surrounded. We advise you to surrender peacefully."

Ann laughs as she tells the story. "Sometimes it's hard to tell a legend from a tall tale," she says. Then suddenly, she is serious. "But one thing you quickly learn in the Boston area is never to go outside your ethnic territory, never to do the unexpected."

Perhaps it is a lesson learned from unexpected hurricanes ravaging the shoreline. Perhaps it is a legacy from the Puritan's self-righteous fury, but in Boston the unexpected creates immediate suspicion, causes sure surveillance, and often ends in sadness.

I am awakened by the sound of a ringing telephone. It is Sunday, raining, winter. Steve is on the telephone, telling me that today is the Day of Remembrance Ceremony—the day to commemorate the fortieth anniversary of the wartime Japanese Relocation Act. He tells me that this is the first time Japanese Americans across the nation will be gathering in recognition that such a thing did take place, in recognition that they cannot forget, in recognition that internment is a wound that still aches. "Can we count on you to be with us?" he asks.

The "we" is intentional. It implies a duty to my parents, my family, my people. Involuntarily, I recall a scene when I was eight years old: I have returned from school and stand in anger before my mother. "Liar, liar!" I shriek. "You made me look stupid in front of the whole class!" "*Nani*, Yuri-chan? What is it?" asks my mother with concern. "You told me you were sent to camp because America made a mistake. Teacher says no. You were sent because you are a traitor." My mother

pulls me close to her, she kisses and soothes my brow. "I am so sorry Yuri-chan," she says, "for all the sadnesses like this that you will face." I tear free. "Liar," I sob. "Lousy Jap traitor."

I stop myself. There are things I do not want to remember.

"Can we count on you?" Steve is repeating.

"Yes," I whisper. I am surprised at how frightened I feel.

It is a chilling, colorless day as I cross Harvard Yard. The Remembrance Ceremony auditorium contains about sixty people. On the East Coast, it is unusual to see so many Japanese Americans congregated in one place. Only at weddings, only at funerals, only when they are kin, I think to myself. Poems and journal excerpts are read aloud. A woman my age reads a letter that her mother had written from camp. Although the mother is long dead, her voice comes through her daughter with youth, confusion, and loss.

In the bright auditorium the audience sits: erect, attentive, and self-contained. A young white husband sits next to his Japanese American wife. He wears a navy blue blazer and a school tie. His glance swerves, in panic, from her profile to the stage and back again. His posture strains crazily both toward her and away from her. His wife leans forward, like an alert student enrapt in a lecture. Her expression is composed. Her shoulders slightly shake. Tears roll steadily down her cheeks, and her husband does not know what to do. Should he put his arm around her? Rigidly, his arm grips the back of her chair. Would that be intrusive? Should he leave her alone with her thoughts? He leans away, trying to achieve enough distance so that he can keep her entire face in focus. Would that be abandoning? He has never seen her like this before. Never knew that this was important. What will this mean in their marriage? His wife is oblivious. She crosses her arms. Enfolded in her own embrace, she shifts forward and away.

The first time I met a Japanese American who was not related to me, I was twenty years old. Actually, he was not Japanese American. He was Japanese Canadian. He played ice hockey and had earned an ath-

letic scholarship to the private liberal arts college I attended. On campus, we were the only students of Asian descent. "You should get together," my friends advised, "you'd look so cute together." He and I made it a point never to speak. Upon graduation, he married the blonde daughter of a Connecticut stockbroker.

In 1983, the first organized gathering of East Coast Asian American women is held in a lecture hall on the campus of Boston University. Two hundred women attend: some driving from places like Maine and Virginia, others flying from as far as Florida and Ohio. Gathering together is a new experience, and the conference hums with the confessional excitement of a consciousness-raising session.

"Sometimes I catch sight of my reflection in a store window," hesitantly says a forty-year-old from New Jersey, "and I am shocked to see that I am Oriental."

"Asian American," corrects a college student.

"Pardon me?"

"Oriental is a label given to us by Europeans; it connotes someplace mysterious and forever foreign. It is considered derogatory."

"Gosh, I'm sorry. I didn't know."

"No, no, it's okay." The student is embarrassed by the embarrassment she has stirred.

"I know what you mean, though," interrupts a Rhode Island woman. "Now and then, I see another—err—Asian American in a shopping mall or in some other crowd. I find myself maneuvering to get closer. I try to be inconspicuous. I pretend to be looking at something in their general direction, but really I'm wondering, Do we really look alike? What parts of me belong to me and what parts are just common to my race?"

"Yes, yes, and sometimes your eyes meet, don't they?" excitedly laughs a woman from Pennsylvania, "and you realize that they are doing the exact same thing as you!"

Group laughter is followed by silence as we reflect on our common experiences.

"Babies are always drawn to each other," someone finally says. "In

the park, on the street, toddlers always notice other toddlers and move toward them, astonished that they are not alone in the world. Here, on the East Coast of America, we are just like toddlers."

Not everyone feels this rapport. Women from the Western states seem impatient with the conference. After the morning sessions, a law student from Los Angeles wrinkles her nose with distaste. "People here are saying corny things about it being acceptable not to strive for European standards of beauty," she says. "They are making Asian-Is-Beautiful type of statements, as if they're just discovering this. In L.A., issues like that were resolved twenty years ago."

"What are your issues?" I ask.

The law student thinks for a moment. "Living in New England, I am forced to realize that I'm a person from a powerless minority group. Where I came from, Asians have visibility and economic power. Politicians court our votes. Here, people think I'm an international student. They speak to me loudly, in slow simple sentences. They compliment me on speaking English with hardly an accent, or worse, they ask me to say a few words in my native tongue."

"Even when I say I was born in Seattle," says another woman, "people still don't act like I'm an American. They embarrassedly drop discussions about topics like U.S.-Japan trade relations. I suppose it's to help me save face. Or they ask me for my perspectives on the Cultural Revolution, as if I am a China expert."

"I hate it. It makes me feel like an F.O.B.," wails a college sophomore.

"F.O.B.?"

"Fresh off the boat. They act as if I'm one of these new immigrants you see these days."

No one seems embarrassed by the acronym or by the disdain in her voice.

A toddler's interest in other toddlers is driven by sheer narcissistic curiosity. Who's the fairest of them all?

I'm glad I'm not judgmental, like these *other* women, I think with relief.

. .

Watery Descents

 Before I left graduate school, my dissertation advisor took me aside. "Your students are going to love you," he said. His tone was oddly mournful.

"Why thank you!" I brightly responded. I thought he was praising my skill.

"You'll be alone, knowing no one, swamped with class preparations and onerous committee assignments. You'll be struggling to meet research demands. You'll be facing New England winters." My advisor, a New Englander himself, sighed. "It happens to all young assistant professors. By God, I wish it didn't."

Sobered, I kept quiet.

"You will be much younger than your colleagues. You will identify with your students. You will spend hours on guiding their doctoral researches. This will make it difficult for you to pursue your own research. Besides, you will be seen as far too young to be tenure material." He sighed again. After a long moment he shook off the phantom of my doomed future, like a dog returned from retrieving a lake-lobbed stick. He looked at me, unconscious of my thoroughly dampened spirits, and smiled. "You'll be a fine teacher," he said with warmth. "Your students are going to love you!"

* * *

I am not and they do not. I am completely overwhelmed. Each semester, I teach three different courses. I prepare constantly. I painstakingly craft fifty-page lectures that out of nervousness I deliver at unintelligibly rapid rates of speech. For weeks, each class seems to end with yawning stretches of blank time in front of restive students who stare at me with incredulity and dismay. "This is what Affirmative Action does to teaching standards," I hear one pointedly say.

Not all my courses are curriculum disasters. In collaboration with a Chicana assistant professor, I develop a course on the dynamics of culture and psychology. It is our great pride, and we are thrilled when it receives national attention. After our colleagues cautiously weight its academic rigor—"What are they fearful of?" grumbles my collaborator during the lengthy review process. "That we'd plan ethnic recipe swaps? That we'd wear our national costumes?"—our course receives annunciation as a core departmental requirement.

The first time I offer this course, the Boston city police enroll half a dozen male officers. The Women's Counseling Program enrolls a dozen feminist activists. Ugly, angry battles break out between the groups. I stand at the blackboard, with the face and authority of a fifteen-year-old, pleading for restraint and goodwill.

Disheartened by my debacle as a classroom teacher, I plunge into research and service. I publish nine research manuscripts in fourteen months. I accept chairmanship (shared with my Chicana colleague) of the massive master's degree program. I serve on countless dissertation committees. I lose weight, catch colds, and develop a lingering cough.

Four times a week, I sink into the sanctuary of the campus swimming pool. Like some prehistoric amphibian—precise and mindless—I move from one end of the pool to the other, over and over again. Sounds lurch sideways through the water, strange and soothing. Warm bubbles, my own breath, burst against my face; my focal distance stretches no farther. Gladly deprived of all other sensations, I

swim until exhausted. I return to class marked by the imprint of my goggles and the slightly salty scent of chlorine.

The more sick and weary I become, the greater the praise I receive. I am productive. Too tired to be frantic, I am poised. Always slender and growing more so, my watery descents make me supple. My hair bleaches to burnished black.

I think my pain and panic are plain to see, but where I feel a frightening, creeping deadening, others see only composure. Nothing shows. I never storm. I never snivel. I never chew my nails. Only I see the small creeping fissure forming in my veneer. Across my brow, solitary as a sigh, grows my first faint wrinkle.

In August, when I first move to Boston, I have a boyfriend in Washington, D.C. That November he visits. It is a rare sunny day. We sit bundled-up by the river. We are eating crackers and brie. He says perhaps we should see other people; and I cry all over the Triscuits.

I do not handle his loss with dignity. I write sly charming letters; how could he leave a woman of such wit and perception? The letters twist, through a slow metamorphosis, into rambling stream-of-consciousness prose, and later to jagged shards of poetry. I escalate to midnight telephone calls.

That summer, I begin to suffer from periods of "otherness." I go out to move my car and find myself, for a second, standing in the street not knowing the city or decade I am in. Or I am swimming my laps— churning with determination and without purpose through my day— when suddenly I imagine that my departed boyfriend is in the next lane, like a twin, separated yet connected through a warm and fetal fluid. Finally, before the fall semester starts, I go to a doctor. I have walking pneumonia. I have been running a fever for months.

Song of the Road

My boyfriend had been born in the American West. His greatest romance was with the open road. He loved the lonesomeness of highway dust, of nameless saloons, of tumbleweed adrift in their destiny. He loved the endless sky.

Desolation held no appeal, but a certain wanderlust gripped me, and when my lungs cleared and my delirium receded, I began a journey of my own.

In a drafty kitchen in South Boston, I listen to my friend Kevin and his neighbor Gary. The men are baby-sitting. Their wives are working late. Kevin's year-old son plays on the floor. Gary's children sleep upstairs.

Gary is an asbestos worker. He left high school at seventeen, weighing one hundred pounds, standing five feet six inches, and he could not find a job. One day, an uncle gave him a call. "Come Tuesday," was all he said. Gary's uncle was a racketeer. He navigated while Gary drove a car. Two strong men sat in the rear. Periodically, Uncle would bid Gary to stop the car. The strong men would get out and rough someone up. When they returned, they would hand neat bundles of cash to Gary's uncle. "Start the car," Uncle would say. "Drive to the corner, turn right." At noon, each man would eat at a separate restaurant. In two years, there was never an unnecessary word among them.

Now Gary is involved in community politics. Kevin is working on his Ph.D. The two men sit drinking beer, talking quietly, laughing loudly. In front of them is a half-empty pizza box. I stand at the sink, silently washing dishes. I am eavesdropping. I have no brothers. I am curious. Is this the way men talk when they are alone?

The conversation moves from precinct managers to memories of parochial school, to fatherhood and life. Gary is torn. His wife is eight months pregnant and working extra shifts as a registered nurse. She is trying to make ends meet. Gary does not hold a job. He is dying of cancer. He does not have any life insurance, never thought he'd need it. After all, he is only thirty-four years old.

He bends down and lifts Kevin's son to his lap. The toddler pulls at his beard. "Kids are a blessing," he says.

"A blessing," echoes Kevin. Kevin's voice is strong and warm. Like an arm across the shoulders.

Jim and Vince invite me to a trucker's bar. Aficionados of rockabilly, they aim to expand my musical tastes. I am apprehensive. I expect brawls and bravado. All the recordings they have loaned me feature tales from the penitentiary.

We go on a Saturday night. Jim's imported car is engulfed in a sea of pickup trucks. The middle-aged crowd looks hardened. The drinking is heavy. Everyone is white. How receptive will they be to a prissy little Asian girl?

I sneak into a corner, and a fight erupts nearby. A bottle is broken; its ugly ravaged neck is thrust and parried. I level an evil stare at Jim and Vince. The slightest trace of amusement in my fear, and I never will speak to them again. I hold them hostage by my side. When they want to go to the men's room, to the bar to buy a drink, I make them take turns.

But as the night wears on, I realize that the patrons are far from dangerous. The rockabilly jars their sensibilities. They demand sentimental songs of married love: dancing slow and close to lyrics that tell

of playing around only to discover that the woman at home is the best lover. They leave early, hurrying home to pay the baby-sitter.

I am sitting on a folding aluminum chair in the basement of a Unitarian church in Boston's Back Bay. Outside it is raining. Along the broad confident boulevard, a red-haired woman walks an Irish setter. Inside, the Writers' Collective has gathered for a reading.

Murphy distributes the latest copies of his play, *Try Arsenic*. I am cast as Promiscuous Daughter. She is venal and stupid.

Murphy is a screamer. He is one of those angry disheveled men who stand on street corners and scream at passersby. I often have hurried past men like him, my eyes averted, my step hastening. In the evenings, Murphy leaves his corner and goes home to his boarding house. There he writes and rewrites the same vitriolic play. The plot is this: Millionaire Father gathers Hateful Family to country estate. Over cocktails, he confronts them with the sordidness of their lives. The family members whine and claw. In the end, they all drop dead. Millionaire Father has poisoned their drinks.

Every week, Murphy changes the lines. He tinkers with the pacing and stage direction. He listens to our halting readings and pensively nods. In this basement, he is close to happy.

The Collective has been meeting for three years. Each week, Mary and Phil open and close the church. They have been married for one year. This is where they met. Both are in their fifties and for both this is the first marriage. The rest of us have become their children.

Mary is plump and gentle. Weekly, she reads her animal poetry. This week, the topic is mice. "I like mice/They are nice/Nice and soft/In the loft," she shyly chants. Phil beams his approval. He serves us crumpets and cocoa.

Week after week we wait for Billy B. Billy B. is heir to a famous circus fortune. Billy B. is a genius. He is the Collective's absent leader. When he fails to appear, the regulars worry. Perhaps he is back in the state mental hospital.

For two months, I attend the meetings. I like the sense of belonging. I grow fond of reading *Try Arsenic*. I try to do right by Promiscuous Daughter. What is her motivation? I ponder.

Now and then, a stranger comes: a student, a journalist, an out-of-work actor. They have seen Phil's announcement in the *Boston Globe*. After a few minutes, the strangers begin to squirm. Their folding chairs begin to squeak. Maybe Murphy is being strangely intense or Mary a bit too dreamy. Whatever the reason, the strangers always leave early. I notice that they never return.

Their flight offends me. Is it a twinge of guilt? I know someday soon I too will leave. But the regulars are undiminished. "It's okay," soothingly says Phil. He is addressing a stranger's vanishing back. "We all sometimes find ourselves in a place where we simply cannot stay."

I once read a children's book about a bird. He was hatched far from his nest. For a time, he was happy enough. Other animals welcomed him. They tried to teach him their way of survival. But soon the loneliness grew. And so he set out to find a place of his own, traveling through barnyard and beyond. He asked every creature he met one question, "Are you my mother?"

And so my road meanders. Taking detours, I pause here and there to sample the hospitality of strangers. Wondering, Is this where I belong? But always I return to my road, wanting to find home, before the darkness falls.

Being Fired

 In the spring of 1983, my department received a
long-sought academic accreditation. The accredita-
tion process had been instrumental in my hiring. In their preliminary
report, the evaluators had suggested that the department could benefit
from a more ethnically diverse faculty.

When we received accreditation, the department celebrated with a
party. I was responsible for refreshments. Laden with bottles of New
York State champagne, I was struggling up the stairway when the
division chairman passed me. "Your line has been cut," he blurted.
"Next week, call my secretary for an appointment."

I was not surprised by the loss of my job. Fear of financial exigency
had raged in the college for months. I was working within a college of
education. When I first was interviewed, my department was located
in a glass-faced tower in the central part of campus. We possessed a
handsome suite of offices and a commanding view of the river. This
splendid site had been bestowed on the education faculty during the
1960s. It was an era when the postwar generation was in elementary
school and education was a growing industry. By the time I left the
university, the college of education had been moved. We occupied a
small brick building on a distant edge of campus. Next door was a gas
station.

* * *

I was relieved when I lost my job, although I did not know it at the time. Solemn-faced, I accepted the commiseration and indignation of my friends.

I listened to the advice of my colleagues: "Consolidate your specialty." "Refocus your research." "Establish a private practice." Everyone tried to buttress me. Associates mobilized—sending me clippings of position vacancies, like mothers sending batches of cookies to an unfortunate child.

I was so appreciative of their concern that I sprang into frenetic action: filing applications, conducting interviews. I was less interested in the positions than fearful that my friends would despise me if they knew I was less than wholehearted about my career.

In my field, I was what is called an "attractive candidate." I possessed skills that currently were desired, which I had acquired through a recognized pattern of prudent positioning. I had presented at the correct conferences, published in the proper journals, received the right small grants. While I was neither brilliant nor gifted, I was perceived to be conscientious and committed. My professors had praised my promise. It was not unreasonable to expect that, in time, I could become an associate professor at a major university or a full professor at a midsized college.

I was not entirely a fraud. I had been drawn to my field with a conviction and a curiosity and a quickness that were true enough; but timidity had crept into my work and had dampened the drive. My research had become more careful than inspired. I sought collaborators more for the comfort of consistent companionship than for the zest of shared discovery. I was involved so fully in proving my willingness to pursue traditional paths—I was so constantly surprised to realize "I can have this"—that I never asked myself, "Do I want this?"

Once one of my students told me about acting.

"The secret is that you cannot use a negative motivation," he said. "You cannot portray 'not wanting to stay,' only 'wanting to leave.' You

cannot be a person who 'does not want to be alone,' only a person who is 'eager to be with others.' "

"Why are you telling me this?"

"Because this knowledge has changed my life."

"I am not following you."

"Acting starts with just that," he said patiently. "Action. It starts with a simple act portraying a simple positive intention. One intention, one action, then another, and another, and gradually you are asserting your vision. Your audience—the people who are around you—can recognize and respond to something solid and authentic."

"All this so magically, so fluidly?"

"It's a gradual process, of course," he said, "but the point simply is to make an initial act toward what you want to become. Stop ruminating and reconsider your life in terms of actions you can take." He smiled slightly, ruefully. "It helps to tame the helplessness."

And so I set out on my journey—trying to change discomfort with my choices into comfort with unknowing. On the final day of June—when both my teaching contract and my apartment lease expired—I returned office keys, apartment keys, and mailbox keys. I retained the keys to my car and a small luggage lock and key. "In America, keys represent the state of your life and values," a friend once said to me. "What do you consider important enough to guard: Your house? Your safe-deposit box? Your workplace? Your diary?" And so on that final day in June, I relinquished stability and embraced mobility.

I went to San Francisco. At Fisherman's Wharf, I swapped a taste of barbecue for a taste of Italian hot sausage with Moe. We rolled our eyes with greedy delight and felt an instant simpatico. I told him about my vacation plans: San Francisco, Hawaii, Hong Kong, Japan, Los Angeles. I told him about Boston and my continuing job search. Moe told me about thirty-five years of travel, of seeing the world with the merchant marines.

Against a mischievous breeze, we spread our fingers like a tent—

protecting our pooled paper-plated cache. Moe's old black hands were long and infinitely etched, hard-earned hands crackling like antique lacquer. My hands were small, soft, the color of caramel.

The sun glittered across the water, reflected through a cloudless sky. Metal riggings tolled against aluminum masts. Muted voices rang like the memory of children's laughter.

"Yes, indeed" said Moe. "Go on and travel. Go on, just for a change of scene. You'll see. Gonna be you that changes. Indeed, indeed. Gonna be you."

III.

In Flight

Traveling in Disguise

 I traveled in the disguise of a soul unfettered by convention. I traveled lightly. A canvas shoulder bag carried camera and clothes. My Boston tweeds were discarded for more jaunty wear: denim jeans, cotton sweaters, supple sundresses. For years, my hair had hung in neat simplicity: straight, black, and glossy. When I lost my job, I went to a hairdresser. I asked for a permanent wave. I went to an optician and purchased eyeglasses with lenses rimmed in riotous red. I felt bold and free. I thought I looked sultry and slightly dangerous—like an Asian-blooded Brigitte Bardot. I must have been senseless with pain.

I am not an adventurous person. I am the sort who hesitates at the brink of escalators, reluctant to relinquish terra firma. Among strangers, my conversation lapses in shy retreats or stumbles forward in earnest rushes. Although I selected my traveling costume with the care of an actor, my character could not be concealed. I was confused and my manner was confusing.

"Where are you from?" people asked in puzzlement. "It is hard to place your appearance, your style."

Fittingly, it was an actress who came the closest to discerning the dilemma beneath my disguise. A Chinese American California television talk-show hostess made the telling observation. "My grandmother's picture!" she suddenly said toward the end of a long evening at my

cousin's house. "It's been bothering me all night, and I've finally fig-
ured it out." She turned toward me in triumph. "You simply lack a
contemporary face. Instead, you're oddly old-fashioned—like a com-
posite of all those immigrant brides at the turn of the century."

The actress attributed my old-fashionedness to my timid use of cos-
metics; but I had a different idea. Those pioneer women—awkward
and game in their Gibson Girl blouses—were immigrants. Each lived
within a kaleidoscope where familiar shapes lay shattered in shards of
color: dazzling, fascinating, infinitely varying. They waited for their
worlds to reassemble in understandable patterns, with more hope
than faith and with twinges of gladness for the wondrousness of
unknowing. Photographers caught the glaze and glitter in their eyes.
And so it was that shortly before dessert a California talk-show host-
ess looked at me and saw her grandmother's face. She had glimpsed
my immigrant soul.

A Nurse's Tale

It was a time when I longed to have everything and
to have it at once. I wanted to lose myself in love,
to have an acclaimed career, to follow daring and different paths, to
secure a niche in some stable community. I fled to the tropics. I wanted
to go to where I could stand and see the world, from a place with a
stronger light.

There are stories of women who simply set out on journeys; women
confidently stepping into a dazzling unknown. I yearned to be that

type of woman but knew that I was not. I wanted to let life affect and deepen me through pure immediate experience but knew that I could not. I planned my voyage: crafted an itinerary, made reservations. The truth was, I did not trust life to provide me with experiences to suit my liking.

I planned my travels to include visits with friends and relatives. They were the safety net beneath my flight. Although I wanted to be seen as a blithe spirit, I needed periodic reassurance that I retained a place in a world of interlocking affections.

I flew to Hawaii where, for the first time, I met my cousin Ruby. Ruby is a name that I always have associated with the tough and tender saloon hostesses of the American Old West. It is a name that suits my cousin.

Ruby was schooled, married, and divorced in the frank, open desert of eastern Washington state. She has two children. Her son entered the military; her daughter entered marriage—both before entering their twenties. Ruby is chagrinned and proud. Her children are like her. They follow their hearts. Ruby is in Hawaii for the love of a man.

Ruby lives in a tall apartment building: story after story of long blank corridors lined with identical doors. The dreary symmetry is saved by one feature of languid beauty. The corridors are opened on each end. Through them, trade winds whistle like warm breath through a bamboo flute. With the winds come aromas of Asian cooking, of almonds and coconuts and hot spicy oils.

Ruby lives in the midst of homey disarray. She lives with a cockatiel bird that follows her like a hopping cat: bumping its head against her ankles, thrusting its chin forward for a massage. "He loves to be scratched behind the ears," says Ruby as the bird closes its eyes in ecstasy. Its peach-colored cheeks puff with pleasure. "They have ears?" I ask, astounded. Scattered across the dining table are newspaper clippings with beak-scored edges. A thousand tiny wads of chewed paper roll across the linoleum and lay buried in the carpet pile.

Ruby is an emergency room supervisor. She works the late night

shift. Each day, while Ruby sleeps, I slip from the apartment and go sightseeing. I ride city buses across fields of pineapples or to a secluded cove.

By the second day, Ruby and I have developed a ritual. Our lives meet just before dawn, when she comes home from the hospital. Slipping into a cotton robe, I boil water for coffee. Stripping down to her silken lingerie, Ruby fetches yesterday's cups from the drain board. We each know our own cup. Just beyond the lanai, the sky lightens to lavender as we sprawl on the living room floor and share what we have seen.

"This is Hawaii—the ocean paradise," says Ruby. "Each night I see honeymooners who are broken and bloated beyond repair. They have miscalculated a dive. They have drowned during a midnight swim. Their bodies wear cute souvenir T-shirts."

She plucks a wad of bird-chewed paper from the shag of the carpet and slowly rolls it between her manicured fingertips. "Tonight we lost a kid. His T-shirt was lettered: B-E-A-S-T. His sunburned widow stood in the hall, wracked with shock and grief. She turned and stared at me with blank eyes."

Ruby flings the paper wad hard and far. "Do you know what was written on the shirt of that poor child?" she demands.

"Beauty," I whisper.

Regularly Ruby brings small surprises to her staff: cartoons, gag gifts, junk food. "They are good kids," she says. "They work hard, under terrible pressures." She is protective of their rights to remain young, silly, and hopeful.

One evening she takes a series of comic books to work. The books portray and parody Hawaiian culture and dialect. "The comics were a great hit," she tells me the next day. "The kids got a big kick out of them." She describes one panel and chortles with glee. Her eyes glitter with tears.

My cousin loves a faithless man. The day before I am to leave, the

telephone rings. A small change in Ruby's voice tells me that it is her lover. I leave the room. After a few minutes, she comes to find me.

"You didn't have to get yourself lost," she says. "It was only my man." She swings her supple hips in a burlesque grind and pantomimes a fluttering heart.

"Will you see him tonight?" I know that he has broken their last few dates.

"Naw, I told him my cousin is here; I'll call when I've got the time."

"Don't let me interfere with your day-to-day life," I say with alarm.

Ruby makes a broad wave of dismissal. "Nawww, it's good for him not to have me at his call. It makes him appreciate me." She laughs a short laugh, cut off as it begins to quiver.

In the world I knew, the future had always been an important part of reality. It loomed ahead of every action. It pressed upon me, brimming with possibilities, urging me to make of it what I could. Time moved toward me in small even man-made steps of minutes, hours, years.

For my cousin, time does not always flow in even drops of seconds and minutes. At work, it leaps and lingers, marked by each moment of shared laughter, by each life lost or saved or barely maintained. Some days, alone in her apartment, time moves slowly, marked by the ringing of a telephone and the too brief sound of the voice of a man.

Ruby was asleep when the taxi came to take me to the airport. I may have left a note of appreciation. Perhaps, I washed the morning's dishes and quietly placed them in the cupboard. I like to think I did these things but actually I cannot recall my leaving. I left loving my cousin: for her gruffness and vigor, for the largeness of her generosity and the smallness of her pretension, for her siren's high-heeled shoes and her mother's caring clucking. I left amazed by how different we were and by how, still, she seemed a kindred spirit. Perhaps in part all love is this—a wonderment over separateness and oneness.

I left with the intention of sending a gift from Hong Kong. I knew

she admired the eelskin wallets that easily could be gotten there. I meant to mail the photographs taken during my visit: Ruby with her bird, me wearing my welcome lei. I never did and I am not certain why. Was it shyness, or hurriedness, or some sad reservedness of adulthood? The next Christmas, I mailed to my cousin a brief message and a seasonal card. Since then, we have had no contact.

On Decorum

My flight from Honolulu to Hong Kong was delayed four hours. Boredom breaks barriers, and I spent the time talking with Renato—a jeepney manufacturer from outside of Manila. Renato was homesick. He had been traveling for several months. "I say to my wife, 'Come!' She says, 'Travel is silliness. I have grandchildren, that is beauty enough.' But always I am wondering, What is beyond Manila? Now I am a rich man. So, I go."

Renato stood straight with dignity, festooned with wilting leis and adorned with his souvenirs: ornate leather boots from Spain, a golden wristwatch from Switzerland, a camera from Japan. Italian shoulder bags hung from his neck—with the leis and the camera—like medals across the proud chest of an Olympian.

Renato was an ingenuous traveler. The airplanes clearly thrilled him. With each arrival and departure, he unashamedly scrabbled to witness the awesome event. He scrambled on top of chairs: hands cupping his eyes and straining against the windowpane.

Each public announcement captured Renato's attention. He froze with head cocked, listening—to multilingual paging and crisp calls to board—like a man who hears a distant music.

A puppy among pigeons, Renato's unflagging enthusiasm discomforted the other travelers. More sophisticated than he, they cast small glances of disdain at his leaping and his twirling. As he moved across the waiting room, crowds parted and regrouped. To this censure, Renato was oblivious.

After the second hour, Renato showed me pictures of his custom-painted automobiles. There were dozens of photographs. Each jeepney was a celebration, a fantastic work of intricacy and gaiety: ablaze with colors, rich with ornamental metal work, splendid with velour fringes, and adorned with a horn that could sound out a specially requested melody.

After I had praised each photograph, Renato carefully slid the pictures back into a paper bag. He repacked the paper bag among baseball caps proclaiming I LOVE NEW YORK. "You are like Rosalia," he said to me, "Rosalia, my daughter."

For the first time, he was subdued. "I wish to show you something very special," he said. Then with solemn shyness, he slipped two worn photographs from the recesses of his new Florentine wallet. "This is my wife and my son," he said, "my son who will inherit the Ford Motor Company of the Philippines." He held out the second photograph. "This is Rosalia, her husband, and my grandsons." He took back his pictures and extended his business card. He offered it formally and carefully: holding it by its edge, pinched between the thumbs and forefingers of both hands. THE FORD MOTOR COMPANY OF THE PHILIPPINES, it read. The lettering was identical to that used by the Ford Motor Company of America. Below the lettering was his name and address. "When you come to visit," he told me, "you will stay with my daughter, like sisters. We will show you how we paint our beautiful cars."

* * *

If I reminded Renato of his daughter, then he also reminded me of someone. When I was ten years old, I had a playmate named Shirley Wagner. For some hushed reason, she was motherless. On summer mornings her father would leave her with his father—Old Pop Wagner.

Old Pop Wagner owned a two-pump gasoline station and a penny candy store on the corner of our road. He had virtually no customers. The old man's businesses were simply relics from the town's rural past. On dusty, August days—when the air hung heavy with the smell of black-top bubbling by the highway's edge—Shirley and I would sit by the pumps and watch the cars go down Route 9. We would play games of make-believe; and sometimes we would wheedle from Old Pop— who was not a generous man—a piece or two of candy.

Shirley and I were summer friends. When school restarted, we were in different classes. We would see each other on opposite sides of the schoolyard, but we would not cross.

The last time I can recall seeing Shirley was at grade school graduation. For the girls of my town, the graduation ceremony marked the leaving behind of childhood.

Annually a dozen or so young girls—in chiffon and organdy pastel party dresses—rustled prettily across the school stage. Each wore a white cardigan sweater draped modestly across her narrow shoulders and white polished Mary Jane pumps upon her feet. Each wore her first badge of womanhood: sheer nylon hosiery.

Graduation was a young ladies' affair. Village boys, their ties askew, would thump heavily across the stage in squeaky shined shoes to grab their rolled and ribboned diplomas. Village girls would cross the stage in practiced steps, their waists betraying the beginnings of gentle curves, their slender legs shimmering silkily in their brand-new hosiery. After receiving diplomas with the left hand and handshakes with the right, the girls would drop a delicate curtsy toward stage front, then turn and lightly trip offstage. They were well aware of the power in their innocent beauty.

My mother prepared me for this debut. She starched my petticoats.

She buffed my shoes. She set hot irons against baby hair to produce a gentle curl.

Shirley Wagner also prepared for the ceremony. I first saw her as she wobbled resolutely across the stage. Like the rest of us, she wore a pair of new nylon stockings; but Shirley had not stopped there. She also wore cardboard and plastic high-heeled shoes, an imitation mink stole, and a rhinestone tiara. I had seen these clothes before. They were part of a child's glamor costume kit. They were a Christmas gift from her father.

Shirley crossed the stage, accompanied by smothered snickers; and when she rejoined the class for the Grand Recessional March to the lawn by the flagpole, chiffon skirts were lifted and shifted, as if to prevent soiling.

After the ceremony, fathers took pictures and mothers smiled mistily. It was the town tradition. I wore an apricot-colored dress. A cluster of rose buds lay pinned to my collar. Like a flower in a meadow, I was happily inconspicuous in my belonging.

Across the schoolyard, I saw Shirley. She was standing alone: friendless, regal, and resplendent. She stood with dignity, adjusting her false-fur stole. I felt a twinge. I shook it off. I carefully looked away. I saw her, but I could not cross.

Victoria Peak

 I stepped from the airplane into a searing Kowloon evening. Heat rose in sheets across the Hong Kong harbor, giving the city a tremulous image. High pungent notes of ginger and anise mingled with the vapors of melting asphalt and automobile exhaust, forming the city's dark and distinctive bouquet. Cool skyscrapers and twisted alleyways glittered with neon and consumer goods: jewels, furs, electronics, optics. Although it was nearly midnight, people and traffic still swarmed the narrow streets, like bees within a honeycomb. Horns blared, whistles shrilled, while throughout the city passengers in cream-colored Mercedes limousines slipped by in air-conditioned quiet.

At 4 A.M., I awoke and dressed. From the chill of the hotel lobby, I entered an already steaming morning. A different Hong Kong greeted me than the one that had bid me good night. A silent sultry Hong Kong fanned only by the low drone of cicadas. The boats at the Star Ferry terminal were docked. They bobbed on their lines as if responding to the memories and promise of clamorous passengers upon their decks. In front of the terminal building, the pavement was strewn with dozens of huddled shapes.

I sensed life in the silhouettes before I knew it. I felt the rise and fall of warm breath in the still, early light—like a person who sees shadows in a distant pasture and somehow knows the sweet grassy

scent of grazing creatures. As I approached, the shapes sharpened into workers, perhaps fifty of them: shrunken men in their eighties carefully clad in clean rags, skinny elementary school-age boys wearing nothing but tattered shorts. The workers were folding newspapers. They were quick and silent and full of the dignity that comes with attention to task. And with the rhythm of creasing came a faint swooshing sound, like the wings of a great bird attempting to rise in an airless morning.

At dawn, I took the tram to Victoria Peak. From the summit, Hong Kong and her famous harbor lay sleeping beneath quilts of mist. Old men and women, dressed in dark pajamas, moved through their t'ai chi exercises: slowly, deliberately, like a phalanx of ghost warriors.

The past reigned in stately supremacy. No future existed. Time flowed backward, unevenly stopping here and there like a branch in a stream catching on rocks and eddies. It carried me through generations. Insects whirred and chirped in primordial supremacy. "You may be right, Moe," I called to my memory of the San Francisco taxi driver as he spun past me in the rush of time. "Perhaps, somehow, I am changing."

The Passage

When *South Pacific* was transferred from stage to film, the Ryukyu Islands were considered as the setting for the island paradise of Bali Hai. The Ryukyus are the most southern of Japanese islands: sixty-five emerald islets scattered in an

azure sea. A hundred species of tropical fish weave through coral jungles. Sunlight and the shadows of mare's tails dapple the ocean floor.

Okinawa is the largest Ryukyu Island. In the aftermath of World War II, occupational forces called it the rock. "I'm short!" they happily would shout as their tours of duty closed. "I'm getting off the rock." In those days, Okinawa was a desolate place. War had killed over 200,000 people, had ripped villages and even entire mountains from the topography. In the wake of war, Okinawa was a raw piece of pumice: a jagged, ravaged rock.

Forty years later, the scars from those battles are hidden. School children fan lush meadows searching for a sudden glint: a souvenir, some shrapnel, a shattered canteen. Their cries of delighted discovery echo from the coral cliffs.

I roar—into this land of aching loveliness—astride a four-cylinder shaft-driven Suzuki 750 motorcycle. Jet black with high-rise handlebars and a punctured muffler, it is arrogant, overpowered, and loud. The driver is Mark: lanky, towheaded, twenty-nine years old. He is a former boyfriend. Recently the University of Maryland has sent him to Okinawa to direct a master's degree program for American military personnel.

Through the worlds of academic ranking and military bearing, Mark slouches. He simultaneously is proud of and defensive about his new status. The motorcycle is a statement of his defiance. It is something unlikely to be owned by a professor, an officer, or a Japanese. Yet in his new fraternities, the love of a fine fast machine is well understood and—to Mark's relief and chagrin—his defiance is met with bemusement more than outrage.

I am a woman fleeing the constraints of a Boston assistant professorship. I stand, with my anxious earnest ways and my silly seductress sundresses, and judge Mark's maturity. I find it lacking. I suspect he does the same with me. This is why romance died. We are too alike.

Mark and I have struck a bargain. I am on a pilgrimage. I supply the route. He supplies the ride. Gripping the motorcycle with my right hand, I navigate from the rear. I cry directions into the wind. I

am comparing road signs with the Japanese characters I have copied from maps onto the back of my left hand.

Down the Okinawan coast we ride. A hot humid wind hovers around us, heavy with the scent of the shore. The sky and the East China Sea are an endless blue. Ancient turtle-backed tombs slumber by the sea. Wind-weathered pines twist and reach from atop ocean outcroppings. They are as beautiful as bonsai.

At midisland, the American military bases begin: Kadena with its landscaped lawns and vast airfield, Camp Butler with its Spartan marine pride. We pass the naval hospital at Foster and acres of sea containers at Camp Kinser. Outside the bases, the towns are dense with special services: bars, tailors, and pawnbrokers. The air is heavy with emission from jets and automobiles. We keep on. We are headed toward the Naha harbor and a ferry that will take me to the Kii peninsula—the Kii peninsula, from which my mother fled.

It takes two days for our ferry to cross from Naha to Kobe. A second-class ticket buys the rights to a blanket, a pillow, and space on the carpeted floor of a broad open room. Passage is fully booked. Several hundred people remove their shoes and lie blanket to blanket.

Around us are eight second-year students from Osaka University, a Buddhist pilgrim, and a honeymoon couple. People share food, conversation, and card games with those at their borders. The students— all boys—serenade us with sixties rock and roll music. Their favorite singer is Paul Anka. The pilgrim takes a tattered map from his knapsack and traces the route he will travel. The honeymooners stay by themselves. They giggle as they sort through a mountain of omiyage—souvenirs to take back to family and friends.

At midnight we dock at the tiny island of Okierabu, and I awaken. The hold is dark and quiet—a gently rocking cradle. I skirt my sleeping comrades and go to the deck. By the kitchen, a small green finch sits in a bamboo cage. He cocks his head and sips water from a hand-painted porcelain sake cup.

Moonlight shimmers across a dark sea. The warm moist air is

stirred by a breeze. Somewhere, flowers are blooming. Two cows are led onto the ship. They stand tethered on a lower deck, nibbling from a sweetly scented bed of grass.

"Auld Lang Syne" plays over the ship's intercommunication system. A dozen passengers board. They are serenaded through megaphones by their well-wishers on shore. In a common instant, each passenger tosses a brightly colored ball. They fly high into the moonlit night. Then from the balls a dozen streamers are fluttering into the open arms of the well-wishers. The streamers represent heartstrings. They tether sea to shore. "*Itte irasshai,*" cry the well-wishers—go now, but come home quickly. "*Itte mairimasu,*" call the passengers—I am going, but I will hasten home. The heartstrings unfurl as the great ship leaves the harbor. They stretch taut. Finally, they snap.

We dock in Kobe and ride southward to Awaji Island—famous for the carving of Bunraku puppets. Rain falls warm and drenching. Blue tiled roofs glisten. Farmhouses float in a sea of new green rice. We take shelter in a small village.

Three old women beckon to us. Tiny, bent, and astonishingly nimble, they scurry down steep cobblestoned alleyways. They lead us to a little house. At a gas grill in an earthen floored kitchen, they laugh toothily and teach us to cook okonomiyaki—Japanese pizzas. For toppings we are offered barbecue sauce, mayonnaise, and shaved bonito.

When we have finished eating, a twenty-year-old granddaughter appears with an umbrella. She leads us toward a coffee shop, from which Mark can telephone his office. As we reach the coffee shop, she repeatedly tries to bestow the umbrella upon us.

"It is in the umbrella's heart," she says with soft insistence, "to go where it is needed." She lowers the umbrella and before refurling it, twirls it to and fro. The loose folds swish becomingly. "Rain," she says in careful English. She catches some glistening droplets in a palm as pink and pretty as a seashell. "*Onee-san, dozo*"—Older sister, please take this umbrella.

The intimacy of "older sister" catches at me. I accept the umbrella. *"Domo arigato gozaimashita,"* I say bowing deeply. "Thank you for what you have done."

A Family Reunion

 I am the product of eight hundred years of inbreeding. After the 1185 battle at Dannoura—when the Taira clan was defeated by Minamoto Yoshitsune and his older brother, Minamoto Yoritomo, had become the first shogun—Yoshitsune became a perceived threat. His victory at Dannoura had stirred acclaim, the strength of which left the new shogun uneasy. Additionally, Yoshitsune had secured the allegiance of the former enemy by marrying a daughter of the defeated Lord Taira. Yoritomo, who had not emerged as shogun through reliance on a trusting nature, ordered his brother's assassination.

Yoshitsune fled south from Nara, the ancient capital, into the sacred Yoshino Forest. With him he took his bride, the Buddhist monk Benkei—famed for his giant stature and wise counsel—and twenty of his most faithful retainers.

In those days, the woods and mountain passes were infested with bandits, and after being attacked and forced to do battle with one such troop, Yoshitsune dismissed his retainers. Traveling with only his wife and Benkei, he would be much less conspicuous. Eventually they

reached the castle of Yoshitsune's late guardian but soon were betrayed and murdered.

The twenty leaderless samurai continued on a southerly route until they reached the shrine of an ally and there founded Niju-kason, The Twenty-Family Village. One of these samurai was the founder of my mother's family house. This at least is the family myth. Perhaps every family has a similar myth.

In any event, my mother descended from centuries of intermarriage among affluent farming families. All shared this exalted past. All were descendants of the twenty retainers and they bore the tint of nobility like an ermine collar atop a heavy mantle of respectability. First cousins married first cousins, nieces married uncles, until a history of eight hundred years lay in intricate plaits like a long and lustrous braid.

Of course, such genetic tinkering has marked the family character. Culture and chromosomes have conspired to produce a people who are respectful and loyal and endowed with dignity and decorum. And in the midst of all this engineering have come the quirks of nature, like the temperamental weaknesses that plague some pedigree dogs. Tendencies—undesirable, embarrassing, and enduring—have repeatedly emerged. Not within each member, to be sure, but certainly within every generation: a hidden vein of arrogance, an anxious need for approval, a constitutional fragility, a mild hypochondria. I am a bearer of these legacies.

My mother's ancestral home is in the prefecture of Wakayama. It is a sparsely inhabited peninsula reaching deep into the Pacific. Yoshino National Forest and the deep misty gorges of the Kino River bisect the prefecture's heart. Mt. Koya is its crown. This sacred mountain is the burial place of Saint Kobo Daishi, and foot trails of Buddhist pilgrims crisscross its evergreen slopes.

Westward from the mountain, fertile plains slope toward the sea. The plains are lush with mandarin orange groves and speckled with prosperous seaside towns. My mother came from such a town. Born

into a family of considerable stature, she left stained by the scandal of her parents' divorce. Overnight, she changed from a beloved child into an acute embarrassment. She became a relic from a marriage whose discord had burst the bounds of discretion.

My mother had not wanted me to return to Wakayama. The idea evoked in her an odd panic. Yet I felt compelled to go. Who can understand the psychology of these matters? Each of us, with our inarticulate yearnings, struggled to reclaim a common ground.

"I refuse to provide my family's address," declared my mother with a strange ferocity. "Everyone will gather. It will cause extensive bother. You are wicked thoughtless girl to burden others so."

Stung and surprised, I struck with Western logic. "I will telephone when I arrive in Wakayama; I will ask if we can meet. It will be a simple matter."

"You do not understand the Japanese," retorted my mother. "You do not know the expectations. You will be judged by Japanese standards. Outwardly, people will be polite, but they will judge you harshly: she does not cover her mouth when she laughs; her clothes are too bright for her age; she has not accepted the responsibilities of maturity. Secretly, you will be disdained and mocked. I cannot bear that my child suffer such affront."

"Do not worry," I said more gently. "They know I am an American. They will expect uncivilized behaviors. If I acted like a proper Japanese, how disappointed they would be: no wonder, no glee, no gossip value in that!"

My mother thought carefully. "You will bring them gifts?"

"Yes."

"But you will be traveling with man who is not your husband!" She stiffened with horror. She did not know the worst of it. She thought that we would be traveling by train.

"He is a university professor."

My mother struggled with her thoughts. "You must never sit with

your legs crossed," she finally said. "Kneel on the floor and sit only on your heels."

"Yes."

There was a long silence. "Perhaps I will help you," she sighed. "I will write. I will request their tolerance. I will ask that you be permitted a small glimpse of your Japanese past."

It was late when Mark and I arrived at the outskirts of Wakayama prefecture. We decided to find an inn and to telephone my mother's family in the morning. My intention was to circumvent a thousand years of convoluted decorum by breezing into town, spending an afternoon with the folks, then bidding them farewell. My confidence was buoyed by Mark who, knowing nothing of Japanese culture, concurred that this was a most reasonable plan. In my heart, I knew it would not be so simple.

Two men fished by the river. A boy, perhaps five years old, accompanied them. The child was clad in yellow seersucker pajamas. As we approached, they glanced at us. I watched as our image slowly registered. Their eyes widened. Their gazes swept to the belching black motorcycle and back. They took in the lanky blonde ghost, the frizzy haired Japanese woman. They stood dumbfounded.

"I am an American. Pardon me but my Japanese is most unskillful." I thought it best to start with a disclaimer.

"But you are Japanese. You are speaking Japanese. You have a Japanese face!" They peered at me closely.

"My ancestors were Japanese. I was born in America. I am an American."

The trio exchanged looks of disbelief and plunged into lively discussion. They seemed to forget about our presence as they argued as to whether such a thing, an American with a Japanese face, really could exist.

"*Shimizu-san*," one man finally said.

"*Nani?*" said his companions—what are you talking about?

"The grandfather of Shimizu-san had a brother, did he not?"

"Yes, perhaps that is so."

"That brother went to America, did he not? And if that brother had children whose children returned to Japan?"

"So it is! An American with a Japanese face." The two men and the boy nodded solemnly and stared at me with satisfaction. I was a puzzle to which they had found a most successful solution.

"My grandfather came from a Wakayama village," I offered.

"So it is!" Their pleasure deepened. We stood and beamed at one another—delighted by the completeness of the explanation.

"What on earth is going on?" Mark broke the spell. "Can they help us find an inn?"

When I explained our situation, our new friends sprang into action. They racked their memories for the names and locations of country inns. They mildly bickered about the merits of each. They led us to a telephone where, crowding together at the receiver, they telephoned their first choice. The inn was full. They called another and then another. Eventually they found a vacancy.

The innkeeper was reluctant. "It is so late; they have missed their supper; the bath is no longer hot," she said. But our new friends would not be deterred. Delicately they probed and cajoled until at last they flashed the V-for-victory sign.

"Follow us. We will lead you. It is not out of our way." They climbed into the cab of a tiny blue truck. I am certain that they lied.

For over thirty minutes we followed the truck as it careened around narrow curves, over one-lane bridges, in and out of villages. Every few seconds, signs of encouragement came to us from the tiny truck: hand signals, flashing lights, patterned horn beepings. When we reached the inn, it was very late and our friends were far from home. They accompanied us to the door.

The innkeeper gave a faint cry of despair when she opened the door and saw Mark. "Arrahhh," she moaned. She looked at our new friends with the large sad eyes of a woman deceived. "A foreigner," she whispered.

"Now, now, good wife," said our friends.

Recognizing the word *foreigner*, Mark jumped to reassure. "I am a university professor," he declared in unsteady Japanese. This was his magic incantation. It always seemed to gain him ease.

The good wife stared blankly at him. Her eyes traveled in horror to the motorcycle helmet cradled in his arms. It was liberally speckled with large calcified bird droppings.

"The Japanese breakfast will displease; the bath will confuse; he will not know to remove his shoes," she moaned in a soft litany.

"His wife is from a fine Wakayama family," boasted our friends. "There is no need to worry." The innkeeper gave a cry of relief and fell upon me with a rush of regional dialect.

"I am afraid I do not understand," I said at last. "My Japanese is most unskillful." I thought it not the best time to explain that Mark and I were unmarried.

The good wife stopped speaking. She stepped back, stricken.

"We will be going then," cried our friends. The small boy blinked and flushed with excitement. This had been an evening he would long recall.

The truck rumbled away, leaving in the moonlit night only the sounds of chirping crickets. The defeated innkeeper turned to us with a tight smile. "Let us go to your room."

Mindful of the innkeeper's anxieties, by breakfast Mark had learned enough Japanese to exclaim: "Thank you for this food," "Oh my, how delicious," and "May I express my appreciation for a fine meal." He charmed the innkeeper whose enthusiasm, perhaps, was fanned by her own shy pride. She had, after all, successfully completed the rite of passage known as Providing Satisfactory Service to Foreigners.

Midway through the meal, two toddlers appeared at the edge of the veranda. Mark lured them in with games of peekaboo and sticks of American chewing gum.

When my relatives arrived, the innkeeper's children were showing us their pets. In reciprocity for Mark's attempts at Japanese, the

innkeeper was speaking in English. "Little bit uhhmm … grotesque, neh?" she said as her son held up a jar of spiders.

That morning I had telephoned my relatives. Not knowing how to explain "mother's cousin's son and his wife," I had told the innkeeper that I was calling my uncle and aunt.

"Welcome honorable guests," said the innkeeper to my relatives. "It has been a pleasure having your niece and her husband stay with us."

"We have no niece," exclaimed Tadao-san, my startled uncle. "We are looking for the unmarried daughter of my mother's cousin." He looked fearful; perhaps he had come to the wrong inn?

"Forgive my most unskillful Japanese," I quickly interjected with what was becoming my most useful phrase. "My most humble greetings."

"Of course you are too young to have a married niece," offered the innkeeper, fearful that she had given offense. "An unmarried-marriageable niece, that is. Of course, I do not wish to imply…" The innkeeper plunged on, in confusion and embarrassment.

I stood frozen: amazed and appalled. In a few seconds, I had retraumatized the kindly innkeeper. Probably she never again would accept a foreign guest. I also had presented the impression that I was a liar and a libertine. This had cost my relatives some loss of face. Additionally, I had diminished the honor of my mother and her manner of child rearing. I began to understand why my mother had dreaded this trip.

After a long time, harmony and ease were restored. Tadao-san rose to leave. "Yuri-san, you can ride with us and Mark-san, you can follow in your car."

"Autobike," smiled Mark. He proudly pointed to the filthy, menacing motorcycle we had nicknamed Darth Vader.

Tadao-san and his wife, Sachiko-san, were speechless.

"They arrived last night by autobike and they were just wonderful

guests," chirped the innkeeper who, once again was beginning to feel uncomfortably responsible.

"You did not arrive in a car?" wondered Tadao-san.

"Autobike," I admitted. I knew that while it is permissible for a lady to commute to and fro on a motor scooter, autobikes are considered the domain of gangsters and their molls.

"You are not traveling by car? You are riding on that errr... autobike?" persisted Tadao-san, who was still numb with disbelief.

"Come with us, Yuri-chan," firmly interrupted Sachiko-san. "Mark-san, you follow us. We have planned a big day."

We went to a restaurant. Separate courses of seafood, chicken, pork, vegetables, noodles, soup, and pickles magically appeared on the table. Saying they were still full from breakfast, Sachiko-san and Tadao-san refused to eat. It was, after all, only ten-thirty in the morning.

"Two years ago, we were most honored by the visit of your distinguished father," Tadao-san intoned as he soberly began performing the rituals expected of a patriarch in a fine old family.

"This is Yuri-chan," interrupted his wife as she playfully slapped him on the arm. "Too much formality!"

Tadao-san blushed but looked relieved.

"Your papa-san has grown a beard," Sachiko-san continued, leaning forward in conspiratorial school-girl fashion. "We wait for train. We look and look for your papa-san. Then, arrahh!" She made the Japanese sound for shock and awe. "Papa-san come out looking like Santa Claus!"

We all laughed.

"In Japan," Sachiko-san continued, "men all alike: no beard, short hair, sit at table like this." She mimicked a dour salaryman. "Yuri-chan, papa-san very different: long hair, beard like Chinese Ancients. We are most surprised. What mama-san think of beard?"

"She says he looks like Colonel Sanders of Kentucky Fried Chicken."

.

"*Honto-ni,* truly yes," roared Tadao-san and Sachiko-san. The colonel and his chickens are ubiquitous in Japan.

By the time we left the restaurant, I had eaten so much that it was painful to stand and straighten. I scrambled toward the car in a strange crablike hunch.

The car bounced along narrow roads, past wooden farmhouses, across terraced hillsides. Blue-tiled rooftops glistened amidst small groves of mandarin oranges. When we stopped, I had no idea where we were.

Beyond a grove of orange trees, perhaps an acre away, lay a house. Its rice paper screens opened and a middle-aged Japanese couple appeared on the veranda. After a moment, they were joined by a man in his early twenties. He towered over them and, from a distance, I could have sworn that he was an American cowboy.

The cowboy waved at us. His silver and turquoise watchband flashed in the sun. He ambled off the veranda and toward us—six feet three inches of lean muscular grace rolling back on the heels of his snake skin cowboy boots. "Hi, I'm Yoshi," he said in English. With an easy grin, he extended his hand. "Welcome to Japan."

Yoshi led us to the house and introduced us to his parents. His mother, a trim and vivacious woman in her late forties, invited us inside and began a barrage of questions, the nature of which led me to understand that she was related to my mother. After learning that my mother was well, that my father was well, that my sister, her husband and her children were well, Masako-san—for that was the mother's name—offered refreshments. "How well bred she is," murmured Masako-san with a pleased familial nod as I pleaded against the need for food.

"Did you live in America?" The sound of English, of Mark's question, startled us and ended the murmur of Japanese greeting rituals. "Where did you learn to speak English so well?"

Yoshi explained that three months earlier he had returned from two years at the University of Arizona. His degree was in agricultural

science. Months earlier, when the family first had learned that Mark and I might visit, Yoshi had received an urgent letter from Japan. He had responded by promising his mother to serve as our Japanese-English interpreter.

"Are you the only son?" asked Mark.

"I am the second son."

Yoshi's older brother studied in Paris. Travel changed him. He grew cosmopolitan. He fell in love with a French woman. The family despaired that he would never return; but the bonds of duty are strong. Older brother accepted a prestigious government position in Tokyo. "We are proud," said Yoshi, "but my brother never will return to Wakayama. He will not continue this farm, this family's place in this village. He has become a man of the city."

"And what do you want?"

"I was happy in America. At times I dream of returning to America and obtaining an advanced degree. But these are selfish dreams. I have my share of memories. I will inherit this farm. I will continue this line. My mother has begun to search for my bride. My duty is in this village."

"Duty! But you've lived in America! What about freedom? What about choice?" Mark was outraged.

Yoshi gently smiled, "This *is* my choice, to perform my duty."

The family elders had been observing closely the interaction between Mark and Yoshi. Now they exchanged nods of shared pleasure. The content of the conversation completely eluded them but they were certain of one thing: Yoshi was a fine son. He was handling the foreigners' visit with grace and ease. Perhaps he *had* come from America with an odd heartiness and with a kind of homesickness—so strange when here he was, home at last. But look how skillfully he handled this potentially awkward situation. *This* was the evidence that mattered. The American education had been worth the risk. Yoshi had come home, and with a confidence and a worldliness to lend. Surely,

he was an asset to the village. He brought credit to the family name.

Masako-san slipped from the room and returned with a tray of snacks. She also brought a special treat: Mountain Dew soda. Yoshi had brought a case from America.

I felt guilty accepting Yoshi's soda. It was only the second can that had been opened. I counted the remaining cans and calculated the occasions in his life. One can for Yoshi's homecoming, another to salute an engagement, the next in celebration of the marriage. If tastings were squandered on insignificant moments like our visit, the soda would be gone before the birth of Yoshi's first child! But Yoshi grinned with pleasure, like a connoisseur of fine wine who is delighted to find another educated palate; and I joined in the toast with gladness.

After a fizzy sip and an appreciative moment of silence, Masako-san spoke. "Show your souvenirs," she urged her son. "Sachiko-san and Tadao-san have not seen them."

Yoshi obliged. He showed us photographs: his university campus, the Grand Canyon, a Halloween party, a bus trip across North America. He provided bilingual narration: explaining geological epochs, relating curious facts about flora and fauna, interpreting American traditions. He was an enthusiastic storyteller and stirred us to wonder and laughter.

"What about Japanese holidays? Does your mother take the train to visit her brothers on New Year's and for the Festival of the Dead?" asked Masako-san.

"No, it is too far," I said.

"Farther than from here to Tokyo?" she asked.

Yoshi removed a map from a knapsack decorated with souvenir badges. He demonstrated how many Japans would fit between New York and Los Angeles, how many Japans would fit into Continental America, how many Japans it would take to fill the Pacific Ocean.

"How vast the world," sighed Masako-san. "I am too old to comprehend it all." She gazed at her son with adoration.

* * *

The good-bye rituals were lengthy but heartfelt. "Please stay longer."

"Thank you so much but we must go on."

"Of course, how selfish of us to keep you from others but please will you take some fruit?"

"You are too kind. I cannot accept."

"We insist. We insist." Yoshi's parents accompanied us through the orchards and to the roadway. "Good-bye! Good-bye!" They bowed to the polished white sedan and to the dirty black motorcycle.

The Patriarch

 As he stepped from the car, Tadao-san straightened his sports jacket. He paused and cleared his throat. It was certain. He was nervous. I fussed with my dress. I wished it were darker, more somber, more modest. Descendants of my grandfather's line, we had arrived for an audience with the patriarch of my grandmother's line.

When my grandparents divorced, relations between their families had been severed. My grandmother was sent to Osaka where she—daughter of a distinguished family—became a household maid. Grieving over the fate of their beloved banished daughter, her parents worked with subtlety and from afar to arrange a second marriage. It was a marriage of little social consequence; but it was a happy union. And when a son was born, the new family moved to the outlands of Manchuria. It was the bright frontier.

My grandmother is long dead. Good fortune did not await her in

Manchuria. A war erupted. She was trapped. Far away, her parents died and later her husband. When Soviet troops advanced through Manchuria, when occupied Japan lay in defeat and shambles, my grandmother returned to Wakayama. She did not return to her house of birth; for once she had dishonored the family name, and she bore her banishment with penitent pride. Instead she walked through village streets, selling fish from baskets balanced on her shoulders. In early middle-age, she suffered a stroke and died.

At the time of my grandmother's death, her youngest brother was the head of the family house. He still is. When I arrived for my audience, the patriarch's daughter-in-law opened the courtyard gate. She bowed low. She led us across a mossy courtyard. Her steps were tiny. Her eyes were averted. She stopped at the threshold of an inner room. Kneeling, with a bow so low that her forehead brushed the fragrant tatami mats, she announced our presence. Keeping her forehead on the mat, she crept backward in deference, inch by inch, until she had disappeared.

Late afternoon sunlight etched shadows on the rice paper screens. A poem hung in the alcove. My mother's uncle sat in a posture of meditation. He was eighty years of age. Unlined, elegant, and austere, he looked like a man in his fifties.

"We have brought Miyeko-san's daughter." Tadao-san flattened himself in a bow.

"It is an honor to meet you this first time." I used a formal, archaic greeting. I touched my forehead to the floor.

The patriarch said nothing. The black silk of his kimono glimmered. He did not glance at me. I pressed my forehead deeper into the tatami mat.

"She is accompanied by a friend, a professor at a great American university," said Tadao-san. He mopped his brow.

"*Oku-san, desu ka?*" shot the old man. He glared at Tadao-san. Is she an honorable wife, married into a fine family?

Sachiko-san came to my rescue. "Miyeko-san's daughter is a uni-

versity professor. In America, for a woman, this is a position of even greater respect than wife."

The patriarch ignored her. In his timeless code, her comment displayed impudence. As a woman, Sachiko-san should not speak. He did not break the stare he leveled at Tadao-san. "Is she not rather old to be unmarried?" His tone suggested that my disgraceful state was due to some negligence, some flaw in Tadao-san's family character. After all, Tadao-san could not even control his wife!

The room fell silent. Miyeko-san was taken from our house, the silence intimated. She and her issue no longer are our responsibility. Had matters been left to us, things would have turned out better. Had matters been left to us, today Miyeko-san's daughter would be an oku-san.

Tadao-san's head sank. He stared at the floor in misery. He was a modern man, discomforted by these ancient wounds. Sachiko-san sat rebuked; her loyal audacity chastened by a snub.

I am a wicked troublesome creature, I thought. I have intruded on the aesthetic refuge of an old man. I have evoked painful memories of a sister he could not save. I have forced together two families, once close, who had learned to live with distance. I have returned like a joke of fate: the foolish granddaughter of foolish grandparents, a self-indulgent simpleton whose impulsiveness could cause pain.

Unable to understand Japanese, unaware of the terrible tension, Mark sat slumped and cross-legged. He raked the room's Zen beauty with the casual eyes of a tourist. He cheerfully waited for more food, more laughter, more family reunion. I hated him for his innocence.

Suddenly, the old man seized a scroll and leapt upon his feet. He moved with the swift and supple grace of a cat. Focusing his attention at a point beyond the room, somewhere in middle distance, he began a fierce chanting monologue. He unfurled the scroll in a seamless movement, as if unsheathing a sword. In a hoarse whisper, Yoshi began to translate.

"The honored gentlemen would like you to know," rasped Yoshi,

"that the scroll is over six hundred years old." He continued with the translation, speaking as if in a trance.

The scroll had come from the family storehouse. It and other holdings had been examined by a visiting team of university professors. The family represented the oldest traceable line in the region. Its stories and artifacts illuminated history. National Japanese television had produced a documentary film.

The patriarch had assembled various objects representing various epochs. For over an hour, around each object displayed, he wove a narrative of national history and family honor. He stood before us, burnished by the setting sun, like the shadow of a ghost warrior.

The rhythms of the narrative lulled and transported us, and then, too soon, it was time to leave. We started to stir and stand. For the first time, the old man looked at me. He turned and studied my face. For a long and breathless time, his keen eyes seized and held me. "This is who you are," he said. "Remember and be proud."

Discordant Fruit

Once, in a cross-cultural training manual, I came across a riddle. In Japan, a young man and woman meet and fall in love. They decide they would like to marry. The young man goes to his mother and describes the situation. "I will visit the girl's family," says the mother. "I will seek their approval." After some time, a meeting between mothers is arranged. The boy's mother goes to the girl's ancestral house. The girl's mother has prepared tea. The women

talk about the fine spring weather: will this be a good year for cherry blossoms? The girl's mother serves a plate of fruit. Bananas are sliced and displayed in an exquisite design. Marriage never is mentioned. After the tea, the boy's mother goes home. "I am so sorry," she tells her son. "The other family has declined the match."

In the training manual, the following question was posed. How did the boy's mother know the marriage was unacceptable? That is easy, I thought when I read it. To a Japanese, the answer is obvious. Bananas do not go well with tea.

All of my life, I have been fluent in communicating through discordant fruit.

"You're not serious about applying to be a foreign exchange student!" exclaims a high school teacher. "The point is to sponsor an *American* kid." On my application, I deliberately misspell the teacher's name. I cross it out with an unsightly splotch. "Take that you mean narrow man," I gloat in triumph.

"Your mother is so deferential, so *quiet*," says a boyfriend. "Women like that drive me crazy." *His* mother is an attorney. That morning, I scorch his scrambled eggs. I hide the sports section of the Sunday news. "No insight, loud-mouth fool," I mutter. Vengeance, I think, is mine.

The Japanese raise their daughters differently than their sons. "*Gambatte!*" they exhort their sons. "Have courage, be like the carp, swim upstream!" "*Kiotsukete,*" they caution their daughters. "Be careful, be modest, keep safe."

In the old stories, men are warriors: fierce and bold. But a lady never lunges to slash the throat of an assailant. Instead, she writes a poem about harsh winter; how it can snap a slender stalk. Then she kills *herself* in protest. How the old stories galled me!

My mother was raised in a world such as this, in a house of tradition and myth. And although she has traveled across continents, oceans, and time, although she considers herself a modern woman—a

believer in the sunlight of science—it is a world that surrounds her still. Feudal Japan floats around my mother. Like an unwanted pool of ectoplasm, it quivers with supernatural might. It followed her into our American home and governed my girlhood life.

And so, I was shaped. In that feudal code, all females were silent and yielding. Even their possessions were accorded more rights. For, if mistreated, belongings were granted an annual holiday when they could spring into life and complaint.

And so, I was haunted. If I left my clothes on the floor, or my bicycle in the rain; if I yanked on my comb with roughness; if it splintered and lost its teeth (and I did these things often and deliberately, trying to challenge their spell); then my misdeeds pursued me in dreams.

Emitting a hair-raising keening, my mittens would mourn for their mates. The floors I had scuffed, the doors I had slammed, herded me into the street. Broken dishes and dulled scissors joined them to form a large, shrill, and reproachful parade of dutiful ill-treated items. How I envied white children and the simple absolution of a spanking.

While other children were learning that in America you get what you ask for, I was being henpecked by inanimate objects. While other children were learning to speak their minds, I was locked in a losing struggle for dominance with my clothing, my toys, and my tools.

The objects meant me no harm; they meant to humble and educate me. "Ownership," they told me "means obligation, caretaking, reciprocity." And although I was a resistant student, in time I was trained. Well-maintained, my possessions live long, useful, and mercifully quiet lives of service.

The consequence, however, is that I cannot view my belongings as mere conveniences. They cannot serve as simple timesavers. For me, acquisitiveness holds little allure. The indebtedness is much too great.

I am a woman who apologizes to her furniture. "Excuse me," I say when I bump into a chair. My voice resonates with solicitude. In America, such behavior is viewed as slightly loony.

I am a woman caught between standards of East and West. "I disagree," I say to elders, to the men in my life. My voice rises and cracks with shame. "Razor-tongue," relatives say with the pleasure of knowing. "No wonder she still is unmarried."

All these incongruities came flooding back while visiting my Japanese family. The pull to be deferent. The push to be bold. The tension and richness between.

In the evening, after we left the patriarch's house, Sachiko-san prepared a feast. She kneeled before us, cooking a huge skillet of sukiyaki. She plucked plump morsels of tender beef from the pot and popped them onto my plate. Her teenaged daughters slipped shyly in and out of the room, bearing flasks of sake and platters of sushi.

Tadao-san, Yoshi, Mark, and I were seated at the table. Sachiko-san and the girls ate in the kitchen. "Where are the other women?" Mark asked Yoshi. "Yuri-chan is the guest," he replied. "She is being paid the house's high honor."

Loosened by the sake, chaffing from days of communicating only with me or through me, Mark bombarded Yoshi with questions. Did Yoshi like American rock and roll? Who were his favorite performers?

Uncomfortable with being the focus of attention, Yoshi attempted to generalize every query. "How familiar are Japanese youth with popular American music?" he translated for Tadao-san.

But Tadao-san was not fooled. Excluded in his own house, shunned in favor of his translator, Tadao-san grew increasingly irritable.

"How long has this one been riding autobikes?" he suddenly interjected. "Has he ever had an accident? Would he know how to make repairs should the autobike become disabled?"

At first, the American in me grinned. Clearly Tadao-san had grown weary of his subordinate role. He was asserting his authority. "How are you providing for Yuri-chan's safety?" his questions implied. "Do not forget you are welcome only in so far as you provide service to members of my house."

But quickly, the Japanese in me surfaced. The evening was not going smoothly and I was responsible.

"You're putting Yoshi on the spot!" I hissed into Mark's ear. "After all, he is not your host. Address your comments to the household head and try to act with more deference!"

"No kidding!" exclaimed Mark. He thought everything had been going along just fine.

I smiled apologetically at Yoshi and Tadao-san. My annoyance and bossy instructiveness had not gone unnoticed. I flushed mightily. I knew my behavior was most unseemly for a lady.

"So Tadao-san," said Mark heartily, "what do you think about all these protests of American military presence in Japan?"

Yoshi reeled in horror. How could he translate, with delicacy, such an openly confrontational question?

"Don't you think it's a little, uhmmm, *ungrateful?*" continued Mark. "After all, by picking up the bill for your country's defense, America has allowed Japan to become an economic competitor."

"How can you be so rude!" I croaked in anger. I staggered under the responsibility of having brought a boor into the ancestral house.

"Relax. You're overreacting," snapped Mark. "Besides, this is *my* conversation." Mark was growing tired of my conduct coaching. I could hardly blame him. Only a few days earlier, as we sat in a coffee shop and I instructed him on the proper method of ordering, I had overheard a comment. "*Rimokon,*" a woman had murmured to her companion. She had nodded in Mark's direction. *Rimokon* is a shortened form of *rimoto-kontororu.* It is the Japanese pronunciation of remote control: slang for a henpecked man.

Tadao-san looked questioningly at Yoshi. What was the meaning of all this clamor? Yoshi rushed to translate.

"This is a most difficult question," said Tadao-san after hearing an edited translation.

I cringed. When a Japanese says a question is difficult he is requesting release from an uncomfortable situation.

"I work on a military base," said Mark, "and the sentiment is that Japan is complaining about a free ride."

I wished we never had left the subject of rock and roll. I wished I were not the honored guest. I wished I was with Sachiko-san, in the refuge of the kitchen.

Tadao-san and Yoshi caucused for a while. "Some Japanese believe that America's motives are not fully benevolent," said Yoshi. His voice hesitated with the task of defusing the situation. "They say Americans do not fully view Asians as people. Japan and her people are expendable. Perhaps the point is not to defend Japan but rather to move the site of possible conflict. Asia may be a buffer zone. If war is based from Japan, South Korea, or the Philippines, the soil and civilians of these countries, not America, would be the first at risk."

"I don't know about that," muttered Mark.

"In each country, there are prejudices," said Tadao-san. "We Japanese are prejudiced against the Koreans. I have read your history. Has there not been discrimination against Japanese in America? Is there not discrimination today?"

"No," said Mark flatly.

"Of course there is!" I cried. We argued hotly for a minute. Then, remembering that I was trying to act like a credit to my mother's upbringing, I demurred.

"Mark and I share slight disagreement about this point," I murmured with sudden modesty.

Perhaps Mark was right. Perhaps I was overreacting. Perhaps among men, even in Japan, verbal confrontations and positioning for power are acceptable social forms. Perhaps when two samurai meet, they must engage in hostile sword play and find themselves well matched, before they can be friends.

The exchange of political opinions left me shaken, but Mark, Tadao-san, and Yoshi seemed unscathed. They raised their cups and had a seemingly splendid time.

But then again, perhaps I was right. Before the evening ended,

Tadao-san slipped me an envelope. "In case you wish to leave the autobike, to continue, alone, by train," he said. Inside, was a staggering sum of money.

After midnight, Sachiko-san led me to her daughters' room. It was the room of teenagers, a sweet jumble of stuffed animals and pinups of popular singers. Several pencil sketches were carefully mounted on one wall. Through a window, I saw the crescent moon.

"Come Yuri-chan." Sachiko-san led me to the sketches. "Come and see your past."

The drawings were light, romantic renderings, of princesses all gowned and gloved.

"Your mother lived here briefly, when she was a girl," Sachiko-san explained. "These are her drawings. My daughters found them in storage and thought them pretty." She paused in reflection. "Your young mother's dreams have been rescued and honored, mounted here on my little ones' wall."

Through the open window came the sound of a bamboo flute. Sachiko-san looked at me with the warmth of a sister. She touched my hair gently and smiled. "The hearts of young girls," she whispered to me, "their visions, forever, the same."

Auntie

My grandfather was unduly harsh to his eldest daughter. When I was in Japan, I saw an old photograph and I understood why. My auntie was a beautiful girl. She looked exactly like her mother.

In the village, it was a resemblance that did not go unnoticed. The oval face, the slender frame. Poor auntie never had a chance. Before she was twelve it was widely predicted: my auntie would grow up to be wanton.

Knowing this would happen, Grandmother had trained her strictly. But her modesty was dismayingly alluring. Auntie's downward gaze emphasized the long sweep of lashes against her porcelain cheek. Her hesitant step accentuated the graceful line of her body. "Why the child is a natural coquette!" exclaimed the villagers.

"After the divorce, we children were sent to the house of my father's sister," says Okaa-chan. I am twenty years old and she is preparing me for my first trip to Japan.

"It was an awkward predicament. Married, this sister owed more allegiance to her husband's line than to her brother's. It was a burden, the sudden acquiring of four outcast children. Still, this auntie loved us, and with an allowance from my father, she established a separate household for us."

"What was it like?"

Okaa-chan pauses. "It was a vast change. For centuries, family members had served as physician in the castle of the regional lord and our grandmother's house reflected this grand status. The woods were worn in rich smooth patina. Light and shadow played along the great halls. Music trembled softly from behind every shoji. And our family crest stood on the door."

For a moment, Okaa-chan lingers in memory. Then briskly she resumes her tale. "The house Auntie rented for us stood away from the village. By a high hill not near to the town. Midway up the hill was an open pit for the cremation of dead people, its smoke mingling with the fog to hang like a veil in the deep bamboo forest. We lived within this veil—within a world lit by flickering oil lamps and heated by weak charcoal braziers—in the company of restless lost souls."

My mother has always been my mother. Calm, certain, stabilizing. To imagine her abandoned by a smokey pit unnerves me. I want to find someone to blame. "How cruel!" I exclaim angrily. "Couldn't she find a nicer place for you? Why make you suffer; you were only little children after all!"

Okaa-chan gently shakes her head. "For this old auntie, it also was not easy. In her husband's family house the favorite son was gambling away the family inheritance. In America, your Ojii-chan was working at three full-time jobs. Each month, he sent almost all his money to Japan. Watching your grandfather's money as it flowed from his toil into the pocket of a spoiled boy was painful to our auntie. She compensated with hard work—traveling back and forth, from her husband's household to ours—cooking, cleaning, caring. Perhaps the strain was too great. She died of a stroke within the year."

Okaa-chan shivers slightly in memory. "When this auntie died, it was like the third time we are orphaned. We lost first our father, then our mother, now this auntie."

"Who took care of you?" I ask. Unexperienced with heartache, I am eager to shift the subject.

"Oh, yes," says Okaa-chan. Perhaps she too seeks relief for she startles, shakes her head, and laughs. "The whole point of this story was

to introduce you to Naomi-san. The story ran away much too far!"

Okaa-chan takes a breath. "Let me see now," she says calmly, examining her narrative as if searching for a stitch dropped in knitting. "Oh, yes. When this auntie died, responsibility passed to her seventeen-year-old daughter. This daughter is Naomi-san: the venerable lady we are going to visit. Now Naomi-san has grown children of her own. She lives with her son Tadao-san, his wife Sachiko-san, and two little daughters. Soon we will meet."

"Naomi-san had to take care of four children when she was just seventeen?"

"*Saa neh,*" Okaa-chan sighs, "it was a great shock for a young girl. Not only did Naomi-san lose her mother but she lost her childhood as well. She lost her position as pampered daughter in a fine house. Most young girls of her class went to Oku-san school ..."

"Oku-san school?"

"Oku-san school was the place to learn graceful, wifely arts. Oku-san school was much fun for young girls. It was a place to learn about flowers and cooking and to spend time giggling over a mirror at own pretty face. Because of one uncle's gambling and another uncle's divorce, Naomi-san missed that fun. Instead, she became a nurse-maid."

"This whole story just sounds so unfair!" These are the tales that frustrate me. That fascinate and repel. That seem to carry a kernel of menace, laid here at my own safe American door.

"*Kawai so desu, neh?*" Okaa-chan sighs. Poor pitiful one to be sure. Then she smiles a sly proud grin. "Dutiful Naomi-san was only few years older than Onee-san, my honorable older sister. And though it was Naomi-san who was of marriageable age, it was Onee-san who received the attention of suitors."

She stops in thought. "It was strange time. The old order was falling. Even in sleepy villages, people spoke of expansion and military might. Young boys were bold and cocky. They brazenly stuffed love notes into Onee-san's schoolbooks. They made her blush and stammer."

Okaa-chan laughs triumphantly. "My poor sister could not help it. Modest confusion made her all the more appealing!"

"Did she get into trouble?" I am still child enough to be interested in hearing of another young girl's trouble—especially if she is pretty.

"Someone wrote to my father—your daughter is openly flirtatious. Father had been reading too many books. He was a learned, ascetic man. 'Do not let children indulge in gastronomical treats,' Father responded at once to Naomi-san, 'it will lead nowhere but to torpor. The way to enlightenment is through mortification of the flesh, be sure the children take daily a cold shower.' "

Okaa-chan shakes her head. "Poor Naomi-san, she was just a child trying to be obedient. Father gave no clues about how to administer his wishes. And in Japan, who had heard of this thing called a shower? As a result, we found ourselves limited to a diet of poor-grade rice. Each morning, before dawn, my brothers found themselves naked by an outdoor well, breaking the ice with their fists, so that they could bathe.

"And your sister?"

"Onee-san was very restricted. She was allowed no contact with friends. She was barely allowed to play with us. She was placed—how is the expression? She was placed under the house in arrest."

My mother had the easiest time. The youngest, the most cuddly, she became Naomi-san's favorite. She also had her uses. When Naomi-san fell in love and was censured by her family for defying an arranged marriage, my mother was sent to carry the billets-doux.

My uncle Koji—the No No Boy—complained vociferously. "Naomi-san starves us," he wrote to his father. "We are tortured. We are American. Send money for our passage immediately!" He did not realize that the man he addressed was the unknowing author of this misery.

Eventually, however, my uncle's arguments were heard. Grandfather—whose reading now advised the unity of families—sent money for the children's passage. Naomi-san wept and wept. Actually, she

. .

was a tender-hearted girl. "Please let me keep little Miyeko-san," she pleaded in a letter to my grandfather. "If you take all of them, my heart will mourn."

For more practical reasons, my grandfather relented. "If I ever return to Japan, I will need a daughter to manage my household," he confessed. And so, when her sister and brothers sailed for Los Angeles, my mother was left behind.

Enraged, Okaa-chan ran away from home. A kindly neighbor found her crying on a street corner. "I refuse to be a conduit for any more love letters!" she declared between sobs. The neighbor took her back to Naomi-san's house where, after some counsel, Okaa-chan was relieved of her courier duties. But my mother had bigger plans. She began a letter-writing campaign. "This is abandonment," she raged. It was, perhaps, the greatest period of defiance she ever would experience.

In time, Naomi-san's family reconciled themselves to the idea of a love match. In time, my grandfather began to feel guilty. By the time Naomi-san had entered her marriage, my mother had returned to America.

In America, my auntie was endlessly courted. Japanese American boys did not stop at love notes. They called her on the telephone. They followed her on the street. My auntie finished high school and took a job. She wore lipstick and Western dresses. The number of suitors tripled.

My grandfather was beside himself. He assigned my mother the duty of chaperone. Everywhere that Auntie went, my mother was supposed to follow.

My auntie had a sentimental streak. Lost puppies, orphan children, tragic men: she wanted to save them all. Stalwart young fellows offered marriage, but she spurned their advances. "They do not need me," she explained. "They will have fine futures without me."

Instead, she dated the anxious son of a hard-drinking, hard-driving

family. One afternoon, she saw him weep when taunted about escorting a girl from a samurai family. Deep in her belly, she felt something quicken and stir. She felt herself grow protective and fierce; and labeled these feelings love.

After marriage, Auntie lived with her husband's family. There, her deference drew contempt. In her new family, men stayed out late at night. Internment hit them hard. Resettlement made them bitter. Her gentle husband was helpless in the face of their fury. By the time Auntie had four children, she was covered with ugly bruises.

And so, the prophesy was fulfilled. Like her mother, my auntie was divorced. But unlike her mother, the divorce was *her* choice. To support her children, Auntie spent endless, blinding hours hunched over a sewing machine. She became a sweatshop laborer: a sample-maker in a garment factory.

To the Japanese American community, it was a fitting job: respectable, menial, drab. It was the kind of self-effacing penitence suitable for a woman who had dared to divorce.

But the women in my family are willful. Why should my children suffer with so little money? Auntie thought. What is the point in all this grim respectability? She sat at her sewing machine and audited her assets. Generous, warm hearted, hardworking. What kind of living could that make? She reviewed her situation again and again. Finally, she acknowledged the obvious. She was beautiful. Putting modesty aside, she made up her mind. She took one more step away from the rigid code of her past and harnessed beauty to ambition.

The Japanese love their mothers: gentle, lovely creatures who listen and soothe, who feed and encourage. Japanese are startled when they hear Western prayers. "Our Father who art in heaven." To them, the creative force *must* be maternal.

Much has been said about the Japanese geisha but I contend that she is a mother. Soft-spoken, sweet-voiced, disciplined in music and dance, the geisha fills your cup. She feeds you by hand. She lives to

nurture her patron. In her presence, men grow drowsy and contented, like sated infants slumbering at the breast.

The Japanese are ambivalent about their geisha. They are cherished. They are revered. But becoming a geisha is not a fate one wishes for one's daughter. For a geisha is a woman touched by melancholy. She is just a substitute mother: wanting a hearth, a husband, a baby of her own.

In America, there are no geisha, but in every Japantown there is at least one fine restaurant. There is a place for banquets and ceremonies and important moments among mortals. In these restaurants, you will find landscaped gardens, pebbled paths, meandering streams, private pavilions, and in the best of them, you will find hostesses.

In Los Angeles, my auntie became such a hostess, a woman whose presence was requested and reserved, whose role it was to sit by the elbow: pouring drinks, coaxing bites, listening, commiserating, cajoling.

Had my grandfather lived to see it, I suspect he would have disowned her. The line between pride and pretension is thin. Upon hearing that the daughter of a fine house had turned to hostessing, many conjured up a tawdry image. They envisioned a hardened woman, losing her youth, wheedling drunken men.

But Auntie was proud. She purchased a house. She began to save money for her daughters' college educations. And Auntie was happy. "For the first time, my sister could enjoy her beauty," says Okaa-chan. "She found she liked the silks and brocades. She learned to take pleasure in her glamor." The natural extroversion, and yes even flirtatiousness, that Auntie long had denied grew to be part of her virtue.

Auntie was valued by her employers and adored by her patrons. She earned enough money to visit New York. I was twelve years old and was staggered by her sophistication. Auntie wore French perfume. Her hair had been done at a salon.

"You have made sound choices," I heard her tell my mother, "honorable, obedient, and married to an educated man." She paused and

TALKING TO HIGH MONKS IN THE SNOW

fingered the frayed sleeve of Okaa-chan's modest sweater. She looked closely at the little sister, who once had been a fashion designer. "But you are too self-denying. Treat yourself well, Miyeko-chan, never forget your worth."

Auntie brought her two youngest daughters. Each represented a different pole. The younger was sweet and mild, possessing a warm, simple grace. The elder daughter was the beautiful beatnik I so admired: unapologetic, headstrong, and demanding.

Sadly, my aunt inherited more than her mother's fine features. She inherited her cardiovascular system as well. Like her mother, shortly after she turned fifty Auntie suffered a stroke and was dead.

When the funeral was over—after my mother had returned from California and was lighting incense and leaving tangerines in front of Auntie's picture on the metal bookcase above the television set—a package came from my cousins. "Mother wanted you to have this," read the letter. "She wanted you to wear it with high heels and heart." Inside was my auntie's mink stole.

I always have frightened my mother. In my eagerness to abandon tradition, in my struggle to become Americanized, she catches glimpses of her mother and sister. I am the daughter who has wanted to fly, who has picked the wrong men to love, who has started and stopped careers. In my mother's experience, such behavior leads to loss: to hardship, and exile, and to an early death.

Yet in Okaa-chan's stories, my grandmother and auntie always are heroines. It is she who has filled my timorous soul with flight dreams.

"I never have encouraged my daughters to pursue scientific or academic careers," says my father to a colleague. "Our field is too rigorous, too demanding. Instead, I have encouraged my girls to be nurses or librarians. Daughters need duty, not daring."

My mother listens politely and smiles. She pinches my fifteen-year-old elbow and drags me to the kitchen. "Do not listen to those old men," she fiercely hisses in my ear. "Soar as high as you can. Go as far as you want. *Never* let anyone stop you."



A Change in Career

 Before I returned to America, I visited the Okinawa Area director for the University of Maryland. The director was frank and friendly. "You could teach psychology here," she said. "Try it for a year or two. Renew your contract if you want." We sat in a simple office in a concrete building on an airforce base in the Pacific. I looked out the window. Hibiscus framed the view. On the adjacent airfield, fighter jets took off and touched down, and at its edge stretched the brilliant blue of the East China Sea.

"Japan is absolutely the wrong place at the wrong point in your career!" exclaimed my dissertation advisor when I returned to America. "Wait until you retire, wait until you are established at a major university. Be realistic. In ten years, you can request a leave of absence. If you go to Japan now, you will lose your professional momentum."

Thus warned, I resumed my job search. I tried to be realistic, but reality had become elusive. I went across America, from interview to interview, like a novice gambler at a grand casino: a spectator and would-be speculator unable to find a game I understood well enough to play.

One night I had a dream. I dreamed I was in the house of my advisor. The house whirled around exerting a powerful centrifugal force. I

felt imprisoned but also fearful. Would breaking free send me frag-
mented and spinning into an endless cosmos?

The next day, I went for a haircut. For two years a man named
Tony had been cutting my hair. I entered the beauty salon and found
that Tony had become Toni. While I had been traveling in Japan,
Tony had undergone a sex change operation. Don't be so timid, I told
myself. Life is short. Do what you want.

Before I moved to Japan, I lived for six weeks in my parents' house. I
moved back into the little pink bedroom of my childhood. I rented a
small tow-along van and transferred my belongings from Ann and
Danny's attic to my parents' basement.

Ten years earlier, I had towed a similar van from Albany to Wash-
ington, D.C. Then, I was leaving a research position to start graduate
school. In Albany my job had been to study due process and the crim-
inally insane. I had interviewed patients judged incompetent to stand
trial: unable to understand the charges brought against them or to aid
in their own defense. Although a few were infamous, for their head-
lined crimes of bloody psychopathology, most were charged with
crimes of incompetence. They had forgotten to take their medication,
had grown disoriented, and had flung a brick through a window. They
had heard voices, flagrantly had collected armloads of merchandise,
and had stumbled into the grasp of a store detective.

While awaiting the return of their mental competence, the
patients lived on locked wards, dribbling their lives away in periods of
thirty-day observations. Some benefited from the medication and
therapy. They regained lucidity. They talked excitedly about their
pending indictment hearings and dreamed about going home. When
their observation periods elapsed, they went to their court dates. Fre-
quently the charges against them were dropped. But within a few
months, many had returned. Without the structure of scheduled med-
ication rounds, one day they would forget to take their medicine.
They would grow confused. Eventually they would commit another
incompetent crime or fall victim to a competent criminal.

While the patients were on the wards, I conducted weekly interviews. For many I was the only visitor. After their release dates, I traced them to places like South Bronx and Bedford-Stuyvesant, where I conducted evaluation interviews. We were interested in the success of their outcomes. I was twenty-one years old and fresh from undergraduate school. I felt excitement and immediacy and the safety of emotional distance. It was like watching myself in a movie.

I was seeing things I had never seen before. Once, in a barren rooming house, my Spanish interpreter and I tried to talk to incoherent Angel M. Cockroaches darted across the floor. A man burst in the room. He wielded a knife, then ran away. Angel stared at the floor unseeingly. One month earlier, in a sunny hospital visitors' room, he had given me a gift. He had made a charcoal rendering of me. In it, I wore a mantilla and held a rosary. A cross nestled at my throat and radiated a beneficent light.

I worked on the wards for a year. The public was fascinated by the topic of criminal insanity, and the project received much publicity. I was envied by my unemployed friends who, like me, had majored in sociology. A few patients consistently refused to complete the interview schedules I weekly brought to them, but they were a meager percentage. Their nonresponse did not jeopardize the scientific validity of our findings.

One day, one of the nonrespondents shuffled over to me.

"I'll fill out one of those things." His voice was gruff.

I quickly located an interview schedule and a pencil. "Thank you, but can you tell me why you've decided to participate?" It was my duty to record such information.

He looked at me shrewdly, a gaunt old man with nicotine stains on nervous fingers.

"I've been watching you for months," he slowly said. "I've decided that you mean well. I've decided that you wouldn't be doing this if you thought it would do us any *harm*." He paused and took a long, greedy inhalation from his cigarette stub. "But before I fill this out, I want you to know—I want you to look around at these men here and

know—that if you think this is going to make some sort of social change; if you think this is going to help our lives in any *real* way, then you are very young indeed."

Five months later, I was towing a rented van to Washington, D.C. I was leaving to study counseling and psychology. I went on the advice of a mad man.

I am the daughter who left home, who went away to college, who went away to work. I have been indulged by my family. I can move in the outer world at will and leave my Japanese spirit to be nurtured at home. Each year on my birthday, my family makes toasts and sings "Happy Birthday" to my vacant chair. When I return, I can leave my outsider ways on the threshold, like street shoes outside a Japanese home.

My family has grown accustomed to my comings and goings, but there was something different about my going to Japan. My father could not offer me magically protective words of advice. Working in a military setting was beyond his experience. He struggled to find an adequate incantation: "Keep up your research," "I will forward your correspondence," "Maintain contact with your American colleagues," "I will keep your automobile in running condition," he repeatedly said.

My mother was worried. She feared that the Japanese would reject me. She visualized a military base as being Spartan in living conditions and rampant with racial prejudice. She knelt in front of my footlockers, painstakingly packing and repacking. She wanted to be certain that I would carry into my new life every solace possible under my weight limit of one hundred and forty pounds.

The Japanese love good-bye rituals. On my first date, when I was sixteen years old and going to the junior prom, my date carefully backed his father's car out of my parents' driveway. My parents stood on the front porch and waved. We waved back. Cautiously, my date shifted the gears and began to pull forward. My parents waved. Now they were at the end of the driveway. When we reached the end of

the road and were about to pull onto the main highway, my date's voice rose in alarm. "They are following us," he shrieked. I turned to see my parents strolling slowly down the road. They waved as they walked. I waved back. "Don't worry," I reassured my anxious date, "they will turn back as soon as we're out of sight. It's only a symbolic thing, so that my last memory will be that they are awaiting my return."

"Jeeez," said my date.

When I left for Japan, my parents, sister, brother-in-law, nephew, and niece accompanied me to the Albany County Airport. When my flight was announced, we rose and stared at one another in panic. They crowded after me to the gate. After I had boarded, I looked from the plane and saw their faces pressed against the waiting room window. Although I knew they could not see me, they were all waving. I waved back. I waved until the plane had climbed in the sky and the terminal building had vanished.

IV.

Japan

Beginnings

 My mother used to tell me the story of Momotaro, an anomalous lad who tumbles from the pit of a peach into the lives of a kindly old couple. Such an extraordinary birth does not foreshadow a quiet life, and so when Momotaro, still a youth, tells his parents that he must leave to pursue his destiny, they are tearful but accepting. His aged father gives him a sword and armor. His mother provides millet dumplings. Momotaro, Peachboy, promises to return.

Every culture has a similar tale. The child sets forth, meeting along the way an odd assortment of characters. Because the child has been well loved, he is generous and without guile. The odd assortment—in Momotaro's case a monkey, a pheasant, a spotted dog—help him on his passage. Later, the child is tested. He learns a little about friendship, a little about courage, and the value of returning to kin.

Now that I am older and more familiar with what it means to love a child, I know that the story was for my mother. Through its repeated telling, she hoped to cast a spell. When the time came for leaving, her child—born miraculously and so unlike any other—would travel under the protection of her love, would find friendship in even the most unlikely of places, would see sorrow only to

the extent needed to make her compassionate. Her child would never lose her way.

But a child listens to the fable and hears a siren's song. I loved, not the soothing security of the tale in its entirety, but the uncertainty in its progress. Proceed to Ogre Island! To the place where your hopes meet your fears! Bring on the cast of comical characters! Now, let the adventure unfold!

On a clear October morning, I arrive in Japan. I have been assigned to Yokota Air Base for several days of orientation. Then I will be reassigned to my Okinawan teaching post.

Yokota is a small base, predominantly used as a crossroads for personnel and supplies. Behind barbed wire, the airfield stretches in a narrow flattened ribbon banked by a post office, a fire station, some offices, some houses, and a chapel. It is a simple almost sleepy place whose serenity is routinely punctured by the shrill screaming of jet aircraft, by an ongoing parade of dazzling flying machines. Scented by jet fuel, set in spacious symmetry among a scattering of shade trees, within the confines of high fences, Yokota is like a preserve—a curious sanctuary for modern flight technology and small-town American life.

A highway runs parallel to the fence. It serves as a moat. Across the highway, a Japanese community erupts in an alluring tangle of gray tiled roofs and impossibly narrow back alleys. The Japanese town is called Fusa. Tokyo lies one and one half hours southeast by train.

On base, I report to the office of my new employer. THE SUN NEVER SETS ON THE UNIVERSITY OF MARYLAND proclaims a poster on the door. It has been the credo of the university's overseas division for over forty years. Inside, atypical administrators—courtly connoisseurs of Asian art formerly groomed for the diplomatic corps, anxious achievement-oriented academicians, eccentric expatriates—try to maintain their careers. Like the second sons of

an austere, august Home Office, they have been abandoned abroad with the directive to make something of themselves.

The tasks are these: to study troop assignments and coordinate educational services to match. Each semester, a percentage of profits from tuition is expected back at Home Office. Toward these ends, the administrators craft course offerings. They deploy instructors, like multicolored pins, all over a map of Asia. They develop academic calendars and worry over financial balance sheets. They are assisted by a pool of perpetually young and new secretaries—military spouses who rotate in and out in a matter of eighteen months—and by an odd and aging army of office boys.

The office boys are Japanese citizens in their sixties. Relying on antiquated adding machines, abacuses, or the sheer power of memory, they hunch over their small desks and calculate columns of figures. In the midst of the computer revolution, they perform in the same manner the same tasks for which they were hired forty years ago.

And like their jobs, their nicknames are frozen in time. Cute Americanized nicknames bestowed by occupational forces on overawed teenaged boys. Kenny-san, Jimmy-san, Tommy-san. In the midst of internationalization, they are cross-cultural elders locked in their status as child.

To an outsider, it seems a strange office: jumbled and underautomated, part colonial outpost, part democratic state university. But the employees are productive and happy and I am eager to begin to belong.

I have arrived on the Friday before a three-day weekend. Monday will be Columbus Day for the Americans and Sports Day for the Japanese. A holiday spirit prevails. In an atmosphere of shared goodwill and individual industriousness, people attempt to clear their desks. I blunder about: friendly and awkward, too new to be very useful. I try to fit in but it is futile. It is like trying to form friendships in a crowd of last-minute Christmas shoppers.

. .

Still plucky, I leave the office and go to make reservations for my military flight. I find that I cannot communicate.

"Where are you PCS-ed?" smiles the young man behind the military ticketing counter. It is clear that PCS is a verb.

"PCS-ed?"

"You're Okinawa TDY-ed aren't you?" he easily continues. "Fourteen October, eighteen hundred hours?"

I nervously swallow and begin to compile a glossary of military acronyms. As the day progresses, I make a chart converting A.M. and P.M. to military clock hours. I record key cryptic phrases such as "go ballistic," which means to succumb to unbridled enthusiasm. By 1500 hours, I am relieved to learn that it is time to check into my Japanese hotel. At least there I will harbor no false expectations of easy acculturation.

By 1500 hours, clouds roil like lava across a hovering sky. A typhoon is on its way. Throughout the day, I have heard the roaring of jet planes as they are evacuated to the Philippines. Against a rising wind, illuminated by an odd lavender light, I drag my footlockers to the curb. I raise my hand.

Immediately, a taxi springs to the curb. The trunk and passenger doors fly open as the driver leaps smartly to my side. Rendered sluggish from travel, novelty, and the falling barometer, I am taken aback. The driver, a slight man in his late fifties, ignores my stupor. With immaculate white-gloved hands, he seizes a footlocker weighing more than half his weight and adroitly tucks it into the taxi's trunk.

"*Arigato gozimasu.*" I stir and begin to tug the other footlocker toward the car. The driver turns toward me. His brows knit with worry. He seizes the footlocker and gestures me toward the interior of the taxi. "*Dozo, Dozo,*" he pleads. I obey shamefacedly. My attempt to help has been construed as a rebuke, as a criticism about promptness of service.

When the driver returns, I try to explain my rudeness. "*Watashi*

wa America-jin desu." Being a foreigner excuses a wide range of barbarisms.

"*Honto ni!* No kidding!" exclaims the driver, glancing in the rearview mirror. He deftly changes the radio station to the American Armed Forces Network. Heavy metal, rock and roll music floods the car.

The Japanese luxuriate in purity. Hence, the fame of the Japanese bath. Most cars in Japan are white and the taxi is no exception. The body is spotless, the hub caps are shined, the seat covers are hand-pressed white linen. From the rear mirror dangle various Shinto traffic-safety charms. One, a tiny Tupperware tub, no bigger than a thumbnail, contains sacred salt—the same salt that Sumo wrestlers heave by handfuls, over their shoulders, for purification and for luck.

"How you like Japanese people?" the driver asks in English. "Treat okay? Like pretty good?"

"*Taihen yasashii desu*"—they are very ease-making. It is a phrase that my mother has taught me. It is the highest of compliments, like saying a man is a mensch.

The driver grins. "Speak Japanese pretty good," he declares.

I gaze around the cab. Beyond the basic theme of cleanliness, the driver has enhanced the decor. The dome light has been replaced by a crystal chandelier. Mickey Mouse dances on the dash. A bottle of air freshener dispenses a faint whiff of roses. On the rear windowsill, a box of tissues has been disguised by pink organdy to resemble a pretty plump pig.

"You are wife?" My reverie is dispelled by a question from the driver.

"No, I am a teacher."

"Where Mama-san?"

"In America."

"Lonely," clucks the driver in sympathy. "Poor pitiful little one."

In Asia, to be taken from your mother's side before the natural separation point of marriage is the most poignant of fates. Touched

by my plight, the driver becomes my guide. "I teach how to catch train, find meal, go to store," he says, and does. He turns off the meter and tours me around the town. Periodically he stops. He abandons his taxi in some outrageously obstructive position and takes me by foot to meet various kindly bilingual shopkeepers. "They take care of you pretty good," he reassures.

The town is dense, twisting, and incongruously charming. Noodle shops, steaming with the aroma of broth, piggyback against modest houses and pocket-sized pharmacies that are scrubbed with antiseptic and festooned with color photographs of advanced cases of athlete's foot presented in horribly enlarged detail. In the pharmacies, condoms (at least I *think* they are condoms, to demand clarification would be somewhat indelicate) are sold in elegant giftwrap.

The centerpiece of the town is a bustling train station flanked by a shopping mall. Outside the station are parked row after row of unlocked, virtually identical bicycles. There are close to a thousand, I am sure. Commuters stream from the station, head for the tangle of bicycles, and locate their own with an ease that astounds me.

As we pass the post office, Driver-san indicates its location with a gentle nod of his head. "Write to Mama-san," he advises with concern. "Make you feel better."

When, finally, the driver deposits me at the desk of my hotel, I thank him in my most polite Japanese. I bow deeply.

Driver-san shakes his head in vigorous denial of the need for thanks. "Bye-bye!" he brightly calls. He gives an American wave. As he reaches his cab, he turns back to me. "*Kiotsukete,*" he admonishes like a Japanese uncle—take care of yourself now, you hear?

The desk manager also speaks English. I provide my signature on various forms. He extends a room key. Our interaction proceeds

with the familiar impersonal cadence of a standard American business trip.

The manager loads my footlockers on a cart. He escorts me to my room. He shows me the television set, the twin beds, the light switches, the bathroom. I pay scant attention. It is a familiar ritual. As the manager prepares to leave, he bows. I wave vaguely. Then he surprises me. He takes two steps forward and bows deeply toward my footlockers.

"*Magiciansan desu ka?*" he politely asks.

I stare at him stupidly. I race through a mental review of my Japanese vocabulary. I cannot recall a translation for the Japanese word *magiciansan*.

"I don't understand," I reply.

He bows again in homage to my footlockers. A smile begins to lift the corners of his mouth. His eyes twinkle. He pantomimes a feminine, mincing approach toward the lockers. He pivots and executes a flirtatious wave.

I watch warily. Am I trapped with a mad man in a foreign hotel?

The manager pantomimes climbing into the trunks. "*Magiciansan*," he repeats. He pantomimes a second person bowing to an audience, approaching the footlockers, and sawing them into two pieces.

"Magician!" I exclaim. "You are asking if I am a magician!"

"Yes, yes," he beams. He taps himself lightly on the nose. "My little joke," he explains, hugging himself with pleasure.

I laugh with delight, as charmed by his effort as by his humor. There is a certain nobility in the willingness to work so hard at establishing one brief moment of lighthearted grace. I stop feeling like a customer and begin to feel like a guest.

On my first day in Japan, the rain begins at dusk. Somewhere in the distant southern seas, the typhoon has shifted. I watch as dozens of housewives hurriedly gather laundry from the balconies

that line a long apartment building across the way. They shake colorful futon mattresses off railings. They slide shirt sleeves and pant legs off bamboo clothes poles. The clothes billow and wave in the turbulent air; and for a few brief moments, the apartment building becomes a giant cruise ship readying for departure. The housewives become passengers waving bright banners from multi-tiered decks. But the illusion is fleeting. Within minutes, color and movement are gone; and the first drops of hard slanting rain bounce off barren balconies of cold concrete and steel.

As evening deepens, lights begin to glow from behind the glistening gray balconies. As families gather for dinner, their silhouettes are bathed in warmth. Children work on homework. Fathers read newspapers. Alone in my darkened room, I feel like a night watchman on a tanker who glimpses the lights of a passing luxury liner. I feel a faint, gnawing sadness and realize that I am hungry.

In a traditional Japanese inn, the entryway is the place where street shoes are shed. It is a physical and psychological transition place separating a hurried modern world from a tranquil traditional world. Into the sanctuary of shelter, the entryway ushers natural beauty. Fluttering cloth banners hang in the doorway. They invite inward, cool breezes and muted sounds. They allow outward glimpses of the garden path. The traditional Japanese inn is rich with repose. Stockinged feet rhythmically brush against the delicate roughness of straw mats. Tea steeps in an earthenware pot. A fish jumps in a pool.

My hotel is not a traditional Japanese inn. Along the highway's edge, facing a long stretch of flightline fencing, my hotel stands in a border area between America and Japan. In the rain-lashed night, the barren airfield glitters under the glare of runway lights. Slanting shadows from the tall steel fence reach toward the road with chain-link lacework, tattooing diamond grids across the slicked street and over a serpentine line of hissing traffic.

My hotel is advertised as a businessman's hotel. It is a Western-

style hotel promising efficiency and economy. Yet, Japanese innkeeping traditions linger. The courtyard is lined with smooth plump pebbles that massage the soles of feet and crunch companionably. Their purpose is to remind guests of a soothing stroll along an ocean beach. On my first evening, the pebbles gleam darkly with a rain-enriched patina. Like onyx gemstones, they are visible below the edge of a cloth banner that hangs lifelessly behind the shelter of an automatic sliding-glass door.

The lobby of my hotel lacks the look of carefully engineered, environmental design often found in a deluxe Western hotel. It also lacks the shadowy, almost melancholy, mystery of a traditional Japanese inn. My hotel is blanketed by bland indoor-outdoor carpeting, as if in reproachful testimony to some contractor's confusion about how to blend Japanese expectations of inviting nature inward with Western expectations of easy maintenance.

The lobby has been decorated with the innocent belief that whatever brings ease and comfort to the decorator will, surely, do the same for others. Overstuffed couches are squeezed between magazine-laden end tables. Fat goldfish circle in a tank that is decorated baroquely with plastic castles and jungle fern. Each fish has a name and personality traits that the manager is eager to describe. In the corner of the lobby stand coin-operated vending machines dispensing soft drinks, cigarettes, and instant noodle dinners. Yet, despite the chaos of its decor, the lobby somehow conveys a sense of ease. In America, I have felt a similar comfort in the family rooms of friends. And there is something else as well. The hotel seems a bit like me. Pieces of East, pieces of West forming their own odd integrity. Sitting alone, eating my instant noodles, I feel a twinge of pride.

"*Yosh, ikimasho.*" Heave ho, let's go. Jostling and laughing, five Japanese workmen cross the lobby. They are construction workers away from home on a project.

In Japan, construction workers look like ronin, like leaderless

samurai: dangerous dark princes, all virility and verve. Lithe, taut, and swashbuckling, they prowl easily along high scaffolding. Costumed dramatically in black nineteenth-century momohiki and jika tabi—in jodhpur-shaped trousers and split-toed boots—they stand silhouetted against the sky. Hands on hips, legs spread wide, they loom mythically, like confident young satyrs. Their T-shirts are scarlet or purple; their muscular arms bear tattoos. Tied around their gleaming foreheads are towels of orange or gold. I am dazzled by their aesthetics.

And when they laugh, when they throw back their dark heads and laugh: white teeth glitter against deeply tanned skin. How different they seem than office workers: wan mousey men, in identical gray business suits, tethered to leaden briefcases.

Later when I describe the workers, my mother will laugh. "You are seeing with American eyes." In the eyes of a Japanese girl, the salaryman is a pale poet, the ronin a crude debaucher. "The Japanese girl," my mother will say, "sees the weary young office worker on the subway, trying to read his newspaper in the rocking press of the crowd, and her heart cries, Oh, please, let it be him! Oh, please, I want to marry *him!*"

In my hotel lobby, on my first night in Yokota, the workmen grab umbrellas from a rack by the front door. Its eye triggered, the automatic door slides open. It rattles in its tracks, and in that instant the long tails of the cloth banner spring to life: soaring and dipping like kites. The evening rushes inside. Rain gurgles in the gutters. Tires hiss along wet pavement.

The workmen belong in this scene. They are one with the force of the storm. Whooping playfully, they unfurl their umbrellas and clatter onto bicycles. They shout happily to one another above the voice of the wind. Like tightrope performers, they clutch their umbrellas and wobble. When they reach a point of balance and momentum, they slip unobtrusively into the night.

Their entire appearance and disappearance takes only a few

moments. Like a stone thrown into a pond, there is a startle of sound and motion, a rippling gradient of muted sensations, and a return to dynamic stillness. But before the electric door lurches closed, night has entered and has left its scent: wet asphalt, moldering leaves, and autumn earth.

In the wake of the Japanese construction workers come seven American men. Wooden-heeled cowboy boots scuff. Battered leather jackets creak. Tall, large-boned, broad-shouldered: the men crowd the corridor and swing wide into the lobby, like cattle moving through a chute into a corral. They drop heavily onto the couches.

I watch, fascinated and invisible. With my Japanese face I am, to them, just another aspect of the Japanese decor.

Like occupying forces, the Americans dominate the room through the simple act of entering and existing. They joke and jostle with the loud, good-natured swagger of comrades far from home.

"Sheeeet man, I'm starvin."

"Git that clerk to rustle us up some taxis."

"An don't git lost now."

The men are Flying Tigers. They are the flight crew for a cargo carrier company founded by World War II flying aces. They wait for their taxis and tease and taunt one another. They speak in a West Virginia country drawl. Later, I will learn its origin. It is the dialect of aircraft pilots, derived from the country cadences of the legendary pilot Chuck Yeager.

Taxis are few on such a stormy night. Their wait lengthens. Their talk deepens. The Flying Tigers are in financial trouble. Consistently, they are underbid by Japanese carriers. More painfully, they are losing military contracts. They speak of Uncle Sam and how he is deserting them. They feel betrayed. Someday soon they may be barred from entering the military bases on which they trained.

The beefy grizzled men slumped on the tired couches of this modest hotel are not the lean young officers who fly the fighting machines. Those pilots have been sent to safety with their jets. They are in the Philippines, drinking and dancing in a tropical night.

The cargo pilots are like the indoor-outdoor carpeting of the lobby. They fit neither here nor there. They are hungry and weary. They are waiting for the sound of a taxi arriving on a stormy night. They talk about the times that were: evacuating people at the fall of Saigon, airlifting orphans from the camps of Thailand. Those were glorious days, the days when they were heros.

Finally, two taxis arrive. The Tigers cram themselves in. I can hear their tired grumbling. I can see their huddled silhouettes. They crowd together for shelter and are driven away. And somehow, the lumbering taxis seem more fragile than the tottering bicycles had been.

Again, the automatic door rattles to a close. Again, the autumn night enters and leaves its mournful musk.

But perhaps I am seeing with Asian eyes. Eyes that love seasonal melancholy. Perhaps there is no sadness in the Flying Tigers' state. They simply may be businessmen eager for a meal. Or perhaps, Japanese eyes would view the scene and find *me* the poignant case. I am without husband or mother, the fallen child of a once great family. Perhaps to Japanese eyes, I am like my grandmother returning from Manchuria. What misfortune could have driven me back? Back from the bold frontier?

Kadena Air Base

On a cold windy morning, I struggled through a screaming flow of jet exhaust, climbed a flight of roll-away boarding stairs, and clamored into the cavernous belly of a stripped plane. This was MAC—my military air command flight. I entered the "cabin" and found there was none: no paneling, no reading lights, no seat back trays, no window shades, no windows. The body, a thin skin of steel sheeting, was held together with visible riveting. Electrical wiring snaked along the ceiling. Water condensed in oxygen outlets and dripped onto the floor. Mailbags and mammoth machinery parts were being lashed to the floor. Passengers were distributed, by weight, among the rest of the cargo, handed ear plugs, and strapped into place. I was being TDY-ed. I was leaving Yakota Air Base and flying to Kadena, my temporary duty station.

In darkness, I sat facing the tail, and it was like traveling within the rib cage of a giant bird. I listened to its pulsing heart, to its labored breathing. I felt the rush of wind around its frame. I thought of childhood Thanksgivings, when a crackling bird had come gliding from the oven, plump as a swollen football, and two hours later had laid stripped to its foundations. The carcass had reminded me of Noah's Ark. A large cavity, with ribs revealed, needing only a supple skin to be launched again. Noah had

seemed a pilgrim of sorts. Years later, I sat in the belly of a sailing bird and dreamed about adventure.

I was assigned to an "Inadequate BOQ," a bachelor officer's quarter. My quarters were one in a motel-like line of eight units, within a long cinder block shell. Separated from its neighbors by plywood and plaster, my "Q" was a large furnished room with an attached bathroom. Once, the indoor-outdoor carpeting had been bright harvest gold; once, the surplus furniture had been glaring avocado green. Now the quarters had been labeled inadequate for the lack of a kitchen; but inhabitants joked that aesthetic deficits were the true cause of its naming.

Our quarters had been built in the late sixties. It was a time when self-respecting bachelors were hell-raisers not gourmets. While newer quarters were replete with self-cleaning ovens and self-defrosting refrigerators, with nonstick stove tops and ample work space bathed in natural lighting, our Qs had nifty bars. Our quarters had long, tiled alleys specifically designed for the storing, mixing, and pouring of alcoholic beverages.

I liked my BOQ: the sagging narrow bed, its worn corduroy bedspread in jack-o'-lantern orange. I bought a hotplate. I emptied the tiny bar refrigerator of a dozen ice cube trays. I restocked it with tofu and milk.

I was at home. An air conditioner hummed at the window. A gecko scaled the walls. A banyan tree stood in the yard and fruit bats lined its limbs.

Nature flourished around my quarters. Shrews peeped along the corridor. Mildew conspired in closets. Through every crack leaked a steady stream of purposeful engineer ants.

In rotation, myriad clans of insecta displayed their hatching cycles. One week would bring the cicada: crawling green and sticky from desiccated casings. The next week would reveal the field maneuvers of an army of bright blue beetles. My neighbors

and I lived in the midst of this fecundity and laughed. We knew we were the encroachers.

Like me, my next-door neighbor was a university instructor. At eighteen and a straight-A student, he had been convicted by a Colorado court. The crime was "unlawful play." He deliberately had intimidated the owners of luxury automobiles by the means of pyrotechnic skateboarding, within a parking garage. At twenty-four and a wunderkind professor, Clark still was playing.

Clark was a lady-killer. Dark-haired, blue-eyed, he was a lean laconic cowboy with an "aw, shucks" earnest bashfulness and a "yahoo" greedy recklessness. While cocky young pilots and swaggering senior officers were away on temporary duties—serving the Mission and sowing their wild oats—Clark seduced their wives. On a sleek silver motorcycle, he would streak across the manicured lawns of the officers' club, like a warrior absconding with the spoils of battle. Behind him, a shrieking wife held on tight, hiding her face against his back.

At heart, Clark was not a cad. The oldest child of a noble no-nonsense mother and an ingratiating hard-drinking father, Clark was dutiful toward his mother and protective of his sister. He was wary around his father. The straight A's that had won his mother's praise had earned his father's scorn. "You're a nothing. You bore me," his father had jeered, but to Clark, the insults were trivial. It was another knowledge that nagged and wounded. Come what may, his father was the favorite child.

Through his work, Clark found recognition and respect. A diligent, entertaining, and even tender-hearted teacher, Clark rejoiced in his students' learning. But the need for admiration that so enriched him as a teacher made him heartless as a lover.

In museums, at lectures, in the middle of a busy street, Clark would amble up to a pretty, local girl. "I am an American college professor," he would admit with a bashful reticence. "I want to

understand the culture of your country." Then he would dazzle with a wolfish leer. It was the perfect snare for virgins.

Clark meant no harm. He found the girls enchanting: so sweet in their innocence and trust. Like a hunter of rabbits who traps simply so he can pet, Clark meant only to admire. He wanted to be the first who held their hands. He wanted to provide their first chaste kiss, to be their first, great infatuation. Then, with a brotherly concern, he wanted to set them free.

The persistence of the girls' devotion discomforted Clark. He traveled through Japan, through Taiwan, through India and Thailand. Always, he was pursued by beseeching letters printed in careful block letters. "Oh honorable teacher and dearest friend, forgive me for my burdensome ways but never will I forget..." "What can I do?" asked the hapless hunter. "I try to explain but they do not understand."

Other men turned cold. Discomfort hardened to disdain. Clark had inherited the woman of one such man. Once, a doctor at the naval hospital had loved a Japanese girl. Well...he had not really loved her but she was a sweet thing who quietly moved into his quarters to tend to all his needs. After several years, when he transferred back to America, he had introduced her to an incoming doctor. It was, he said, the kindest way to leave. The third man to inherit her was Clark. By this time, she was over thirty. "Watch out," was the warning that came with the bequest. "She's getting old and conniving to get married. But she is not a bad sort. When you're involved with other women, she'll discreetly move her futon out and only come in to keep house."

As a psychologist, I had been well versed on potential pathologies of overseas military life: the press for conformity, the relentless scrutiny, the xenophobic bonding. I had heard about compulsive escapism through danger, or drinking, or sex. No doubt such pressures existed.

In part, Kadena was not unlike Africa or India in the closing days of the Empire. The sparkling sea, the humidity, the lush and languid life. But as Independence had ended those days of beauty and boredom, when the focus of a day had been dressing for dinner and slipping a gin and tonic from a servant's silver tray, so history was changing Kadena.

Once, officers had lived beyond the gates, in houses with servants and views. Once, while Okinawa's population lived in makeshift huts, roadways had been built for troop transport and the convenience of American luxury cars. But when I arrived, Kadena was the site of a peacetime all-volunteer air force. And warriors no longer were gods.

The new military had ceased to be the playing field of affluent gentlemen's sons. It was a place where steadfast young outsiders hoped to advance through a government career. There was scant time for games of adultery. Alcoholism held little allure.

When I arrived at Kadena, the dollar was falling. There were waiting lists for substandard, on-base housing. There were student overloads in all the college courses. And compared to the Americans, the Okinawans drove nicer cars.

I found life on the airbase to be oddly liberating. My idiosyncrasies caused nary a stir. As a college instructor, I was *expected* to be odd, absent-minded, abstract. Eccentricity established authority.

In Okinawa, the faculty was rich with characters. There was the English teacher—still beautiful at eighty-three—who had danced with Cole Porter in Shanghai, when Shanghai was like Paris, who had ridden the Great Wall on horseback, and who had been memsahib in a dozen well-ordered colonial households across the continent of Asia. There was the high school shop teacher, ambivalent about his talents, who after two years in the Peace Corps had returned to open Miracle Woodworking. IF IT'S A GOOD JOB, IT'S A MIRACLE read his business card. One instructor, before receiving

his doctorate from Harvard, had been a member of an internationally recognized rock and roll band. Another instructor—Hindu by birth, Catholic by conversion, Chinese by marriage, and American by naturalization—was known for her ability to move objects, using only her psychic powers.

Teachers go overseas for many reasons: some for adventure, some for romance. Some go for solitude, for the opportunity to think and write. Others go in haste, in flight from a loveless marriage, a financial ruin, or a life that failed to take. I went because I am an American. Like our immigrant ancestors, I was seeking in a new land, some shining future.

Dr. and Mrs. Kinjo

When I first arrived in Okinawa, I was eager to belong. To hasten my acclimation, I approached my new environment with my old ally: studiousness. I enrolled in a course on Japanese culture and a course in Japanese language. The instructors were husband and wife.

"Oh, the Kinjos," someone exclaimed when she heard I had enrolled. "They are great teachers. They work like the dickens; each has two full-time jobs. Besides teaching college courses on base, Dr. Kinjo is a distinguished professor at the Japanese university. Mrs. Kinjo teaches both high school and college. For vacations, they take students on cultural study tours."

I listened and my head began to ache.

"During the occupation," said my undaunted informant, "when they were mere teenagers, the Kinjos each won scholarships to Indiana, or was it Ohio? No, no, I'm sure it was Indiana. Now, between them, they have six college degrees. Wait until you meet them. You'll see..." She finished with a triumphant flourish. "The Kinjos are really *good* people!"

I smiled uneasily. Her praise had made me apprehensive. Sometimes good people can be such terrible bores.

"I try but my *mistakes*," the young enlisted man slapped the side of his head. "I'm a walking social blunder!" He chuckled at some private memory. "When you first went to America, Dr. Kinjo, how was it for you?"

It was the first night of Japanese culture class. At 4 P.M. Kadena High School had been converted to the University of Maryland. In its air-conditioned halls, giggling hand-holding teenagers had been replaced by men and women marines conspicuous in combat camouflage, by air force officers commanding in crisp dress blues: caps neatly folded and precisely pocketed like silk handkerchiefs in a corporate dress code.

Dr. Kinjo was in his late forties. A man of medium build, about five feet four inches tall, he had a mischievous mobile face and bristling eyebrows that stood up in an expression of mild and enduring amazement.

"When I went to America," said Dr. Kinjo, "I was seventeen years old. I was sponsored by a Christian organization, and a kind Christian family invited me to live with them. When I arrived, it was late afternoon.

" 'You must be tired,' said the wife of the family. 'Unpack, take a bath, and then we will have dinner.'

"They took me upstairs to my room.

" 'Here is your bed,' the wife explained. 'You can use this little table as a desk.'

"I looked around. I was overwhelmed.

" 'And this is the bathroom,' she said, moving down the hall-way. 'Here are some towels. After your bath, come on downstairs and dinner will be ready.'

"After she left, I tiptoed around the bathroom. Obviously, it was the site of spiritual as well as physical cleansing. A porcelain read-ing chair stood under the window; the seat was a pure oval of wood. Next to the chair stood a rack of important spiritual read-ings: *Life*, *Time*, *Good Housekeeping*. I nodded to myself. These were the values I had expected to find in a fine American home.

"I sat down and tried the chair. It was hard and offered no sup-port to the back. This is like Zen meditation, I thought to myself. Designed to induce a disciplined concentration.

"I started to draw my bath. I was very pleased with myself. Already, I was understanding the American Way of Life. When the tub was filled, I squatted by its side. I was astonished by the array of towels the missus had provided. I jumped up, seized the largest towel, and flung it into the tub. Slowly, it grew heavy and sank. I retrieved it, soaped it, and began to scrub.

"The towel dripped lavishly onto the small carpeted rectangle on which I perched, but it was curiously unwieldy. It lacked the flexibility needed to scrub the back. I looked for the rinse bucket and understood why. The rinse bucket stood between the tub and the reading chair. In the bucket, rested a long-handled brush. Its gentle scooping shape was perfect for the back. I soaped it up and tried it. Yankee know-how, I thought to myself. We Japanese could learn a lot.

"After my scrub, I repeatedly filled the bucket and rinsed the soap away. I was careful to stay well clear of the tub. I did not want any soap to accidently splash into the water.

" 'Is everything okay up there?' called the husband. He sounded worried. 'Very nice, very nice,' I called in return.

"I jumped into the tub and some water flowed over the top onto the soapy floor. I soaked the second-largest towel. I rang it out and

perched it atop my head. Steam rose all around and I sighed with contentment.

"When I finished my bath, I dressed and opened the door. I saw that some of the rinse water had seeped into the hall. The inefficiency of the drainage had puzzled me. Only now was the water beginning to drain smoothly through the floor. Downstairs, I heard the family talking loudly, excitedly, almost in hysteria. I was eager to join the festivities. I took the smallest towel—a little square—I folded it neatly and placed it in the breast pocket of my new American suit. It was the most luxurious dinner napkin I had ever seen."

At the end of class, Dr. Kinjo stopped me at the door. "What are your research interests?" he queried.

I started to stammer. I no longer knew. I mumbled something about culture and marginal members.

"Good," said Dr. Kinjo. "I will help you. Now is the point in your career to broaden. You must develop an international perspective."

I nodded blindly. Broaden? I had been hoping to retreat.

"When shall we meet to discuss this?" Dr. Kinjo was saying. His voice boomed with enthusiasm. "Sunday?"

"This Sunday I am teaching a workshop from nine through five," I said with relief. I thought I had been spared.

"Fine," said Dr. Kinjo. "I will be waiting outside your classroom." Then, with a cheerful wave, he was gone.

By the close of my Sunday workshop, I am hoarse and hungry. I am not looking forward to meeting with someone renowned for his two full-time jobs and his working vacations. I imagine my time in Japan and see the months leaking away: studying and teaching in military base classrooms, researching culture and marginality in all my free moments. "I'll never see Japan," I sulk. "I might as well still be in graduate school."

I leave the class building and look for the new polished car I expect a Japanese professor to drive. Dr. Kinjo can be jocular but I know he is no buffoon. He is highly respected at his university. He is consulted by the prefectural governor. He is an advisor to the American consul general. Perhaps he has a chauffeur.

My eye is attracted to frantic motion inside a ten-year-old subcompact. It is Dr. Kinjo. With him, is his wife.

Mrs. Kinjo is a tiny woman, under five feet tall, with a strict graceful carriage and a dignified elegance. She is a teacher of gentle firmness. "Perhaps Richard-san did not read the homework?" she asks with delicate knowing when a student stumbles in recitation. Richard-san—large and blustering—pauses, blushes, and meekly nods. The next day he will be prepared. Like all her students, I respect Mrs. Kinjo. I bask in the warmth of her rich rippling laughter; I suffer under her disappointment. Like all her students, I do my best. This evening, however, I am surprised to see her. She is an independent soul. Why would she accompany her husband to a routine research meeting?

"Climb in, climb in," the Kinjos gaily call. "Let us go and eat some sushi."

We speed toward the prefectural capital. A red light, reading EMPTY, glows insistently from the dashboard. Floral fragrances, coral dust, and spectacular drop-away vistas of the sea flood the open window.

As he careens through narrow city streets—jammed with cars and mopeds, with miniature cement mixers and dump trucks in the unlikely colors of pink and violet—and zips through shortcuts, which send me sliding across the backseat, Dr. Kinjo tells a story. When he and Mrs. Kinjo were nineteen, they decided to get married. Tuition and books were paid through scholarships, but they could not afford even the smallest of apartments. Dr. Kinjo searched in vain for work.

"Do not worry," he told his bride. "Things will work out."

One day, he saw an advertisement: Wanted, Japanese gardener.

Dr. Kinjo knew nothing about gardening. But he suspected he was the only male Japanese in the state of Indiana.

"I will apply for this job," he said.

"You must not misrepresent yourself," said his wife.

"Everything will work out," was his reply. "I have a feeling."

Everything did work out. Dr. Kinjo became the gardener. Mrs. Kinjo helped in the house. They were provided with a salary and with a place to stay. The first week went well. Dr. Kinjo was a wizard at raking. He had a knack for watering and a positive genius for plucking withered blooms. One morning, in the second week, he looked up from his weeding to see his employer. She was strolling along the garden path. She was smiling and humming a pretty tune. In her hands were pruning shears.

"Isn't this a lovely day?" she called to him.

"Yes, indeed," he replied. He watched the shears with wariness, the way another man might watch a snake.

"I've always wanted to learn how you shape a tree," her voice rang with gaiety.

Young Dr. Kinjo, he was not *Dr.* Kinjo then, felt his throat tighten. It was the moment he had dreaded. He studied a tree. He studied a limb. He took a deep breath. Then, in a mad rush, he seized the shears and began a wanton pruning.

"What are you doing?" his employer's voice rose in alarm.

He tried to be nonchalant. "Did you want a traditional shape?" he asked with careful innocence. "My training was in abstract expressionist gardening."

Thirty years later, Mrs. Kinjo interrupts the tale. "We stayed for two years," she says. "When we left for graduate school, our employer took me aside. 'I will miss you both,' she said, 'but one thing is for certain. I am very glad I no longer need pretend that your husband knows anything about gardening.' Thirty years later, in a car hurtling toward Naha, Mrs. Kinjo gives her husband a fond look and laughs to the point of tears.

* * *

The Kinjos take me to the old pleasure district, to a sushi bar near the port where—once, in another century—Commodore Matthew Perry landed. Nearby stands the Teahouse of the August Moon. In the days of Perry, the daughters of poor families were sold as geisha to such teahouses. There the girls learned traditional arts and delicate manners. They learned the skill of eating so daintily that their pretty, pursed lips touched neither morsel nor moisture. Men found it fascinating to watch.

The girls were indentured servants whose debts included not only the modest sum paid to their parents but also the high costs of silk kimono, handmade wigs, and, of course, the endless lessons. A few girls—the very clever, the exceptionally pretty—found a wealthy patron to purchase their contract. But most never left.

The Japanese love poignancy and the geisha is its personification. Behind her ravishing gaiety is the sadness of a dutiful child whispering memorized double entendres. Knowing this, knowing that profits lie in the proffering of exquisite misfortune, the teahouses staged an annual parade.

Once a year, when the cherry blossoms had begun to fade—so evocative of a geisha's fate—shakuhachi and shamisen would plaintively pierce the air. Long phantom lines of geisha—rendered anonymous by their uniform exoticness—would measuredly move through classic dances of sorrow and supplication.

It was the only time when common folk could hope to gaze on a geisha; and the geisha's grieving, guilt-ridden parents would press to see. They would stand, jostled by merchants and craftsmen, children and dogs, and would breathe with a collective gasp of awe. Is that she? How beautiful she has become. Almost unrecognizable, so subdued, so distant. But see how her head bends. Is it unhappiness? No, no. Amidst such luxury, amidst such discipline, it must be modesty, the weight of honor, that makes her bow so low.

And the girls, moving in unison through their drama *would* feel a stir of pride, would feel the crowd fall silent. The girls, searching

from beneath their eyelashes for a glimpse of Mother, would feel the nobility in their karma.

Today, the diminished Teahouse of the August Moon receives an occasional tourist. Today, the anniversary of the geisha parade is still observed with traditional dance. But the grand teahouses have vanished. In their place are modern luxury hotels catering to ubiquitous All-Nippon-Airlines tours of honeymooners and office girls.

The block-long white-marbled hotels loom monstrously over alleyways crowded with modest restaurants, with beauty shops and wedding photographers, with pachinko halls and tiny bars—purchased with the careful savings of middle-aged former bar hostesses—whose seating capacity is seven.

And because this is the oldest section of the city, here and there, unexpectedly, are found the temples of Naha. Pockets of mystery and stillness, resonating with the sounding of gongs, with the scent of aging wood, with the glimmer of golden lotus leaves.

In the dusk, as I step from the Kinjos' car, I smell sea salt and incense, and the aroma of tempura frying. I hear religious chanting, and ribald laughter, and the soundings of lonely ships.

"*Irasshaimase!*" cries the sushi maker. We brush aside the cloth door banners and are enveloped in comfort. Toward me rush warmth, the flushed faces of sake drinkers, the childhood smell of sticky, steamed white rice.

The sushi maker is deft and cordial. The hachimaki binding his gleaming forehead is no ordinary sweatband. It is worn by Japanese men at kendo matches, at college exams, at any endeavor that matters. Effort, discipline, courage! it exhorts its wearer. After a few rounds, Dr. Kinjo has the sushi maker guess my age.

"Twenty-two?" The response is wary. Guessing a woman's age is always a risky business.

"Thank you for the kindness you have shown!" I cry with a

deep bow of deference. I am rewarded with laughter, but Dr. Kinjo has a message to impart.

"She is university professor from Boston," he confides with a gesture toward me.

"Ahhhhh," offers the sushi maker, uncertain of the response expected.

"In America," says Dr. Kinjo, "the young daughter of immigrant parents can hope for such a thing."

"Most impressive family," the sushi maker nods emphatically.

Dr. Kinjo shakes his head in mild annoyance. We have missed the point. "It is this willingness," he explains, "the willingness to allow the unexpected, that is *America's* greatness."

Then, as if to test my pluck, he orders a special dish. From the kitchen comes the huge, bug-eyed, decapitated head of a fish. It covers an entire serving platter. Dr. Kinjo watches me slyly. "The best meat is below the eye," he says. "Deep, in the cheek socket." I raise my chopsticks and gouge.

After dinner, the Kinjos take me sightseeing. They drive me through downtown Naha and into the hills. They show me the university and the new international relations institute. Periodically, Mrs. Kinjo urgently whispers into her husband's ear. She has noticed the empty fuel gauge. Dr. Kinjo shrugs with nonchalance.

They take me to their house, a modest two-bedroom ranch. Can houses in Okinawa be described as ranch? Built with pale concrete—everything in Okinawa is built from pastel painted concrete to ward off the heat of the sun and the fury of typhoons—with orange tiled roofs and climbing bougainvillea, Okinawan houses have almost a Mediterranean feel.

We remove our shoes and enter. The house is designed and furnished Western-style, with one room reserved for traditional tatami mats. We drink tea. Then, finally, Dr. Kinjo begins to speak of research. Twenty books on culture and marginality are stacked upon the coffee table.

.

"Are you familiar with any of these works?" he asks.

"A few," I say. "Some I have read; some are titles I have searched for but have never found."

"Which ones have you read?" questions Dr. Kinjo. He removes the books I indicate. "Why don't you take the rest home and read them at your leisure?"

"Are you sure?" I hate to borrow so many valuable books.

"They may provide you with ideas for research," replies Dr. Kinjo. "And now, I think we had better be driving you home." He pauses and smiles. "My wife has noticed that my car is low on fuel. Perhaps, you also have observed? And so, we will be driving you home in hers." We climb into another ten-year-old subcompact and start upon our way.

Although the final blow occurs on base, the breakdown begins about three miles south of Kadena. It starts with some steam escaping from beneath the hood of the car.

"Why don't we drive to a service station?" I ask. "If it needs work, we can take taxis home." My suggestion is not altogether innocent. I have an ulterior motive. I love Japanese service stations, where a smartly uniformed team of six leaps upon your automobile with lean and limber grace—like a pit crew at the Grand Prix—then rushes out to the street and stops traffic—all for your exiting ease—and ultimately, with an exultant shout of appreciation, bows to your departing vehicle—sharp and snappy as a chorus line.

The Kinjos are uninterested in such a detour. "Nonsense, nonsense," murmurs Mrs. Kinjo. "It is nothing. It happens every day."

We reach the base, but in front of the officers' club the car wheezes to a stop. It will not restart. Dr. Kinjo pushes it off the road, opens the hood, and disappears behind a hissing veil of smoke.

"Be careful," I cry. "It may explode."

"Do not worry, Lydia-san," soothes Mrs. Kinjo. "The automobile

has a small leak. Each day, I add water. Other than that, every-thing is fine."

"Perhaps you can get some water," suggests Dr. Kinjo. "I am not authorized to use the base's facilities."

"Of course, of course." I rush toward the officers' club.

The club is surrounded by carefully landscaped palm trees. The interior is ornate and windowless. Built to provide security, to pro-vide a reassuring sense of American overabundance as well as safe-ty from typhoons and air raids, the officers' club is like Las Vegas in a bunker.

Sunday, midnight, only the bar is open. Stale cigarette smoke hangs in the air. A woman stands in shadows, feeding quarters into a slot machine. Clunk, whirrrr, clunk, whirrrr. It is a lonely sound. "Hey, baby," slurs the lone patron at the bar. "Come and join me."

"No thank you..." I explain my predicament, but it is needless politeness. The patron is carefully frowning into his empty glass, as if searching for a contact lens, for something of value that has been lost. Already, he has forgotten me. Wordlessly, the bartender fills an aluminum pitcher with ice water.

Walking carefully, so as not to spill, I leave the club and approach the Kinjos. The ice clinks congenially. I sound like a waitress bringing margaritas on a summer's eve.

We stand by the automobile. We count twenty minutes. Then we carefully pour the water into an orifice somewhere on the engine's body.

KAPOW! Liquid pours onto the ground beneath the car.

"You run along home now," lightly say the Kinjos.

"Wait here, I will call a taxi for you." I tear my gaze from the seeping stain and start to move.

"No need. We will see you tomorrow in class."

"Please wait." I grab my stack of books and break into a run. "I will be right back."

I run to my quarters. It takes some time to locate the number for Base Taxi.

"Sorry," says Base Taxi. "Can't help. Go to the gate, then catch an off-base taxi."

"But the gate is a mile away!"

"Take us to the gate and switch taxis."

I sprint out the door and back to the officers' club. When I arrive, the Kinjos are nowhere in sight. I wander out to the road that leads to the gate.

There, in the distance, I can see them. They are moving at a sprightly pace. They will be at the gate before Base Taxi comes. I stand in the moonlight and watch them.

This is how they move through life, I realize, cheerful, generous, and undaunted.

I walk back to the club and cancel the cab. I walk home. Before I go to bed, I thumb through one of the books I have borrowed. Then, I go through them all. Inscribed in the flyleaf of each book is my name, the date, and their signatures.

The Speech Contest

 Having sprung fully formed from the pit of a peach, Momotaro was a precocious lad. Instinctively, he understood the warrior code. And so with nary a lesson from his woodcutter father save the decent example he provided, Momotaro met his destiny.

I suspect this is why Momotaro was my favorite tale. For him, enlightenment was so easy. In my mother's other stories—historical epics of samurai families—the young lord spends a lifetime studying with sages, demonstrating discipline, pondering about the shadowy places in his own heart and ambitions. This did not sound like my path.

Perhaps this is why, for me, my mother always returned to Momotaro. She knew my nature. My sister, practical and persistent, more certain of who she is, less given to grandiosity, could find meaning in the epic tales. But I, long on dreams and short on patience, grew distracted. Okaa-chan would sigh and turn again to the fantastic fable. Hoping that my life, if not deepened through diligence, would be like Momotaro's, be graced with easy friendship and blessed with incredible good luck.

And surprisingly, for the most part it has been so. Friendly, idiosyncratic folk seem always to appear—in airports and classrooms, in taxi cabs and travel agencies. And their simple shining decency has illuminated my way.

Early one Saturday, my telephone rings. "I have been asked to judge a speech contest," says Dr. Kinjo. "Would you like to attend?"

The contest's purpose is to recognize and reward foreigners for their efforts to learn Japanese. Two of my friends will be entrants. Mrs. Kinjo will serve as my interpreter. It is a major, annual, televised affair. "Sounds like fun," I reply.

The contest is held in a sky-top ballroom. Floor-to-ceiling windows create one wall. From them stretch an endless view: the city of Naha, the harbor at work, the blue of the East China Sea. Sunlight strikes the crystal chandelier and dazzles the capacity crowd.

The first contestant is the fifteen-year-old son of a marine family. He is a skinny earnest child wearing a necktie sized for a man. The boy's topic is sugar caning. In Okinawa, harvesting must hap-

pen at one critical moment. If not, the crop is lost. Each season, farmers issue an urgent call. Last season, the boy had responded.

"I was treated like a man," he declares in wobbly Japanese. "I was granted no privileges. This was not a cultural exchange. Livelihoods stood at risk. And when at last the crop was in, the family head took me aside. 'You are my son,' he said in English. I could tell he had practiced the words."

The boy's speech is sincere and clumsy. It is a speech of great feeling and little fluency. I wait for the judgment.

In America when there is a contest, we develop standards of objective excellence. We devise secret ballots and some means of tie-breaking so that the one performance that most closely approximates these absolute criteria is fairly rewarded. In America, the sugar cane boy would be an "also-ran."

But in Japan, judges discuss and lobby. Eventually, they reach consensus. In Japan the sugar cane boy almost is dismissed until, that is, one judge argues the Case of Heart. The boy, the judge explains, displays the type of heart that the contest means to honor. Twice the boy has proven himself willing to brave an unfamiliar setting, to attempt an untried challenge, to risk a public failure, and why? All to participate in the world of another. For this, the boy receives a special prize.

The speech competition takes hours. I suspect no entrant has been denied. Toward the close, I grow weary and leave to take a walk. Dusk is gathering when finally we start for home.

"In a way, these contests are a shallow thing," Dr. Kinjo muses. "In part they flourish for the shallow fun of hearing Japanese come forth from foreign faces. But always, something else occurs. The speakers have studied long and hard. They come, one by one, to the podium and they bring with them a dignity. Each comes with a separate story, a personal story. No one ever has stood there reciting ancient Japanese, court poetry. From a dozen countries they

come, each with their own tale to tell, their own argument to present, their own question to pose."

"It starts as speech production, as funny sounds from funny faces, and ends as communication," says Mrs. Kinjo. "The Japanese come to see Gaijin and in the end we realize there is no Gaijin, no one thing called foreigner." She pauses a moment in thought. "I suppose it is for this reason that I am a language teacher."

We leave the tangle of Naha, slipping through shortcuts, twisting toward the hillcrests. Through blossom-laden hibiscus, through giant crown-of-thorn and poinsettia ten feet tall, I catch glimpses of the sea and sky. As always, I am astonished. Yesterday, weak with fever, I huddled over a steaming tea cup in my Boston kitchen; I fretted over my tiny windowsill garden; I watched my goldfish turn in his bowl. Now, magically, that world has grown and engulfed me; the flora have turned to trees. As the sun dies, my pet—transformed into a mighty school of ocean carp—leaps in little licks of orange light and sets the sea aflame.

Mrs. Kinjo breaks into my thoughts. "While you were gone, Lydia-chan," she murmurs reflectively, "a young enlisted man took the stage." She trails off, like a sleeptalker succumbing to dream.

"What did he say?" I inquire. But Mrs. Kinjo is too deep in her thoughts.

"He spoke of his first days in Okinawa," replies Dr. Kinjo. "He told us how a man can feel when suddenly he is out of place, how a military fence can mark the boundaries of his world and how hard it is to leave that world."

Dr. Kinjo pauses in his telling. "It was the season of typhoon when finally he left the base. The young man caught a bus and went to a northern town. Rain streaked the windows, and in the grayness, orange roof tiles flashed like the autumn leaves of home. The young G.I. had shown the driver a letter of instructions.

When the bus stopped and the driver nodded, the young G.I. stepped down."

"And?"

"And he saw a tiny bent old woman," says Dr. Kinjo. "She stood in the rain, searching the faces of all who disembarked. Her arms were laden with packages."

"It was his grandmother," Mrs. Kinjo continues. "The young man's father had been a black American soldier. His mother was Okinawan. All his life, they had lived in black communities, never discussing the lost world of his mother. Then, one day, he stepped from a bus and saw an old woman. And although she was holding an umbrella, her back was soaked with rain. For it was her gifts that she meant to protect—ungainly parcels filled with all her best intentions."

"And so it came to be that he spoke to us today," concludes Dr. Kinjo. "His grandmother was in the audience."

We drive a while in silence. I think about my grandmothers. One challenging her husband—offering to work the railroads like a man—so that her son can leave for college. The other reading from an encyclopedia—busily filling her children with possibilities—before she is sent away. I too have come to this place because of their best intentions.

Ghosts

 It was in Okinawa where I first began to feel the presence of ghosts. Oh, maybe not *ghosts* per se, not the white diaphanous things that rise from graveyards in a Halloween's tale. But it was in Okinawa that I first began to believe in things I could not see.

Sometimes, in different places at different times, different spirits, different *moods* if you will, tugged insistently at my awareness. A sense of sorrow here, of gentleness there, of confusion, or tranquility, or vengeance would rise and assume a felt form and a known weight. It was not a scary thing. It was a familiar dimension of daily life.

I lived amidst ancient souls: of people and events, of storms and trees, of lost buttons and broken sewing needles. I would walk into a coral cave and find a wartime agony still cowering. I would enter an old wooden house and be warmed by the faithful glow of generations of household appliances. In Okinawa, the supernatural became a familiar presence, like a stout uncle dozing over the evening papers after a heavy meal.

Perhaps I am overly fanciful. I have been accused of owning a preindustrial mind. To me, it is a mysterious thing that bridges do not crumble atop their spindly legs of steel. To the mathematical formulations that undergird such structures, I grant only my grudg-

ing trust. It is far easier for me to believe that a gentle prayer, written and fastened to the branch of a tree, will find its way to heaven.

I am not a religious person. For my father, religion was a practical matter: a need to be educated more than a need to believe.

"Since you live in a Judeo-Christian society," he said when I was six years old, "you will need to understand the assumptions within that society."

"Yes, Daddy," said I.

My father studied the religious choices available to my sister and me. He made the selection of Judaism.

"The family is important to American Jews," I heard him tell my mother, "as is the tradition of education. These beliefs are shared by Japanese Americans."

But although there were advantages of cultural congruency, the deciding factor was practical.

"Besides," said Father as he shifted his gaze to Misa and me, "the Jewish Community Center has a pool. The girls will learn to swim."

When my father shared his decision with his Gentile colleagues, they dissuaded him; and eventually, my sister and I went to Methodist Sunday school. The church was within walking distance from our home.

I was disappointed. The AME Zion Church had been my choice. It too was close to where we lived; its back lot adjoining ours. If proximity was to be the test, surely it fit the bill.

I loved the AME Zion Church. Each Sunday the sounds of the gospel choir would wash across our yard. Rich, soaring voices knowing both joy and pain. Voices that could wrap each note in such transcendent faith, in such perfect reverence, that the purity touched me clear to the bone. "Through many dangers, toils and snares, I have already come. Tis grace that's brought me safe this far. And grace will lead me home." To me, it was the song of angels.

* * *

When I was in Japan and beginning to feel the nudging of things metaphysical, I asked Dr. Kinjo if I could attend his course on Japanese religion. Besides much scholarly reading, the course included field trips to Zen masters, ecstatic healers, and other ascetic beings. During these field trips, some in the class reported sightings of auras and waves of light shooting forth from holy fingertips. I saw nothing. It was fascinating, but I found no answers, no formal faith to embrace. Somehow, I was relieved.

Dr. Kinjo and I were interested in character: cross-cultural, national, individual. Distilling such an interest into a researchable topic was a long process of glorious grieving. It was an exultant, ongoing wake, in which all the ideas we could not pursue were lovingly examined before they were laid to rest.

Once, I dabbled with ideas of grandiose projects.

"Wouldn't it be interesting," I mused, "to gather people's stories? Maybe to videotape them as they recalled some key historical event that had shaped their lives? Collectively, it could illuminate the consequences of history."

"What do you mean?" Dr. Kinjo looked at me strangely.

"Well, for example, the American wartime Relocation. The survivors are all aging. Soon their stories will be lost. Or, in Japan, what was the Battle of Okinawa like for real people? Most of us depersonalize history. We cannot learn its lessons because it does not seem to have occurred to real people, to people we can care about and suffer with..." I was swept away by the boldness of my vision.

"Perhaps that is one of the purposes of art," gently interrupted Dr. Kinjo, "to teach without exploiting."

"Exploiting?"

"A videotape? Of individual people? As they relive the horrors that they knew?"

I flushed.

"My father was an engineer in Taiwan," said Dr. Kinjo. "During

the war, I did not live in Okinawa, but my wife did. The war is the only subject that is taboo in our marriage. Once, when our boys were in high school, they casually asked her what it was like. 'Tell us about the Battle of Okinawa, Mom,' they said. 'What was it like for you?' My wife grew still and remote. It is the only time I have ever seen her act with coolness toward her sons."

We sat in silence. Then, Dr. Kinjo spoke.

"My wife lost both her parents. Still in early elementary school, she took her brother and sister by their hands and walked through the battle. She walked and walked, toward the north, toward the mountains where she thought they might be safe."

Dr. Kinjo paused, then gently shook his head. "I cannot imagine what she saw."

When I lived in Boston, I did not like my job. Such a small disappointment, really, but the bitterness made me twisted and shorn. Like a tree that is hit by lightning, I darkened and shrank.

I am not a person of great or specific faith, but I thought of Mrs. Kinjo, of her transcendence and goodness and warmth; and somehow I understood. The lessons I had learned in the backyard of the AME Zion Church came home to me at last. Somewhere, there is a force called Grace.

Lessons

 I was lecturing on Darwin's theory of evolution. From there, I intended to launch an exploration into adaptive behavior and theories of motivation. It was the season of the monsoon. Rain hammered on the tin roof of our tiny Quonset hut classroom and rumbled in roadside ditches. It was 10 P.M. In a remote corner of an obscure marine camp, in the depths of a sub-tropical jungle, ours were the only lights.

I paused to see if my students were following and heard only the rain and the scratching of pens. In the wilting heat, sixteen polite, conscientious marines bent their heads in industry: twelve men and four women dressed in camouflage, who had been on duty and working for the past fifteen hours. They took my class seriously and they took my class for pleasure. It was one glad step toward the dream of a college degree.

"What do you think of the theory?" I asked. "Have you heard of it before?" Many had come from strict Christian communities where such teachings were forbidden.

Seven or eight students nodded their heads. "We learned it in high school," said one.

"Any questions or comments?"

"Yes, ma'am." A gangling redhead, in his early twenties, was flipping through his textbook. "I was reading where they were

talking about our appendixes getting useless and about us losing our little toes." He located the page he wanted. "On page two-sixty-one." He rubbed his large knuckles down the page to secure his place.

There was a collective rustling as textbooks opened to page two-sixty-one.

"Ah, yes, the text uses these as examples of evolutionary processes in the human species," I said. I summarized the page.

The redhead still seemed troubled. "Yes, ma'am," he said, "but I was just sort of wondering. . . " He stared at the blunt black tips of his polished field boots. "I mean, with our little toes, ma'am." He paused and looked at me in earnestness. "Will they just sort of pull in?" He curled his right hand into a claw to demonstrate a retracting process. "Or will they kind of . . . er . . . will they just fall off?"

I read the worry in his face. I saw it mirrored in a half dozen of his classmates. I gently explained the slowness of evolution, how these things would not occur within our lifetimes or even within a span of hundreds of years. The class relaxed.

"Any other questions or comments?"

"You certainly do learn some interesting things in college," said a young woman marine. She patted her textbook with satisfaction.

I also was learning. For the first time, I really liked my students. In Boston, I had liked them all right, but I also had been afraid of them. I was concerned about how I would look if I saw myself through their eyes.

In Japan, I was like a circuit preacher. I drove from base to base, dispensing psychological information to populations hungry for my words. It was a role I found somewhat disconcerting. But I had no need for worry. The students were not gullible. They were as endlessly questioning as they were unfailingly polite. And, in every classroom, the students were very different.

There were the Special Forces at Torii Station: solitary, brilliant, intense. Their specialty was espionage. Gifted with the abili-

ty to learn five or six languages in a matter of months, they were assigned with monitoring radio signals, with electronic surveillance of the skies. Attentive to the inobvious, the Special Forces would come to class having read not only the textbook but having researched all the references as well. Independently—just to keep their minds occupied—they would conduct quantitative inquiries—teaching themselves statistics along the way—the designs of which were worthy of doctoral students.

There were the young mothers in my lunchtime classes: committed, curious, and tired. Balancing family, school, and their military careers, these women were fascinated with topics of infant development and research on deprivation of sleep.

I puttered up and down the island in my rust-eaten, primer-paint green car, with the broken air conditioning and the steering wheel on the right, that I had purchased sixth-hand for a sum of three hundred dollars. And somewhere between Camp Hansen and Foster Naval Hospital, somewhere between my morning seminar and my late night lecture, I forgot to worry about whether or not I was liked.

It is no accident that I am a psychologist. All of my life I have wondered: Who am I? But as I lived in Japan, my anxiety eased. I was a Japanese American, teaching cross-cultural psychology, on American bases in the midst of Japan, and the sheer intellectual tidiness of my situation pleased me. I saw my presence as a perfect case of goodness of fit, as a meeting of yin and yang.

And gradually my gaze turned outward. Like a toddler who finds first her footing, and then cannot be contained, I fell in love with the world beyond. When the university asked me to teach in China, I accepted in a flash.

V.

China

Introductions

The University of Maryland was sending me to China. I was to teach American language and culture. I had spent a harried day: rising in an eighty-degree dawn; hurrying past pollen-laden fields to the airport; transferring at Hong Kong to a flight for Guangzhou. It was on this final flight that I began to relax. As a tourist, I had visited China before. I looked forward to my return.

The problems began when I ceased to be tense and planful. It was when I started to relax and to exist in the moment that the moment fell to disarray. Perhaps, with my slight knowledge of Chinese history, I should have foreseen it. Perhaps I should have known that small disruptions in a tourist's convenience can belie or portend profound disruptions in a country's psyche—the way a sudden shrilling of birds and insects, following a pregnant lull, can signal molten convolutions within a volcano's core. Later, like the Chinese, I would be more attuned to multiple meanings within the most mundane of moments. But now I was a tourist concerned with tourist things.

"You're going to love China," I said to Bob Stone, who also would be teaching in China, "The ceremonial welcomes, the magnificent banquets, the sheer *differentness* of it all." I prattled on and on. A computer scientist, Bob was inclined to hold his opinions in

reserve, but by the time we landed, he too was eager and optimistic.

No one met us at the airport. We searched a sea of printed placards for our names. We stood with our suitcases by a broken floor fan and watched as, one by one, assorted foreigners were claimed by Chinese welcoming committees. No one came forward in hearty comradeship to greet us.

The building was a deliberately graceless structure, effective at capturing and amplifying heat in the summer and at allowing the steady circulation of cooling wind during the winter. The waiting room was huge and echoing. It reminded me of a visitors' room in a federal penitentiary. No carpeting covered the floors; no travel posters adorned the walls. Unmatched pieces of furniture—here, a heavy wooden table, there, a bench or a plastic molded chair— seemed to have been dragged in and randomly abandoned. Heavily used spittoons dotted the scene.

"Perhaps there is a message," said Bob. He left me with the suitcases and scouted for an information counter. There was no information counter. A sullen young woman selling last-minute friendship items from behind a makeshift booth made it very clear: no one had come for us; no one had called for us; and, in her opinion, there was no reason why anyone ever should.

"Let us try the tourist hotels," I said. "Perhaps we have a reservation and a message." The heat was oppressive. The floor was littered. The friendship vendor was scornful. I longed to escape to the air-conditioned, overdecorated, and underpopulated sanctuary of the White Swan Hotel.

The White Swan is a massive foreigners-only retreat. Recently opened, built with international venture capital, it is located on the Shamian Island in the midst of the Pearl River. In a city of gray concrete, of small straggly trees dying from air pollution, the hotel is dazzling white. In addition, it is decorated with a kind of

excessive purity—with a huge interior waterfall simulating natural simplicity, with overwhelming displays of decorative understatement—as if Rococo had merged with Bauhaus.

At the White Swan Hotel there were neither reservations nor messages, but we drank some water and changed some money. Rehydrated, and heartened by the money in our pockets, we set off for the American consulate, which we were told is located in the Dong Fang Hotel. We had been invited by the Chinese government; perhaps the United States government could investigate in our behalf.

The Dong Fang reminded me of Grand Central Station. It is an older hotel whose once elegant lobby now is choked with transient traffic. Visitors from Hong Kong favor the Dong Fang, and, I suspect, therein lies the secret to its crowds. To protect foreigners from "bad elements" and her own citizens from envy, China has banned Chinese from entering tourist hotels. However, it would be rude to demand, with every coming and going, that guests from Hong Kong display their citizenship. Additionally, it is relatively simple to pose as an overseas Chinese. Hence, the Dong Fang has become a cultural amnesty zone.

The public spaces of the Dong Fang are intimidatingly vast. Indeed, the hotel is so large that the skytop suites each have their own private garden. Negotiating the hotel was not easy, and the consulate, *our* consulate, turned out to be virtually unapproachable: buffered from communism by heavy doors and several insulating layers of secured glass-walled corridors—the better, I suppose, to anticipate the approach of undesirables. We were denied access. However, after we pleaded extensively through a crackling intercom, an American woman came to meet us on Chinese ground. She listened to the opening lines of our tale of woe, then curtly interrupted. "This is not our affair," she said. "I suggest you make your own arrangements and proceed to your assignment." Briskly turning, she clicked away on high-heeled shoes.

Fortunately, Bob thrived on the solving of problems. Undaunt-

ed, he found our way back to the lobby and asked for directions to the nearest office of the China International Travel Service.

"Very lucky, CITS is in the Dong Fang Hotel," said the desk clerk. "Second floor, no problem."

It took some time to locate. Actually, there are two Dong Fang Hotels, the old and new, with no interior means of traversal. Additionally, the second floor of one of these hotels is an endless arcade choked with every electronic game imaginable and teaming with glassy-eyed late-adolescent males who shuffle through this dinging, whirring, light-flashing orgy of Western decadence like the inhabitants of some postmodern hell.

Eventually we found ourselves at the end of a long empty corridor. A CITS representative sat behind a tiny wooden desk. She peered at us in the dim light and listened to our problem. From deep in her throat came sounds of soothing sympathy. "I cannot help you," she clucked. "Go to CAAC, the China Airline office. It is not far. Around industrial park, next to train station." She smiled and waved us on our way.

The industrial park was a mammoth compound across from the hotel. It was enclosed by a high fence from which loomed innumerable billboards depicting smiling, ruddy-cheeked families of three excitedly pointing and rushing toward large pieces of industrial machinery. Around this island of future prosperity, swerved a dozen lanes of traffic.

It is my suspicion that the Chinese road system is the product of foreign advisors who diligently taught the importance of road marking—paint double lines down the center, paint dotted lines and arrows—while forgetting to explain the meaning of these markings. In every major city, astonishing snarls—of bell-ringing bicycles, speeding, honking trucks, tourist buses and taxis, lumbering carts and large domesticated hoofed animals—compete for every possible inch of the roadway. And in the midst of this chaos, on a round, canopied podium, stands an immaculate man in a

crisp white uniform with red epaulets and a visored cap. The man, who seems to be totally disregarded, waves his arms smartly, as if conducting a Sousa march from a town-square gazebo on an Iowa summer's eve.

After a death-defying crossing of the roadway and a long trek around the industrial park, we found ourselves in an airless, second-story office. There was no furniture. People tangled in a mass and thronged two tiny ticket windows. There was no shouting and little shoving. Only an anxious steady squirming as people pressed to insinuate themselves into the queue. After one hour, we found ourselves at a window. It was the wrong window. First we needed to procure application forms from the other window. We retreated—forced back to the entry by a sort of peristaltic action—and began the process anew. When we reached the application window, we learned that they were out of forms.

I was scrabbling on the floor, trying to rescue trampled blank forms, when I heard the magic words: "Foreign Friends." Quickly, we were transported to the front of the line. English application forms appeared. We paid two hundred and forty yuan—noting that ticket prices had risen as rapidly as our status—and received two tickets for the next day's flight.

It was early evening as we walked back to the Dong Fang Hotel. Pedestrians flooded the sidewalks. Couples dressed in drab uniformity carried plump, pink-cheeked infants clad in hand-embroidered rompers. The hot air was filled with dust and the shrieking traffic. Bob stopped. He bought an ice cream bar and some haw juice from a street vendor of dubious hygiene. He took a deep breath of the ghastly air and looked around in beaming satisfaction. "You were right," he said. "I really like this country."

"Doc tor Mean na toy a, Mee stair stow na."

We had just checked into the Old Dong Fang Hotel when we heard the strangest sound. A high, harried voice was singing our

names. We looked around. Fifteen feet away, along the reception counter, a small portly man was wrestling with a desk clerk for control over the guest register.

"We are Stone and Minatoya." We rushed over and introduced ourselves.

For a startled second, the man stared at us. Seeing his advantage, the clerk seized the register and hid it beneath the counter.

"Most naughty, most naughty. I have been worried so!" Like the relieved parent of delinquent children, the singing man fell into a scold. "You did not telephone from Hong Kong. You did not say which plane to meet. Am I to meet each flight, each day, each week? Think of my duties. And if you had not been found... ahhhh ... think of the embarrassment!"

"But we sent our flight information to our campus liaison," we cried defensively. "No one said we were to telephone Guangzhou."

"Of course they did," snapped the distraught man. "A simple telephone call. Ohhhh. Why did you forget?" He stared at us with reproach.

"There must have been a confusion," I stammered. "We are sorry for your worry."

The man continued to fret.

"And you are?" I prompted.

"I am Mr. Soo. I am an engineer from the Bureau of Civil Aeronautics." He was polite, but we had not yet won his trust. "I do not understand this confusion," he said. "All was explained in your letter of instruction."

"Perhaps it was lost in the mail," I said with deliberate guile.

Mr. Soo looked at me with suspicion. Then he relented. "The Japanese," he said, "so modern and yet important letters in their post...."

Having allowed the assignment of blame to fall beyond our circle, he gathered himself together and beamed in official welcome.

"Because you will teach at one of our finest aeronautical universities," pronounced Mr. Soo, "the Bureau of Civil Aeronautics has

arranged for your flights." He rummaged through a black plastic briefcase and presented us with two tickets.

"We already have purchased these." Bob withdrew our tickets.

"You *bought* those?" whispered Mr. Soo. He blanched with horror.

"Why, yes, we went over to CAAC—it was not easy to find by the way—and filled out the forms." Bob was happy to share our tale of resourcefulness.

"You paid *money?*"

"Two hundred and forty yuan."

"Oh, dear. Oh, dear," moaned poor Mr. Soo, for by now I had begun to think of him as poor Mr. Soo. "Why did you not telephone from Hong Kong? Why did you not wait at the airport? Eventually, the police would have found you."

Through the misfortune of English fluency, poor Mr. Soo had been given an assignment that was bringing him to the brink of professional ruin.

Bob and I shared a glance of guilty complicity. We had introduced money into an interdepartmental arrangement of complimentary ticketing. To refund and reissue would be a major diplomatic headache.

"And your rooms?" Mr. Soo manfully braced himself to face the enormity of the damage. "How much will they cost?"

Hours later, after considerable consultation with innumerable off-duty officials, a solution was crafted. Bob and I would pay for our rooms; Civil Aeronautics would provide a partial reimbursement for our flight. It was unfortunate that we had ignored our letters of instruction. Apparently, the Japanese postal service had been vindicated.

Tea and Oranges

In our host province, we were met by university vice president Dr. Zhu, English language interpreter Ms. Zhang, and university chauffeur Mr. Xu. Responsibility for our safety and convenience was transferred into their hands. I am certain that, back in Guangzhou, Mr. Soo felt only relief.

"You will be staying within the city gates," beamed Dr. Zhu, "at the Renmin People's Hotel."

We parked along the circular drive. Built in another era and with the assistance of Soviet advisors, the Renmin Hotel loomed in the gargantuan style of people's public buildings: massive and severe. We crept up the stairs and entered the lobby. The floors gleamed glossily and emitted a faint odor of disinfectant. The ceilings soared. The corridors were long, dim, and echoing. Everything seemed old and yet strangely unused. I was reminded of the locked back wards of Mattewan State Hospital for the Criminally Insane.

Our rooms were on the fourth floor.

"We can take the stairs," said Bob, but our hosts were insistent. As we crowded into a wheezing, jerking elevator, I saw Mr. Xu's eyes glitter with excitement. Then, it struck me. My hosts were as enthralled by the opulence of the hotel as I was by its austerity.

Each room was equipped with twin beds, a fifteen-inch Japanese color television set, a claw-footed bathtub, a toilet that flushed with a roar, a cork-topped thermos bottle of boiled water, and one pair of plastic bedroom slippers.

In my room, Ms. Zhang grinned happily and bounced on the center of one bed. "Wheee," she said like a child. As she admiringly stroked the worn chenille bedspread I noticed a small pile of pellets on the pillow. This was my introduction to my nocturnal mouse. Each morning thereafter I would find a tidy grouping of mouse droppings on the twin bed next to mine.

After we had explored the cavernous dining room, where my hosts whispered as if in a cathedral, and, once more, had ridden the wheezing elevator, Dr. Zhu snapped to sudden seriousness. "We must go," he said. "Your students are waiting."

We drove through the university gate—two brick columns spanned by an ornate metal bridge, auspiciously adorned by a score of small red flags and two large dangling red paper lanterns—and stopped at an imposing granite building. We rushed upstairs to an immense lounge. Massive armchairs and mammoth couches, covered with white linen doilies, stood in a dozen identical groupings.

"Please sit," said Dr. Zhu. "We will introduce your classroom monitors."

"Some tea?" said Ms. Zhang. She poured a boiling liquid into huge porcelain cups and handed them to us.

"Thank you." We took the cups, which were too hot to be handled with comfort, and settled into a couch so deep that even Bob, who was nearly six feet tall, could not comfortably touch his feet to the floor. I wondered if the scale of furnishings was intended as a reminder of the heroic proportions of the mighty People's Republic.

"And here are the monitors," said Dr. Zhu. He urged two men forward. "Mr. Wei is the monitor for Dr. Lydia, and Mr. Wu is the monitor for Mr. Stone."

"It is a pleasure to meet you." We put down our cups and sprang to our feet.

"Sit down," urged our hosts. "Drink your tea. You will be teaching for the next three hours."

"Thank you." We sat down and picked up our teacups.

"This is your textbook, and this is the lesson you will teach today," said Ms. Zhang. She held out two textbooks for the teaching of intermediate American language skills.

We put down our teacups and accepted the books.

"American language not English language," we chuckled.

Ms. Zhang misread our levity. "Your students have high expectations," she said. Her voice was stern.

"Yes." Chastened, we scanned the first lesson. I felt the rising panic of an understudy who is handed the script five minutes before curtain.

"You will read the dialogue. The students will recite in unison," said Ms. Zhang. "Please relax and drink your tea." She thrust our cups at us.

"Time to go," said Dr. Zhu. We put down our cups. "Ahhhh, you did not drink your tea." He spoke in a mournful voice. "Perhaps you would have preferred orange soda?"

Mr. Wei led me to a large echoing classroom. As I entered, fifty students rose to their feet and applauded. I applauded in return. Clapping my hands, smiling, and bobbing in brief bows, I made my way to the head of the class. The applause amplified. I faced the class and grinned. They grinned in return. I stopped clapping. They continued. At a loss, I resumed clapping. Again, the applause amplified. My mouth went dry. I envisioned three hours of this politeness.

"Please stop, you are too kind," I said.

The applause gained in strength.

"CLASS!" bellowed Mr. Wei. "SIT!"

At once, the students fell heavily into their chairs and into a deathly silence.

Mr. Wei introduced me with a florid speech. He extolled my virtues. He praised the selflessness I had shown in my willingness to teach this class. He paused and finished dramatically, "And now ...Dr. Lydia will begin our lessons!"

I started with a brief speech about the gratitude and excitement I felt at being invited to China. I confessed that I had not yet studied the textbook and that our first lessons might proceed with awkwardness. The class listened attentively. Encouraged, I began to add flourishes. I requested the patience and participation of the class. I promised that together we would shape the future of our American conversation classes.

Mr. Wei interrupted my oration. "The class has prepared introductions," he crisply said. "They will introduce themselves in turn." He gave the class a nod. "Begin."

Each student gave his or her name and a statement of welcome. There were thirty-six people from the university: professors and graduate students who hoped to win fellowships to study in America, or who had been vigorously prodded by their departments into American language study. A dozen people came from outside the university. They had heard rumors that these classes were to be held and had come to practice their English.

"Dr. Lydia will now teach simple present tense and frequency adverbs," announced Mr. Wei. "She will read to us: paragraph one on page three." He gave me a meaningful look.

I scrambled to find my place and began to read. "Joe wants to marry Frank's daughter," I read. Joe is a bookkeeper. He works in a bank. He loves Frank's daughter and she loves him." I paused and read the printed question.

"What does Joe do?"

"Joe is a bookkeeper," chanted the class.

The textbook exercises were fun. We read about Felix Mendosa: a movie star who plays outlaws but who actually is a very gentle man. We read about Jane, a typist who likes to sleep late. We read about happily married Bruce and Laura, who live in a condominium and who work in a city. We made a list of new ideas and words: get engaged, wake-up call, dual-career couple.

"Are there any questions?" I asked.

"Dearest Teacher," said a professor of mechanical engineering. "Is it true that everyone in America owns two or three guns?"

"Oh, my, I don't think so." I laughed.

"But Dearest Dr. Lydia," said another student, "Dr. Matt, the American professor who taught us last year, said he owns three guns. Dr. Matt lives in Santa Barbara. Is that not the savage frontier?"

"Dr. Matt said he would not step into the streets of New York or Los Angeles without a gun," interrupted the mechanical engineering professor. "Is it true? Are all American professors—" she paused and seized her new vocabulary word with pride—"gunslingers?"

After an hour and a half, Mr. Wei called for a ten-minute break. "No more questions," he declared. "Dr. Lydia must refresh herself." As if on cue, Ms. Zhang burst through the door. She brought, with her, my libations: another scalding cup of tea and a bottle of orange soda.

Modern Ways

Three professors of computer science defected from my classroom to that of Mr. Stone. Mr. Wei composed a diplomatic explanation. Students from within the university clashed with students from beyond, over whose interests would prevail. Mr. Wei intervened. The outsiders vanished and peace was restored. As the size of my class shrank, the role of my classroom monitor grew.

I had expected a people's republic to be filled with exhibitions of selflessness. Instead people were refreshingly selfish: very reasonable, extravagantly generous, but well prepared to go head-to-head over matters of personal interest. Whenever I called upon one student to speak, the others burst into loud jocular activity. They considered silent observation of another's learning to be an obvious waste of time. Mr. Wei whispered some suggestions, and soon I returned to group recitations.

A classroom monitor is a discreet conduit of displeasure. Students took their complaints and suggestions to Mr. Wei. He brought them to me. In this way, students were spared the embarrassment of direct confrontation. Because they were not *his* complaints, Mr. Wei was granted immunity from censure.

In the end, both Bob's and my classes stabilized at about twenty-

five students. They were very different groups. Bob's class was dominated by male professors and students from within the computer science department. His free-talks focused on topics such as robot intelligence and the microcomputer that the university had just acquired.

My class consisted of very young graduate students and middle-aged women professors. During free-talk we did things like role-play American and Chinese weddings. We mimicked proud fathers and weeping mothers and old aunties all tipsy with rum.

It was Mr. Wei's idea that we go on a field trip. One day, to augment the learning of a critical concept, we went to the opening of the city's first *supermarket*.

We crowded onto a coughing shuddering bus that spewed plumes of black smoke and lurched though congested streets which—in the press of people—I was unable to see. Horn blaring, we swerved frequently, violently, barely avoiding certain destruction in the path of who knows what frightening foes. Finally, we were disgorged in front of the store.

The supermarket was a crumbling brick building between vacant lots where old men in sleeveless undershirts spat vigorously and played clattering games of mah jong. Mumbled accusations of cheating and excited cries of triumph mixed with the squeals of children running naked in the heat. A scorching wind—caused by a deforestation of the Asian steppes resulting from when Chairman Mao demanded the eradication of birds, triggering, in turn, a devastating rise in the insect population—blew grating dust through the air. Along the street, a line of small trees stood dying of neglect.

"Soon we will see the many triumphs that modern ways are bringing to our country," my students eagerly exclaimed as we hurried toward the building.

The supermarket was one huge damp echoing room smelling of

mildew and lit by a few bare bulbs. An aluminum turnstile guarded the door. The shelves were virtually bare. Several withered items—bok choy, long bean, ginger root—were artlessly interspersed with dusty bottles of oyster sauce and boxes of haw juice.

"Ai ya," breathed my twenty-five students in a common gasp of pride and awe.

They rushed through the store. Paying close attention to each item of merchandise, total inventory took less than five minutes. They dashed to the front of the store and crowded by another turnstile. Following, I thought them eager to be gone. But I was far from correct, for at the exit stood a marvel: an ornate electric cash register. To me it was a relic, a model I had seen in museums of industry. But to my students—jet aircraft engineers who had never seen the interior of an automobile—it was completely captivating.

"Dearest Dr. Lydia!" exclaimed cherubic Mr. Mao. "Within this machine, writing out the bill of purchase, is another wheel in our march toward *upward mobility*."

Dr. "Auntie" Liu explained. She was a maternal, mirthful woman, who also was a renowned professor of metal fatigue. "In China, there are four wheels of upward mobility. Two wheels on the bicycle, one wheel in the wristwatch, and one wheel on the sewing machine. When a man can provide the four wheels, then he feels he is ready for marriage."

"But times change," chortled young bachelor Mr. Mao. "Two more wheels in the musical cassette player, another small wheel to turn the channel on the color television set, and soon, four wheels on the automobile." He turned toward me in sudden seriousness. "Someday," he said, his voice rising in anticipation, "someday we too will have automobile, telephone, and traffic jam!" In the barren supermarket, his words echoed with prophetic power.

When I first began teaching in China, I was charmed by my students' naïveté. "Please describe, again, the bedroom of your child-

hood!" they would exclaim. "Tell us, once more, how your father quarreled with the rabbit in his flower garden!" Of their own pasts, they rarely said a word.

My students were brilliant. Selected from a nation of a billion people. Nimble with manipulating theoretical abstractions. Agile at wrestling reality. Yet they never tired of hearing about the most simple details of my life. Did I possess a photograph of my grand-parents? Could I drive an automobile? They listened, as if enchanted, to my halting descriptions of American government—recalled from eighth-grade civics class—the system of checks and balances, the way a bill becomes a law. During our free-talks, they planned activities so innocent—a trip to the zoo where we each portrayed different animals, a surprise party with small cakes and tea—that they almost made me weep.

Day after day we played together like children, and slowly a realization grew. It was *my* childhood that was being celebrated. It was *my* innocence that was being protected. It was not my lessons in American government that enraptured them. It was the simple faith in my voice.

For I was the only one who had experienced a happy childhood. I was the one with so much confidence in the possibility of indi-vidual happiness that I had chosen the profession of counseling. And my culture *legitimated* such a profession; America deemed *rea-sonable* the job of helping people to find meaning and pleasure in their existence. For the Chinese, such a thing was dumbfounding.

In China, how I made a living was so obscure a concept that the title of my profession could not be translated. The closest anyone ever came was "one who listens to and finds intelligence in the ravings of lunatics."

To my students, I offered my own kind of lunacy. Reminiscences about a fairy tale past. And people were eager to listen. For who could bear to live with my students' pasts? From 1966 to 1976—when I was cradled in my pretty pink bedroom dreaming of my father's battles with bunnies—their families were dying in labor

camps. When I was studying the liberal arts, their Four Olds—ideology, culture, customs, and habits—brutally were being purged. No wonder my students crowded to see my family photographs. Theirs had all been burned.

When I first arrived in China, somewhere in my consciousness was an awareness of the Cultural Revolution. But those whispered tales of torture seemed so distant from the slapstick of daily life, from the beleaguered optimism emerging after ten years of gradual liberalization, from the spectacle of people struggling to use monstrously overscaled corroded machinery to build the most simple of dreams. The hope of growing old with one's family. The belief that one's efforts have been of some use.

Tacitly and over time, my students and I spun a soothing myth. That our lives were not so different. That their futures would be much like mine.

When we were together there was only sunlight. Swimming parties and rowboat rides. I do not believe I ever would have seen the poignancy behind the playfulness if the old professor had not suddenly left.

In my class there was one old man. Frail and stooped and frowning fiercely, he looked like a man condemned always to concentrate on some devilishly difficult puzzle. For weeks, the old professor sat in the center of the front row. He never smiled. He never recited. He only stared at me, with unwavering intensity and incomprehension.

The old man piqued my curiosity. I was told that a number of years earlier, at another university, the professor had sat in another language class. Then, at the urging of party officials, he had been studying Russian. Now, Russian fluency made his loyalty suspect. American language and culture were more politically correct.

Day after day, as I cheerfully burbled on about coffee dates and condominiums, the professor studied me as if I were a Zen koan. It was not a question of language comprehension. The professor pos-

sessed a perfect command of English. It was the meaning of my performance that eluded him.

One morning, the professor was not in his seat. Everyone had moved over, one chair, as if he never had been there. He did not reappear.

When I asked Mr. Wei what had happened to the old professor, he sighed and began to speak of other matters. I did not press. Then Mr. Wei suddenly interrupted himself. "Perhaps you are beginning to see," he said. "To live in China is to live with contradiction and uncertainty." With his eyes, he asked me to inquire no further. It was the first time that I had been spoken to as an adult.

Over the next few weeks, amidst the cheerful chatter in my classroom, I thought about the old professor. How almost fifty years earlier he had won the opportunity to study in Europe. How the rise of fascism must have interrupted that study. How, nevertheless, he had risen to prominence in his field. How during the Cultural Revolution that prominence had led to debasement and imprisonment. How in the last ten years, his eighth decade, he had regained the right to study and to teach. How after all this, after all these cruel reversals of fortune, his suitability as a scholar perhaps was being measured by his willingness to participate in the frolicking foolishness of my class.

I do not know what became of the old professor. But my hope is that he left through choice and with impunity. I know well the total irrelevance of my credentials for teaching at a polytechnic institute; I know my lectures were inane. My hope is that my role deliberately was crafted to be inconsequential: to parody harmlessly an openness to international academic exchange, to invoke mild displays of party loyalty through willingness to engage in largely meaningless activity, to accommodate—in valued persons—small acts of resistance by allowing deviation from insignifi-

cant expectations with impunity. Especially the last. How I hoped the old professor had been allowed the last.

When I was in China, I found it difficult to say why I was there or whether my presence provided my students any real benefit. But I cared about them and knew they cared about me. And I longed for the certainty that the courage they showed in their willingness to befriend me, *at least*, would do them no harm. After only one month in China, I found myself yearning for the same things as my students: for some unambiguous situation of simplicity and innocence where, surely, fate would not horribly twist the outcomes of my good intentions. Where I could know, without question, the rightness of my course.

Now, after the student massacres of May 1989, I am even less certain. I no longer hear from my Chinese friends; and I fear that the sweet silly moments we shared have, for them, resulted in some dire retribution. I do not know what became of the old professor but he taught me a lesson. Life can be a devilishly difficult moral puzzle.

Ms. Zhang

The university had prepared a schedule for us: 6 A.M. rising, 8 A.M. teaching, noontime lunch and napping, afternoon small group free-talking, predinner cultural touring. Accustomed to a Western professor's life of "plan your own routine and teach eight hours a week," I found the schedule exhausting.

It was a response that was anticipated and relished. It was evidence of American softness.

"The schedule was shaped by our knowing of Americans," said Ms. Zhang. "Chinese teachers can work long hours and Saturdays without loss of robustness, but for our foreign friends we have adopted an American custom." She paused and gave us a significant look. "Americans require the weekend."

To ensure that our weekends were productive, additional cultural tours were scheduled. I marveled at the fortitude of Ms. Zhang, who accompanied us everywhere and who provided a tireless stream of historical and political education. Probably I should not have been surprised by her vigor. On our first day, university leaders had provided us with a handsome souvenir picture book. Ms. Zhang had written the English captions, and on its final pages appeared this admonition:

> The treasure land, the ancient site,
> Tour it, enjoy it
> Or you'll feel sorry.

I liked Ms. Zhang, who was younger, smarter, tougher, and busier than I. She also was very pretty, but this was not an attribute she valued. She broached no nonsense and bore no grudges. She was as aware of my shortcomings as she was of my elevated status and of the fact that rewards are not always based on deserving.

"Always, I was a tomboy," she said to me one day as she climbed a tree in order to steal the ripest grapes from a roadside arbor. We were on a cultural tour to see distant royal tombs. "I was the strongest and the quickest. I am very competitive." She scrambled farther, leaving me far below on the ground and watching. "During the Cultural Revolution, when all the schools were closed, I organized walks and hikes. I was very young, not yet in middle school. Always, I was the first girl to the mountain peak. The first boy was a soccer player: very handsome, very smart, perhaps a lit-

tle spoiled." Ms. Zhang popped a grape into her mouth and grinned. "Can you guess? Eventually, this boy became my husband."

We returned to the car and headed on our way, but when we reached the archaeological site, Ms. Zhang's enthusiasm flagged.

"You do not enjoy these historical visits, do you?" I said. We stood dwarfed by time in a desolate valley between three burial mounds, by a path lined with twelve-hundred-year-old stone sculptures of a funeral procession. There were camels and horses, the vast imperial armed guard, representatives of the sixty-three ethnic minorities of China, and every foreign representative who had attended the funeral. Centuries ago, the royal dead had rotted away, but the enduring scale of their vanity was immediate and overwhelming.

"No," said Ms. Zhang. She paused and when she continued there was sudden vehemence in her voice. "I hate old things!" She spat the words. "Ornaments from an imperial past. What is the point in admiring dusty relics? Maybe I was indoctrinated during the Cultural Revolution, but I believe in technology." She paused and shuddered, her voice softening. "The past has too much pain."

We returned to the car and started for home. Sunlight filtered through poplars and dappled the winding asphalt lane. We crossed a stretch of grain-strewn roadway.

"What is this?" I asked.

"Each morning, grain is scattered by peasants from the mud villages that we pass. Cars and trucks will crush and polish the grain, and at dusk the peasants will sweep it away. Traffic safety makes this an illegal practice, but it is rather picturesque."

Ms. Zhang pointed to a flock of birds rising over the windshield. "Look," she said. "The grain attracts the sparrow and the sparrow attracts the small yellow wolf."

I searched for signs of skulking weasels.

"It is the beauty of nature," she said.

As dusk gathered, I watched the passing road. I saw a man rid-

ing a bicycle and holding a leash. A monkey loped by his side. I saw a bicycle with two baskets attached to its rear wheels. In one basket a white goat sat with military erectness. It blinked against the setting sun. In the other basket rode a fat scrubbed pink pig. Farther down the road a small boy—his arms filled with bright flowers—sat in front of his father on a bicycle. Mother rode, sidesaddle, on the rear fender. As we passed, I heard them singing. Ms. Zhang turned and watched the family fade behind us. I wondered if she thought of her handsome husband, separated from her for six months of scientific training. I wondered if she thought of her plump baby boy.

"At the start of Cultural Revolution," said Ms. Zhang, "my father was director of an opera company. For his intellectual crimes, he spent five years in prison. My mother was assigned to menial work. Night times, I would wake to hear her weeping." She spoke with calm, as if simply relating incidental events. "You remember my friend the interpreter of German?"

"Yes."

"Her mother was a singer in my father's company. Her mother hanged herself in prison. Another friend was sent north with her family. When she returned, her father and brothers did not accompany her. They were dead and her hair had turned a snowy white." Ms. Zhang turned and looked at me. Her voice was small and puzzled. "It was an odd and beautiful white and my friend was not even fifteen years old."

The hills swallowed the setting sun and we rode in shadows.

"For six months of the year, I was sent to the country. I lived on the bank of a river. Where, before, I had read books and listened to music, now I labored in fields of cotton. I spent myself in unthinking effort," Ms. Zhang paused. "Do you know? Intellectuals despise the drudgery of the peasant. But I found something soothing, something pure, something to love that—unlike learning—could not turn and hurt me, in the endless beauty of scenery."

I strained to meet her eyes, to give her some small comfort, but

our faces were obscured by darkness. When she spoke again, her voice was bright. "Next week come to my house. Together we will make dumplings and perhaps you will meet my baby." She paused and her voice rippled with proud laughter. "Surely, he is the naughtiest of boys."

The summer I taught in China, the weather was hot and enervating. The campus was austere and gargantuan. The technology was ponderous and slow. My schedule was so tightly orchestrated—I was given so little freedom of time and movement—that I felt I was a participant in a prison work-release program. I was glad to be "just passing through."

But over time, I learned from my Chinese friends. They live in a country as large as a continent and twice as old as Christianity. Governance of such a place is barely imaginable. Historically, it has been achieved through megalomania, through staggering bureaucracy, and through unspeakable pain. Yet from China also have come philosophy and science and art.

China is a paradoxical place, a place of great suffering and great rejoicing. The Chinese take time for delighting: in the marvel of a cash register, in the pleasure of being with friends, in the joys of the naughtiest of boys.

In America, in the Pacific Northwest, there are a hundred optimistic ways to describe the expectation for dreary, wet weather. Rain, followed by showers. Overcast with a twenty percent chance of sunbreaks in the afternoon. Where others, accustomed to a more bountiful sun, see only a dismal day, Pacific Northwesterners can catch glimmer in the gloom.

The Chinese are like that. Only more. Only so much achingly more. The Chinese have learned to discern beauty in moments ephemeral and eternal. It is an ancient skill: honed by hardship, codified by Confucius, spread with trade throughout all Southeast Asia. They have taught themselves to search for unexpected wisdom in their past, in their pleasures and their pain. And as I grew

to appreciate China, I found I could look back—to my family and country—and see the bounty they offered as well.

My father loves to travel. Every summer when Misa and I were small, he would chart a magnificent voyage. We visited Cornell, Harvard, Princeton, and Vassar. Perhaps travel was not his sole motive.

Often we visited Manhattan. We would drive by Columbia, stroll the streets near NYU, then go to the Guggenheim or, if lucky, to Macy's to look at the toys. Once, we took a ferry to the Statue of Liberty. I was nine or ten years old, occupied with the harbor spray and with watching seagulls take french fried potatoes right out of the passengers' hands.

"What a sight!" sighed my father in rapture. He gathered me in his arms, holding me up to see, as if I were still a very little girl. He pointed at New York's famous skyline.

"They call her the asphalt jungle," mused my father, "a jungle of asphalt and steel. But look how pretty New York is, how delicate." He shook his head in wonder. "All those intimidating skyscrapers look so slender, like wood nymphs shyly tiptoeing into the sea."

He paused a while until, over the screech of gulls, came Misa's excited cry.

"Here comes Miss Liberty!"

Remembering his role as educational advocate, my father spoke sternly. "You live in a land of liberty, Yuri-chan," he said, "and you are unable to see your luck." Then his voice softened. "It is not your fault. One hour ago, we could not see the beauty of the skyline." He reflected a moment. "To see the fortune in your home you must leave. You must look back, to see beauty along the shore."

Dangling in my father's arms, listening to the rumble of his voice, to the rush of the wind, to the roar of the engine, I blinked through the salt spray and forgot to squirm away.

Bamboo Heart

My sister married a German American. When they traveled in Europe, when they traveled in Asia, the first question people asked was: can you show me pictures of your children? Everyone was curious. Did the children have their mother's eyes? Did they have their father's nose? All those universal wonderings that arise whenever a child is born—and that amplify when the child is of mixed heritage—grew to obsessive proportions when my family traveled abroad.

And my theory is this. Perhaps those children—captured shy and smiling in their wallet-sized school photographs—are what America is all about. Iconoclastic choice and irrepressible hope. For is it not hope that both children and America represent? Fulfillment and opportunity. Possibilities and risks. To be re-created: losing some things, gaining so much more. Our genes are blended. Our futures are charted. And all through a leap of faith, through some mysterious and maddeningly random process.

In China, I am like the photographs of my sister's children. I am a talisman offering a glimpse of how life might be if others were Asian American. Teaching in China is like an ongoing press conference. Everyone is curious. Everyone is blunt. No one fears for my feelings.

One afternoon, we go to Dr. Auntie Liu's for a tea party. Dr. Auntie, her husband, and child live in a one-room apartment in a huge high-rise dormitory provided by the college. It is a place of unpainted concrete, with neither refrigerator nor hot water, but potted flowers stretch toward the balcony. Mozart comes from a battery-operated, pocket-sized, cassette tape player. Bright paper cutouts, of butterfly-chasing puppies and kittens, frolic across the walls.

We sit on a small straw rug, eating the almond cookies and moon cakes that Dr. Auntie is baking on her stove, on a charcoal hibachi set into the wall. In the stultifying heat, we eat watermelon and carefully spit the seeds into our hands. We are joking and singing and having a wonderful time.

"Your grandfather went to America to find fortune," Mr. Zhou suddenly demands of me, "but why he did not come home?"

Mr. Zhou is a careful, conscientious man. In his early twenties, he is tall, thin, ascetic. Already he has begun to resemble one of the esteemed Chinese ancients.

"Why did this happen to him? Why did this happen to so many overseas Chinese? Did they not see the seasons change and dream of their beautiful homeland?"

The room goes silent with instant attentiveness. These are not questions of idle curiosity. My students want to *know*. They are preparing for study in America. They are keen to forecast their fates.

"Maybe because there are no seasons in Los Angeles, maybe they became confused," I lamely joke. "In Southern California the weather is always mild, maybe it confuses the spirit." I am a little self-conscious. I long to return to the levity. But then I see the earnestness. I see the hope and dread. "What are the costs?" my students are asking. "Between continents, between generations, what is gained and what is lost?"

* * *

"My grandfather did want to go back," I say. I take a deep breath and try to piece together the stories I have heard.

"When the rains fell and the rutted roads ran muddy, my grandfather would think of the plum tree in his family courtyard. He would imagine, day by day, the blossoms slowly emerging until they burst like butterflies flocking from their cocoons. When the days grow hot and long, my grandfather would think, then I will have the money to go home. But when the time came, when the roads were scarred with deep dry fissures, my grandfather would think, One more season, and I can buy my sisters dowries of the finest silks. One more season, and I can give my family a life of ease. Always my grandfather thought another season would make the difference."

"And in time it did?"

"Yes, but not in the way he imagined. As the seasons passed, the voices calling him home grew more faint. His parents died. His sisters married. And so my grandfather took a portion of his savings and brought a wife from Japan. Someone to share the loneliness until they could go home."

"And then?"

"And then children were born."

"Ai ya, children change all," sighs Dr. Chin, a professor of aeronautical engineering. She is a mother and her head nods under the weight of her knowing.

"When my grandfather looked at his sons, he wondered about his selfishness. In America, there was so much opportunity. In Japan, before his children could have such opportunity, he would need a greater fortune. So he took on yet another job. He became chief janitor in the Orpheum Theatre. He worked day and night, and sometimes his babies would sit in the back of that great Hollywood palace. There they would watch the vaudeville shows or the mysterious flickering movies. And when he was not paying atten-

tion, his babies began to change. They grew into American children."

"But if such babies grow into Americans," cries Dr. Auntie Liu, "later, can they go home to Japan, to China, and know that they are home?"

My students fear for their children, and I do not want to scare them. But it is a difficult question.

My mother—born in America, raised in Japan—went back and forth until she was twenty years old. Then she sailed home to America, was sent to Relocation Camp, got married, and moved first to Chicago and then to New York. It was over thirty years before she returned to Japan, and when she went she took me.

The last trip was a disappointment to my mother. I could see it in her eyes. They scrambled here and there, searching for the familiar, for recognition and homecoming and welcome. My eyes also scrambled—in greedy curiosity. I was a tourist looking for novelty. I was twenty years old. My eyes were easily satisfied.

What my mother saw was that she no longer was Japanese. She was too youthful. Her face was too mobile. Her laughter too bright. Even when she wore somber clothes, even when she used the most deferential forms of speech, it was obvious. She was not a provincial matron.

With her slim figure, her fresh face, her undyed deep black hair, my mother looked like a sister to me. In America, this was an asset. The embarrassment she evoked in her self-conscious daughters—with her funny accent, her Zen homilies, her culinary oddities—was compensated by their pride in her warm, unaffected prettiness.

"Your mother is a jewel," friends would exclaim. "You'll have no trouble catching a husband. One look at your mom and any man would know he's getting a deal for life." My sister and I would blush—as if the compliment belonged to us. We thought the praise was prophetic, that we could acquire our mother's grace while avoiding her stubborn foreignness.

In Wakayama, in my father's humble house, Okaa-chan was sus-
pected of being a spoiled aristocrat: a woman whose prettiness was
due to a shallow life. "A woman without wrinkles is a woman
without character," grumbled my uncle's wizened wife.

In Wakayama, in her father's proud house, Okaa-chan also did
not belong. She lacked a certain wabi: a worn and regal richness.
In her father's house, Okaa-chan was her banished mother's
daughter. The quickness of her smile, the smoothness of her skin,
were inappropriate and disturbing.

And if Okaa-chan's appearance was too youthful, then her
speech was too archaic. Her values and language were carryovers
from the close of the nineteenth century. They were the virtues
her parents had pressed upon her, and she in turn had urged upon
me. They were admirable but slightly off-putting, for Japanese
society had evolved. In America, my mother's Japan had frozen.

Okaa-chan was disappointed. In America she was well aware of
her strangeness. In Japan she had hoped for vindication. My moth-
er had taken me to Japan for a reason. There were lessons she
wanted to impart. The dangers of ego. The value of patience. The
pleasures of being with kin. My mother had wanted me to see the
wisdom of Japanese ways.

I watched—with my unwise, young girl eyes—and my respect
for Okaa-chan grew. She saw it grow and it saddened her. For she
knew I found the Japanese weird; that I liked the fact that my
mother seemed out of place. It proved that she was not so Japanese
after all. She was more like me. More normal than I had thought.

My Chinese friends are waiting. They are arguing among them-
selves.

"Why do you have such sour thoughts?" demands one of anoth-
er. "Eastern attitude, Western education. It can be a most advanta-
geous situation."

But Dr. Chin, the aeronautics professor, is concerned. She will
be taking her daughter to America.

.

"Dearest Teacher Dr. Lydia," she says, "you are American Japanese. Can such babies honor their parents? Can they grow strong and straight? Or do they grow strong but misshapen, bowing between East and West winds? Or, perhaps, do they snap?"

These are questions I always have evaded. Are you estranged? Do you belong? In the past to answer such questions seemed vaguely incriminating. Like blundering into a subtle trap by which I prove myself alien or, at best, amusingly odd. But in this setting, coming from these people, the questions seem important to consider.

"My mother told me that in America children could grow to be like the bamboo," I say. "Bowing between competing winds, the tree grows strong and flexible. It will not snap."

Dr. Chin listens avidly.

"But in some ways the bamboo is a fragile tree. It needs to grow in groves. By itself, the bamboo is a lonely tree for, inside, it is hollow." The insight surprises me. "Perhaps this is what I have found. In Japan. In China. Here with you my dear dear friends..."

"Your bamboo heart!" exclaims Dr. Auntie Liu. And everybody smiles.

Leaving

And then, we are leaving. The tea parties, and free-talks, and field trips have ended, and Bob and I are leaving. Vice President Zhu accompanies us to the airport. He helps to carry the ceramic horses, the ornamental wall hangings, the armloads of souvenirs that our students have given us. He shakes our hands, he waves good-bye, and then he is gone.

There is rain in our destination city and our flight is delayed. In the airport cafeteria, we wait for the storm to pass with assorted Chinese travelers, with a troupe of French-Swiss ballet dancers, and with three Japanese mountain-climbing couples.

To escape the tedium of inestimable hours on wooden folding chairs at rickety tables in a stuffy barren room, the ballet troupe sings and clowns. They teach us a step or two. The Japanese, all in their midsixties, construct origami and noisemakers. Together, we make innumerable toasts in multiple languages, drinking endless pots of steaming tea and bottles of orange soda. We grow giddy on caffeine and sugar.

The American tour groups have been led to a separate room. Five hours later, when we board the plane, the Americans are bored and angry. "They could at least have taken us to a Friendship Store," snaps one woman, "so that we could shop."

Above the clouds, the moon is full. Before we land, there is an

electrical storm. It is astonishingly beautiful. The flight attendants pass out silk scarves, crudely crafted key chains, small plastic bags of hard candy. "We have received complaints," they explain. "We apologize to our American friends. We know that this has been a difficult flight." The passage has been so rich with things I have come to know about China. The announcement makes me sad.

We are in Beijing as guests of the Ministry of Education. We are taken to the Forbidden City and to a Peking duck banquet. Bob is taken to the Great Wall. After much wheedling and because I have traveled in China before, I am allowed "semistructured free time." I may go wherever I want, as long as a driver waits at each site. It is the first time I have been alone in China.

I stay in the hotel and call room service. A sturdy woman with a gentle face comes to give me a massage. It is a vigorous massage with acupressure and incredible protracted rubbing, as if I am a stubborn blackboard needing to be erased.

Later the car comes and takes me to Tiananmen Square. I try to buy admission to the People's Hall and am sent to a shorter line for foreigners. The sign says five yuan but I am charged three. I think it is a special price for overseas Chinese.

Inside I wander through the Room of Ten Thousand with fifty Hong Kong visitors. I fall behind and am swept into a group from Macao. They leave to look for a souvenir stand, and I find myself amidst a group of acupuncturists, in Beijing to attend an international conference. It is an easy, restful day. I drift from group to group and seem to belong in them all.

After the People's Hall, I meet the driver and am taken to the gates of Behai Park. That evening I return to the hotel and am told that my laundry has been misplaced.

The news seems fitting and right. With fewer clothes, my farewell gifts fit into my suitcase. I leave Beijing with no regrets.

We fly to Guangzhou where Mr. Soo meets our plane. I feel some-

what guilty about the agonies he had suffered when we arrived in China, but he seems genuinely happy to see us.

"Good news I have for you," he beams, "regarding your initial stay in Guangzhou. You will receive total repayment for your expenses." Sudden worry clouds his face like an unexpected eclipse of the sun. "We only can repay you with Chinese yuan. I do not think this can be exchanged. You will have to spend it all before you leave China." The smile returns, radiating with shy pride. "I, therefore, have arranged a plan. Tomorrow morning, before your flight to Hong Kong, we will visit a Friendship Store!"

Early the next morning, we pile our suitcases into the trunk of a taxi and head for the Friendship Store. Mr. Soo is relaxed and voluble. He hands us our Chinese yuan. He asks us about our sojourn. He relates charming anecdotes about his work and his city. As we near the Friendship Store, he is interrupted by the driver.

"You go and spend your money," urges Mr. Soo. "I will wait and talk with the driver."

Inside the store, I purchase a panda hand puppet. Bob buys a hanging scroll. We look at each other and shrug. We have hundreds of yuan to spare. We leave the store and go back to the taxi. The driver and Mr. Soo are engaged in hot debate. The driver pounds his fist on the trunk of the car. Mr. Soo screams and grabs the driver by the collar. Then he notices our presence.

"There is a small misunderstanding," says Mr. Soo with dignity. He stands and straightens his clothes. "Please go inside and continue your shopping."

The driver watches with guarded, glaring eyes.

We go back into the store.

"What do you think is going on?" I ask.

"I suspect some kind of extortion," says Bob. "I think that once again our conscientious friend is being thwarted in the successful discharge of his duties."

I buy some hand-made paper. Bob buys a fountain pen.

"Shall we try again?" It is almost time to depart for the airport.

When we return to the car, the driver is picking his teeth. He is suppressing a triumphant grin. Mr. Soo is choked with anger.

"I am so humiliated that you should see this part of China," he cries. "This *creature*"—he points his finger and hurls his voice like lightening bolts—"refuses to accept my Chinese money. He insists on the foreign exchange money that he saw in the wallet of Mr. Stone."

"If it really is insoluble, I will pay," says Bob.

"But it is *illegal*," screams Mr. Soo in the direction of the driver. "And then the *creature* tries to threaten me. He says, if I do not pay, he will drive away with your baggage in his trunk. He says you will miss your plane. He says he will sell your belongings."

The driver looks at us and waves.

Mr. Soo shudders. "I tried to fight this man," he says. "We came almost to *blows*." His crisp white shirt hangs limp and crooked. His shoes are caked with dust. "And the *worst* is that the creature is correct. We must leave now. If I call the police, you will miss your airplane." His voice shakes. "Please forgive me, Mr. Stone, but I must ask you to pay this wretched creature. I will try my utmost to see that you are reimbursed."

The driver holds the door open for us to enter. He gives his cap a small salute. Mr. Soo's face goes purple with rage. We ride to the airport. Bob pays the driver. We stop at the bank where, surprisingly, our Chinese yuan are accepted and traded for Hong Kong dollars. Mr. Soo follows until officials bar him from our side. "You have my word," he cries as we walk toward passport control. "I will try my utmost to reclaim your money."

Bob stops and turns. "This is a vast and beautiful country," he says, "filled with kind and generous people. You are a good and honest man. We never will doubt your honor."

Mr. Soo bows his head; his eyes cloud with sudden sorrow.

We all know that the money is gone for good.

"Thank you for arranging my stay in China," I call. "I will never forget your country."

For the final time, Mr. Soo graces us with his beatific smile. With his round gentle face and disciplined proud posture, he looks like the ubiquitous, roadside, granite statues—modest in scale, worn by weather, half hidden by foliage and garlands of flowers— of the Japanese patron saint of the vulnerable. He looks like Jizo, guardian of travelers and babies. "May life provide you rich journeys," he says.

His words cast a blessing. Four months later, I am traveling to Nepal.

VI.

The

Kingdom

of

Nepal

A Moonless Night

In a few minutes, we will be landing in Kathmandu. Local time is eight-forty P.M. Please extinguish all smoking materials and return your seat backs and trays to the upright, locked position.

Royal Nepal Airlines Flight 402 from Hong Kong is descending into the kingdom of Nepal. I look out the window, searching for the lights of Kathmandu, and see only the rushing darkness.

Since boarding, I have been wrestling with a feeling of déjà vu. The ambiance of the flight is naggingly familiar. I am reminded of something—what? Most of the passengers are Nepali men in their twenties and early thirties. Throughout the flight, they have played tag across the seats. They have raced through the aisles. They have teased and taunted and tested one another. The few wives aboard this long journey have soothed their overexhausted children and have watched their men with a certain *look*: wariness, tenderness, resignation. As I obediently rebuckle my seat belt, it registers. I can name the déjà vu. Fighter pilots, I think. The fraternal bond, the knowledge of approaching danger, the edgy exhilaration. I realize that the plane is filled with smugglers.

The smugglers prepare for customs with blatant slapstick. They hop, one-legged, out of control through the aisle, trying to fit into three and four pairs of pants. With boisterous glee, they demonstrate to one another the impossibility of zipping and buttoning

the bountiful bulk of their trousers. They crash into other men who are shambling back and forth blindly, their heads caught in fabric as they layer on four and five and six polo shirts. They scream with hilarity. I am reminded of Vietnam-era pilots easing the tension between flights, shouting "Dead Bug!" falling to the floor on their backs, twitching their arms and legs in the air, sobbing, sobbing with laughter.

Through my window, I can recognize the shapes of hillsides. The smugglers have become subdued, efficient. They retrieve their carry-on baggage. Each man carries five or six videotape cassette players into a country where the annual per capita income is estimated at one hundred twenty dollars. The women, who have displayed no mirth on this passage, briskly conceal small valuables within their saris and among the wrappings of their babies: cigarettes, cosmetics, wristwatches, tape recorders.

The flight attendants pay no heed to the cabin chaos. Three teenaged girls, slender in their silken saris, they gaze intently into their compact mirrors, slowly twisting their heads left and right, up and down, retouching mascara, freshening lipstick, and searching their reflections for flaws. Each wears a small perfect jewel in her left nostril. They return mirrors and makeup to large black shoulder bags. They chew gum. In sulky boredom, they wait.

As the wheels of the plane bump against the runway and the jet engines whine into reverse, I catch my first glimpse of Nepal. Near the airport, in the hills, leap the flames of village fires.

I am in Nepal to join my friend Pam. Pam is an anthropologist, an American. Born in Colorado, she spent the summers of her girlhood chasing wild horses in Rocky Mountain canyons. Pam is a pioneer: long on physical courage, tenacious in spirit. Twelve years earlier, Pam was working on her doctoral degree at the Sorbonne. Her dissertation topic was mountain peoples and her professors' expectations were that she would study neighboring Alpine villages. She decided to study the Himalayas. She packed typewriter,

camera, and tape recorder in waterproof, dust-proof plastic containers. "Anthropologists look at Tupperware in a different light," Pam has said. She caught a plane to Hong Kong, a ferry to India, and buses to Nepal. In Kathmandu, she hired a guide and walked into the mountains. After eight days, at an altitude of 12,000 feet, she found a Sherpa village. She stayed for over three years, learning to speak Nepali and Sherpa, battling dysentery and fever, and completing one of the first major studies of Sherpa life.

Today, Pam is well known in Nepal. Her photographs are in the museums of his Majesty the King. Her reports guide policy in many public health centers. Her recommendations influence decisions on tourism and development. Whenever Pam returns to the Sherpa village where she lived, little boys clamor over who will have the privilege of carrying her typewriter, for from her typewriter have come science and change.

Pam's father is a maverick, an oil company executive who bolted from his desk to spend a lifetime excavating and abandoning niches: jerryrigging inventions, speculating on land, going into and out of businesses.

Pam's mother was a beauty queen, the only and accidental child of a flamboyant, autocratic woman who outlived all her husbands. "Folks say Grandmother drove her first husband to drink and killed the second with bossiness," laughs Pam. From this bossiness, Pam's mother escaped by marrying young. She married with the expectation of becoming the partner of a staid, upwardly mobile company man. Instead she moved from scheme to scheme, in the wake of a flamboyant, autocratic husband. The charm she had cultivated for corporate dinners was pressed into service mollifying bill collectors.

At forty, Pam is a hybrid. From her mother, she has inherited a remarkable all-American prettiness, a love of beautiful things, and a hankering for the people around her to buckle down, meet their obligations, and do as they are expected. From her father she has inherited vitality, restlessness, and an inspired "let me just give it a

try" impracticality. These qualities have led Pam from Colorado to Berkeley, France, Nepal, Germany, Korea, and finally to Okinawa, Japan.

In Okinawa, in her one-room bachelor officer's quarter, striking, sculptural flower arrangements stand in various stages of atrophy, like her father's abandoned inventions. Articles to file and manuscripts to publish are strewn across the institutional indoor-outdoor carpeting. Packed away in neatly labeled boxes are hand-embroidered linens, oriental carpets, and enough bone china to serve a dinner party of twenty-four. "Someday I may have an urge," Pam explains, "to build a log cabin and live in nineteenth-century elegance."

Pam does possess a certain nineteenth-century heroine quality. Annie Oakley and Scarlett O'Hara, I have thought to myself. History has seen Pam tossing her pretty head in determination, successfully managing vast territories and multi-servanted households, gleefully beating the boys at their own games, and loving a land more tenderly, more faithfully, than she has loved any man. Watching "Memsahib Pami" in Nepal, I am reminded of Baroness Blixen on her coffee farm in Africa.

The Western mind tries to seize ungraspable experience. Like gold miners panning a stream for shattered reflections of the sun, we search the flow of experience, sorting its shadowy play of patterns into objects that can be held and owned and trusted enough to be loved. In this way, Baroness Blixen owned a farm in Africa. In this way, Pam can love *her* Nepal, *her* servants, *her* Sherpa village.

But in a continent, or a country, or even in a moment, there resides a vastness of space and spirit that cannot be owned, and when Pam says "my Nepal," she knows that it refuses to belong to her. Instead, it bestows the grace of belonging.

Pam has a knowing of Nepal—a sense of belonging—with the long rains, the killing droughts, the sudden mountain avalanches. She has an intimacy with the exhaustion of endless illness, the

sweetness of faith, the inevitability of early death, the tribute of trust. Pam loves Nepal with a possessiveness that is primordial.

"I'm going back," she said in happy realization as she packed for our trip. "When I am away from Nepal, I get a longing. I long to be there again, to go outside my house, to look up at the stars, and to pee on the ground."

It is December. Four of us have traveled to join Pam for five winter weeks in Nepal. I am accompanied by Dot, an anthropology student, Hank, an army engineer, and Bob, the computer scientist who taught with me in China. We leave the airplane and step shivering into the dark silence of a new night. As I gulp the thin cold air I feel giddy and, like a newborn, not yet able to perceive my surroundings. The terminal building seems only barely discernable. It must be the altitude, I think, but it is not. It is a power brown-out, a frequent occurrence in Kathmandu, where twenty-four-hour electrical power is a recent phenomenon.

We follow the flow of some three hundred passengers into a snaking line that fills the small terminal room. The building is an unfurnished gray shell. There is no discernable paint on the walls. People settle on the cold hard floor among their piled belongings and prepare for sleep. They look like refugees from some natural disaster in some other century. The power shortage bathes the room in dreamy sepia tones.

"Ellis Island," I murmur.

A Japanese traveler thinks I am addressing her. "This is baggage and customs line," she responds cheerfully.

The Japanese woman is a travel agent. She is married to a Sherpa trekking guide. Her two toddlers wear matching cowboy boots and tiny, colorful knapsacks that have been padded and molded so that each child appears to be piggybacking a small, friendly animal. In this setting they seem incongruous, like pert infants who have time-traveled into a yellowing photograph.

"Memsahib Pami?" A lanky, lively young man suddenly materi-

alizes. He gives us a dazzling smile of welcome. "We go," he calls over his shoulder as he disappears into the crowd.

Like bewildered, imprinted ducklings, we trail as he swoops through the crowd. At one point we fear we have lost him, but he quickly reappears with a smiling, plump young man and with all our luggage. At another point, he exchanges a few terse words with a uniformed man. Then he extends his hand in what appears to be a conciliatory handshake. Finally, like an exuberant firecracker, he bursts from the terminal into the moonless night.

"How did you get through so fast?" asks an astonished Pam. "I sent the driver in to monitor your progress; usually it takes hours.

"Memsahib." The driver engages Pam in a vivid conversation in Nepali. He waves at the building, at us, at our luggage; he looks quite proud.

"Baksheesh, of course," laughs Pam. "No wonder you're out so fast."

"What is it?" we ask. Since boarding the plane, everything has been a mystifying cultural experience.

"A little bribe here, a little bribe there," says Pam as she repays the driver. "A business lubricant, like the two-martini lunch."

It is difficult to establish government bureaucracy in a nation accustomed to bartering. Following procedural guidelines simply lacks the adventure of bargaining, the sensibleness of simpler forms of operating. Pam tells a story. Once there was a postal clerk in Nepal. He was conscientious and efficient. He would accept no bribes. He would never open letters to look for money or packages to look for valuables. One day someone visited his house. Scenic postcards covered his walls. They were undelivered mail. The clerk's reasoning was this: the cards had little monetary value; they bore no urgent messages; probably they never were missed by their intended recipients. Undoubtedly, the clerk loved the cards more and cared for them better than could the addressees. Surely it was through karma that he had secured his position. Was he not

.

208

intended to provide scenic postcards with a safe and loving home in the universe?

On our first night in Nepal, we force seven people and a month's worth of luggage into the taxi—a rusting, fifteen-year-old two-door Toyota subcompact. We jolt through absolute darkness, along deeply rutted frozen dirt roads. The trunk hood bounces open and closed in fanfare as the driver and his friend sing loudly above the unmuffled exhaust system. Warmed by our crowding, our breath freezing lacily on the window, we travel like bonded molecules within the structure of a snowflake. We are as happy as children.

Like a mother awaiting the return of her first-born, the desk clerk at the Blue Diamond Hotel hears the crunch of gravel beneath our taxi and rushes out to greet us. He dances excitedly around the car as we disentangle, crawl toward the door, and drop one by one into his driveway, like puppies being born. He thumps each of us on the back and grins with pure radiant joy. Throughout Nepal I will see smiles like his: an opening of the heart, a total unreservedness, a smile of piercing sweetness. When the desk clerk smiles, I feel I have been bestowed with an unexpected blessing and honored with an unearned tribute. In America infants smile in this way, before they have learned the danger of granting trust too soon. In Kathmandu, the shopkeepers, the restaurateurs, and the clerks at the luxury-class hotels have begun to smile with professional restraint and personal caution. It is a poignant sign of modernization.

The stamina of the desk clerk at the Blue Diamond Hotel is even more astonishing than his smile. A man in his early thirties, weighing perhaps 110 pounds, standing about five feet tall, the clerk snatches our luggage—collectively weighing over 200 pounds—and easily balances it on his shoulders and head.

"Nice room, tonight no heat. Tomorrow we move nice room

and heat. We go upstairs okay?" he cries in one breath as he lightly scampers, two steps at a bound, up four flights of stairs.

By the time we have reached the second floor, we are sucking for breath; our hearts are pounding; our legs are shaking. In the distance, we hear the desk clerk calling to us in encouragement, opening doors, sorting bags.

"I was an Outward Bound instructor in Colorado," says Pam as we labor up the stairs. "I'd scornfully watch as men dropped weeping in the middle of trails. In my Sherpa village, I lived with Ani. She was a seventy-four-year-old Buddhist nun. Whenever we walked to the next village, I would be gulping jagged oxygen-starved gasps. Ani would skip around me in companionable circles, singing hymns and picking herbs."

In my room, the sheets do not match the pillowcase. The mirror is cracked and cloudy in hue. But the hotel brims with pride. It has earned an international one-star rating. The floor has been swept. The bare light bulb has been dusted. Down the hall is a bathroom replete with cold running water and a new porcelain Western-style toilet.

At midnight, we take flashlights and stroll toward Thamel, where Pam is staying with her friends, the owners of the Kathmandu Guest House. The Guest House has a long history. Although Nepal has been headed by Shah kings since 1768, from 1846–1951 power was held by a hereditary line of Rana prime ministers. The Rana family ruled in arrogant opulence, exacting cruel tribute and building European-style pleasure palaces. The Kathmandu Guest House was one such palace. Once it looked like Fontainebleau. Now it echoes with lost grandeur while bustling with present-day life, like an ornate jewel box—heedlessly dropped in a forest—that has become a burrow for mice. Trekking agencies and street vendors crowd its outer courtyard, stirring up noise and dust. Souvenirs are spread across the warped dance floor of its ballroom. The

rooms overlooking the rubble-strewn inner courtyard are rented by the week, month, or season to international aid workers, Peace Corps volunteers, expedition organizers, and solitary expatriates. The expatriates—who perhaps are foreign agents—emit the stale odor of stalled careers and lost idealism.

On our first night in Nepal, in Thamel, at a juncture of roughly cobblestoned roads, some Westerners have gathered. They are men: large, ruddy, and hearty. Climbers from America, England, and Australia, they distribute candles and sheet music.

"O little town of Bethlehem, how still we see thee lie."

Young beggar boys—perhaps eight or nine years old—turn the music over in their hands, mystified by its meaning. Skinny scavengers, all eyes and elbows, they stare at the singers in curiosity.

"Above thy deep and dreamless sleep."

An emaciated cow clops past. A vendor stops. He carries a long pole from which dozens of flutes protrude like beautiful branches on an oddly barren tree. He removes a flute and searches for the melody.

The singers are rowdy. They yodel and gesticulate. They pound one another on the backs of their expedition-quality parkas. And in the chaos, the first flute notes are lost.

But the slight, stooped man plays on. His cold, cracked fingers find the song. And suddenly, everything changes.

The Westerners look startled. They freeze in the midst of their strutting. They gulp the icy night and fall silent.

The flute's sweet voice dips and soars, flying upward to the heavens like a kite, like the stretching wavering flames of our candles. And, slowly, the Westerners yield. They shrink before my eyes. The bluster fading; the shoulders relaxing. They bow their heads. Finally, they sing.

"A thousand stars go by." Their voices join the flute. Music trembles in the cold night air.

I think about the climbers. Tomorrow they will set out for the

high Himalayas. They will hire a dozen small men, and as tonight they set forth to dominate the dark, they will go forth to conquer the heights. And, I believe, sometime—when they are big with hauteur and pride—the mountain will take them by surprise. Like the deep night, which has given us harmony, the mountain will surprise them and give them gratitude and awe.

I, who have always felt discomfort with being in-between, stand in perfect peace in a cobbled crossroad on the roof of the world at the edge of a new year. I stand amidst Christians and Hindus, among Anglo-Saxons and Asians. Perhaps this is why I have come to this place.

A Nepali father lifts his son to his shoulders. The toddler stretches chubby fingers toward the light and music, feeling the shadowy echo, memorizing the moment like a blind man.

A River Journey

We are floating down the Trisuli River on our way to Chitwan Royal Wildlife Preserve. There are a few passages with pitching, frothing, crosscurrents, where we paddle furiously to stay afloat, but mostly we drift—slipping steadily along a smooth, southwest passage, in clear rippling water between steeply terraced hills.

Occasionally, we pass a village, a small huddle of wooden dwellings standing high on a treeless ridge top. We are met by the scent of burning brush, by the sight of a scattering of people,

dressed as they have been for centuries, trying to coax some pota-
toes from the dry, unyielding dirt.

These are the villages of the Rai and Limbu and Magar tribes.
These are the lives of tough endurance from which the legendary
Gurkha soldiers—Nepali citizens in the British or Indian armies—
have come. And always, in the distance, soar the pure white
Himalayas.

Pam is in a professorial mood. She is assessing the safety and
practicality of bringing university study tours to Nepal.

"Nepal is the third poorest country in the world," she says. "Its
only natural resources are rugged beauty and strategic spy sites.
The economy rests on foreign aid, Gurkha soldier pensions, and
tourism. In the past, Kathmandu Valley created timeless works of
art, developed pagoda architecture, and minted its own currency."

"And now?"

"Nepal's flimsy paper money has to be imported from India."

In Nepal, poverty is a matter of fact, undramatic. I do not see
villages filled with the terrifying spiritlessness of starvation. In
Nepal, people work hard, eat little, fight illness, and wear out early.
On the average, they die at forty. In the meantime, children brim
with mischief, soldiers stroll with arm-in-arm comradeship, cou-
ples blush and giggle, and parents tie ribbons in their babies' hair.

Along the river, many children are familiar with the sight of
tourists. They run along the banks or hang from the high wood
and rope suspension bridges. Like woodland animals against a leafy
backdrop, they are visible only when they move. Now and then,
one wears a treasure. Some strange trinket found washed up upon
the shore. A mismatched pair of bright rubber zori, sunglasses with
only one lens. The children wave and hold their fore and middle
fingers upright in the shape of a V.

"Bye-bye," they call.

"*Namaste*," we call—I salute all that is holy within you.

We and they call and wave, growing fainter and smaller, until
call and callers disappear.

* * *

Each day we stop for lunch, pulling our rafts to the gently sloping, gray sandy shore. A strengthening sun pierces the chilly morning fog, warming our faces and shoulders. We picnic on loaves of fresh bread and spicy chicken salad, on oranges and grapes. We listen to lapping water. On the second day we climb a deforested hillside and visit a village of the Tibeto-Burman Magar tribe.

Approachable only by rocky eroded footpaths, six wooden shelters are clustered near banana trees and sugar cane. The door to one is open, revealing a small room with no furniture. Sunlight filters through the wooden shuttered windows, squeezes through the tiny chinks in the walls, and dapples the neatly swept earthen floor. There is no electricity. Water is gathered, in tightly woven baskets, from the river far below. The houses lean together, in various states of striated weathering, as if replaced board by board through numerous repairs and multiple generations.

Suddenly, two young girls appear. They stand before Pam and me, tidy in the dusty day, barefooted in the late morning chill. They wear bright floral cloth, golden and green, tied tightly into sarongs. They wear magenta high-collared Tibetan-style blouses. They are unspeakably lovely.

"*Namaste,*" I whisper. I am afraid of startling them. I feel slightly ashamed, like a trespasser in a forest who turns and meets the solemn gaze of grazing fawns. I wait for them to turn and flee. Instead, they break into radiant smiles.

The girls run forward eagerly. They have watched our approach and now rush to greet us with gifts. The older girl gathers me in, like I am long-lost family returning. She gently touches my elbow, my shoulder, offering me sticks of sugar cane.

"How...old...you?" she asks of us. Her English is carefully considered; her vowels are gently rounded.

"Forty," Pam answers for herself.

The girl smiles and gestures toward the younger child, who

hangs back in shyness, "My sister... also fourteen," she happily says.

With the tenderness of an older sister, she takes my hand.

"Come meet mother," she invites.

We are led through an alley between the small houses to a woman who is in her late twenties or early thirties. Perhaps the same age as I. Because Pam and I are still unworn, because we travel without husbands or family, she also thinks we are teenaged children. While Pam speaks in Nepali with the mother, the girls and I go and play.

We sit on sun-warmed outcroppings and watch three skinny goats nosing for invisible sprigs of green along the arid path. We hold hands. We suck on sugar cane and smile at one another.

"Where... you mother?" asks my new friend as she strokes back the hairs that have escaped from my braid. Her braid is tidy and gleaming. No wonder I seem like a younger child.

"In America."

"So... far," she says in sympathy. She struggles with another idea. "Where... you... people?" she finally asks.

"Japan."

The girl nods happily, pleased at her ability to communicate. Then she realizes what I have said. Her eyes sadden; she squeezes my hand in sweet commiseration.

"So far... you people," she says.

Pam discovers that my sixteen-year-old friend is the oldest of four daughters. Faced with the burdens of providing dowries for so many girls, the father left the village and has never returned. In a country where girls' rate of illiteracy has been estimated at ninety percent, my friend is going to school. If she completes high school, she can hope to become a teacher; she can hope to provide her younger sisters with dowries and her mother with support. Because of her obligations, she never will marry.

* * *

In Nepal, people closely look you in the face, seeing from which tribe you come, assessing how far from home you are, how lonesome you must be.

"I notice that people in Nepal treat you differently than they do most tourists," says Pam as we leave the Magar village.

"I know."

"You must look more like a Nepali than a Westerner," she muses aloud, "but then they also see Japanese tourists, and they just don't treat you like a tourist."

"Japanese tourists travel with other Japanese tourists," I say. "I think I look like an orphan, like the girls from Sherpa and other tribes who marry Westerners and get taken far, far from home."

I think it is something else as well. I am traveling with a face that could belong to a Nepali tribeswoman, through a corridor having its first contact with an outside world. It is a world about which Nepal feels ambivalent. This new world is beckoning; it is a world where people have food, enough to throw away, and useful belongings, like glass bottles for storage and carrying. Yet it also is a world that lures husbands and sons to their deaths on alien mountain terrains and children into a strange impatience and a frightening distance from tradition. I am traveling this corridor wearing Western clothes, accompanied by tall, white companions. I am welcomed with tenderness and compassion. Perhaps I am the personification of barely conscious doubts. I am a cheerful child, traveling in carefree luxury, away from her people, away from her soul. I am who the Nepali people may become, and they console me for losses they will sustain.

I am grateful for this sympathy. Lately, I have become aware that mobility has its costs. When I taught in China, my classroom monitor, Mr. Wei, would greet me daily at dawn. He would meet me at my door and accompany me to the college. Mr. Wei had a firm earnest manner, gray hair, and a frame so slight that at first, from a distance, I thought he was a wizened old man. Of course I was

wrong. Mr. Wei was in his forties. But during the Cultural Revolution, things had happened that had aged him in a flash.

One morning Mr. Wei was several minutes late. "Dr. Lydia, I must apologize to you," he said, "but tomorrow I will not be here to greet you as the day begins. For this I am very sorry."

"That's fine, don't worry...but where will you be?"

"Tomorrow, I will see my venerable professor. He is ill with the cancer. For months, he has weakened and now we must stay by his side."

"Of course...how sad."

"My venerable professor has taught for many years," said Mr. Wei. "He is loved by all his students. When we learned he had the cancer, we gathered together and made a promise. We decided that when the time came, we would go to his house and sit by his side. We would schedule shifts. He would not die alone. One hundred students made this promise and now the time is here."

"It is a sad time. I am sorry."

Mr. Wei nodded. "In China, we love our teachers," he said. "Historically, we have lived and died near the villages of our birth. From this came a certainty and trust." He paused and searched for words. "As we grew, with each kind person that we met, we were certain to know them for life."

He gazed at the ground. In the sultry dawn, my hair clung damply to the back of my neck. It was rush hour. I looked at the road, a double lane of asphalt lined by poplar trees. Huge open-bedded trucks—monstrous lorries from the 1940s—and small oxen-drawn carts—wooden-wheeled reminders of the sixteenth century—lumbered past. An old man in a gray Mao suit rode past us on a battered black bicycle. Over the rear wheel was strapped an enormous overstuffed sofa.

After a while, Mr. Wei spoke. "In our new China we have mobility and progress. We can leave the village. We can travel to the university and, after the university, we can be assigned to distant places. In our new China, students may leave their teachers

and teachers may leave their students." He shook his head. "Many people will never know the honor to sit by the bed of a beloved professor."

We traveled in silence. We both knew that soon I would be leaving.

Finally, Mr. Wei looked at me with earnestness. "In a traditional world, good-bye is a gentle thing. It comes only with the death. In a modern world, good-bye is bold and aggressive. It comes again and again."

He thought a moment and sighed. "In a modern world, Dearest Teacher Lydia, I think much tenderness is lost."

In Nepal, I think of Mr. Wei as I descend toward the river. I look back and the little Magar girls are right there. They wave vigorously from the hilltop.

"*Namaste*," I call, the word catching in my throat.

"Bye-bye," say the children. "Bye-bye, bye-bye, bye-bye."

We are not traveling alone on our raft ride. An expert guide and his assistant ride with us. The twenty-year-old guide comes from a small Limbu village. Muscled and hardened from a lifetime of subsistence farming and darkened by the river sun, he moves with the lithe strength and graceful knowing of a panther. Bright and ambitious, he has earned a coveted place at Nepal's one university.

He has not always been a guide. Three years earlier, he was an accounting apprentice. After one month he quit and was hired to be a rafting guide. He was happy. He convinced a boyhood friend to join him as a guide trainee; but the river is not always tranquil. After the rains of the monsoon, the ride, which is taking us three days, can be completed in several hours. Five minutes into his first river trip, the guide's raft capsized. He washed ten kilometers down the river before snagging on a log. Another guide was found, with a concussion, twelve kilometers beyond. His boyhood friend was drowned.

Our guide works with the easy authority of a man certain of his many capabilities. He is an expert oarsman. He jokes and sings. He shows us how to spot signs of human activity along the river: a broken fishing line, a small pile of stones on a pebbled beach, a thin smell of smoke in the morning. He teaches us to distribute empty bottles, plastic bags—things we would consider refuse—to villagers along the way.

Our raft is part of an improbable caravan. Trailing, at a distance of a half day, is another raft. It carries three couples: the owner of the rafting company, Mr. Sharma, and his wife; Mrs. Sharma's sister and her husband; and a judge and his wife.

In their late thirties, at the height of their careers, the men's prosperity has begun to show in their midriffs. Dressed in velour designer sweat suits, they stroke through the rapids with skill and heart; they drift through the quiet waters, stirred to philosophy. Their wives wear silk saris and canvas tennis shoes and perch on the rocking sides of the orange rubber raft with great pluck and little ease.

As our rafts float, unfettered, two Land Rovers labor along a parallel land route, through the twisting Mahabharat Hills, along a highway punctuated by washouts from the landslides of the monsoons. The Land Rovers are heavily loaded with water, food, and equipment and staff for two complete kitchens. They carry tents, sleeping bags, lanterns, tools, tires, personal luggage, and spare rafting equipment. Also on board are six chickens, one goose, and Bonti—the beloved pet spaniel of Mr. and Mrs. Sharma.

On the first morning of the expedition, Bonti and the goose argue over dominion and have to be separated when Bonti becomes ill from overexcitement. After one day on the raft, the three wives decide that they would prefer to ride along the swerving, jarring, dust-choked road with servants, cargo, Bonti, and the chickens.

At dusk, the clear waters darken. Shadows stretch like reaching

fingers across the hills and the canyon sky bruises to the reddish gray of navy cloth left too long in the sun's bleaching glare. We pull sweaters and jackets over our sun-burned bodies. In the hills, village fires glimmer like the lightning bugs of a childhood summer.

We glide to a gentle thudding stop at a white sanded beach and are greeted by the smell and sight of a completely established camp. Tea is ready: three different aromatic blends. Breads, butter, honey and jams, are laid on large tarps. Nearby small wood fires have been built for warmth, light, and crackling beauty.

Two chefs and four assistants, all tightly knotted muscle and sharp urgent sound, are busily preparing our meal. From large copper kettles, dented and oxidized from years of usage, waft the seasoned scents of curried soup. Cauliflower and potatoes simmer with freshly ground cumin and cardamom; chickens roast with dahl and rice. The amazing chefs even are baking delicate croissants and moist crumbling cakes over the cooking fires.

Our tents have been set. Inside, our belongings are neatly stacked. The goose, which will be eaten by Mr. Sharma's party on Christmas Eve, waddles, grumbling for attention and receives scraps of food and pats on the head. A jealous Bonti growls but is reduced to whining retreat when the goose spreads its wings and rushes. I wonder if the haughty goose has noticed that each day it travels with fewer chicken companions.

Huddled by the kitchen staff, receiving morsels to taste and to take home, are six children from a village about three kilometers up the river. Aged five to eleven, they have witnessed our bizarre procession of jeeps and rafts and have chased us down in barefoot breathless wonder. They squat, wrapped together by the shawls of the older girls, maintaining a safe distance from the Westerners at whom they stare with all their might. All that can be seen under the dark lumpy tent of multicolored woolen weavings is the glitter of dark brown eyes and the flash of golden nose rings.

Mr. Sharma engages us in conversation about religion and

humanity and finally about Nepal. Nepal has a curious history. Here a king staged a revolution against the oligarchy in his kingdom. During the century-long reign of the self-indulgent Rana ministers, the royal family lived largely under house arrest. In 1951, King Tribhuvan escaped and returned—fortified by aid from India—to lead a revolution of freedom fighters. The revolution was successful, but after a decade of parliamentary democracy, the son of Tribhuvan instituted a one-party government. In 1980, a second popular uprising forced the current king—grandson of Tribhuvan—to hold a national referendum. Amidst charges of election fraud, the demand for a two-party system was narrowly defeated.

"My people are so poor," sighs Mr. Sharma.

He gestures toward the hills.

"A few landlord families own the country; the people of Nepal live under feudalism. Yes, yes, it is feudalism!" he cries.

"Too weak and sick to mount a challenge, too ignorant to stop the hunger and disease, when will it end?" asks the judge.

Mrs. Sharma has been listening; she is watching her husband and gauging the weight of his spirits. She rests her hand briefly, tenderly, on his shoulder.

"We are all together tonight," she says with gentle firmness. "Come, let us be happy."

Mrs. Sharma is a pretty woman in her early thirties, a woman with girlish liveliness and steady warmth. Her husband's mood lightens.

When the meal is ready, we sit together on the bumpy, sandy tarps. We pass dishes and press food upon one another. There is much laughter. The village children refuse to join us. They hover on the borders of the laughter and light. Food is wrapped for them to take home.

After we have eaten and she has fed Bonti from her own hand, Mrs. Sharma grows quiet and pale; she goes early to bed. Pam explains. "Mrs. Sharma suffers from the exhaustion of a lifetime siege against sickness. She has been unable to have children. She

suffers from mysterious, blinding headaches. She cannot expect to live for many more years."

In the saddened silence, Pam suddenly stabs angrily at the waning fire with a stick. A thousand tiny sparks glow skyward, like our prayers in the night.

When the dishes have been cleared away, when the kettles have been scoured with sand and we have slipped into our tents, only then do the village children go home. As we sleep, the kitchen assistants and Land Rover drivers take turns. They stand guard against bandits and wolves.

At dawn, the children are back. They bring with them an additional five friends. They race one another down the hillside to the beach, anxious that we may have slipped away like a dream lost at waking.

"I bet their mothers had to tie them to their beds last night," chuckles Pam.

Bob picks three stones from the beach, shows them to the children, and begins to juggle.

"*Namaste*," he calls.

"*Namaste*." They creep a little closer.

A computer scientist, Bob is eager to learn how things work and is delighted by the seemingly impossible. He is skillful enough to be entertaining and awkward enough to be engaging at juggling, magic tricks, rope twirling, harmonica playing, and ear wiggling. He is always a hit with children. Bob's roots are in the begrudging soil of Virginia's isolated eastern peninsula—a place where you learn to respect rural ingenuity and tenacity. In Nepal, his interest in the work men—in knowing how logs are hollowed into canoes, how soil is tilled—has earned him rapport with village elders whose own sons longingly look to the city.

After an aromatic breakfast of porridge and eggs and breads and jams, of freshly brewed coffee and three kinds of teas, the drivers pack the Land Rovers and the river guides pack the rafts.

"Photographs, please." Mr. Sharma waves his Japanese camera.

"I want a group picture, with everyone, including Bonti and the goose!" cries Dot.

"I'll take the picture," offers our river guide, who likes to handle cameras.

Eight cameras are thrust at him.

"Please put on your wrappings, your plastic things," shyly begs Mrs. Sharma's sister.

While the Americans have been delighting in the incongruity of saris and sneakers, the Nepalis have been fascinated by our strange waterproof ensembles. In the early morning cold, Hank is hale and resplendently immodest in maroon running shorts. The Nepali women sneak sly glances of horrified fascination at his large, muscular, pink legs, covered with freckles and wiry hair. Draped in a green plastic poncho, her eyeglasses secured with a piece of dental floss to prevent loss in the event of capsizing, Dot looks like a flourishing legume.

Only Pam, in a sky blue cape, manages to look both sensible and fashionable.

We assemble: rafters, crew, children, chickens, goose, and dog. We strike a pose we have seen in photographs of Everest expeditions. Happy, and a little bit crazy, we are pinpoints in a vast timeless space. The cameras flash. And the moment is captured on film.

The Jungle Camp

 Once, I listened to a biologist. She had been awarded a grant supporting field study in the Kalahari Desert. It was the opportunity of a lifetime. Over vast distances, in a rented Land Rover, she scurried here and there. She marked sites. She took readings. She made plans. Always rushing toward the momentous occasion, triggered by the distant rains, when the animals she studied would appear.

One day, the Land Rover overheated. In order to reach water and safety a strategy was devised. The vehicle could travel a few kilometers each day. Then the engine required rest to cool down. The result was that the scientist was forced to spend many hours in remote locations where she had no business being. It nearly drove her mad.

There she was, with so much urgent busyness to be doing, in a place where nothing could be done. Loathing to waste time she transcribed her notes. Then she reread her field manuals. She stared impatiently across the vast wilderness, willing the coming of the rains, of the animals, or at least of a spare and sprightly jeep. "Here I am in the Kalahari," she fumed, "having worked all my life to fulfill a girlhood dream. Here I am and everything has been thwarted."

Then as the hours turned to days, it dawned on her. She was in the Kalahari with eyes and ears and time on her hands. This *was* her girlhood dream. The biologist took a deep breath and looked around. Small insects labored in the sands. She watched them for a while and her anxious pulse rate slowed.

And as the days stretched to a week, she noticed the subtle shifts in scent of the desert during the day. She noticed that at a certain hour, if certain conditions prevailed—like thirty-two distinctive signs accompanying an auspicious horoscope—then small iguanas would appear.

Over time, her drive to achieve scientific notoriety eroded, and her sense of wonder emerged. And in the desert the biologist found her motto. It is one that she carries to this day.

"Don't just *do* something," the scientist said to me, "*sit* there."

What the scientist was talking about was receptivity—a concept not entirely new to me. Since birth, my mother had been trying to teach me its virtues. But youth—and a daughter's natural opposition to parental wisdom—kept getting in the way.

"What does my name look like?" I question my mother. I am ten years old. It is an August afternoon. My glass of lemonade sweats in my hand.

My mother focuses on her task. She is seated at the kitchen table, translating correspondence for my father's pharmaceutical firm. With a stiff brush she is painting strange characters onto translucent, wrinkled airmail paper. The ink smells sharp and acrid.

I wait. I know my mother cannot resist an opportunity to bestow her cultural knowledge.

My mother reaches for a fresh piece of paper. It whispers in complaint. "Come Yuri-chan," she says. "I will teach you to write your name."

She dips the brush in ink. Her forearm hovers above the paper circling before it descends. "Yu-ri," she says making the strokes, "cle-ver." She looks at the character with satisfaction. "I chose this character for its special meaning."

"Clever? It means clever?" I am disappointed.

"Other mother write *Yuri* this way." She flicks her wrist and another character appears. "To them, the meaning is lily flower."

"That's pretty!"

"Take that glass to the sink. It drips. Besides, too much sweet is not good for young girls." My mother is annoyed. She deliberately has named me "clever" and I am too stupid to see why.

"Why didn't you name me lily flower?" I persist.

"Too many flowers already. In America, it is better to prepare a child to be clever—to be open to the world, to accept imagination, to see the unseen. A flower girl gets picked. A flower girl gets trampled. A clever girl gets prize."

I make what my mother calls my unpleasant American face. I am skeptical. I know nice Japanese names, names that mean something important, like Michiko—beautiful *and* intelligent. Clever, hmmph. Clever is what you want in your dog.

In Asia, I have met many clever people. Dr. and Mrs. Kinjo, Mr. Wei, Dr. Auntie, and more. They are not aimless dreamers. They live lives of direction and action, but they are different from the anxious achievers that I have known at home. In Asia, people do not lock their doors. They do not cling worriedly to their possessions: objects, emotions, or time.

On my first day in Nepal, at 11 A.M., I met another man of receptivity and cleverness. His name is Major Rai.

On my first day in Nepal, roosters and dogs wake me at dawn. The room is cold. I have slept fully clothed, wrapped in blankets and my down-filled jacket. A faint smell of hashish filters through the air. I creep through the quiet halls, past the lobby—where the desk

clerk and other hotel personnel lie sleeping on the floor—and slip into a mist-veiled morning.

Shards of sunlight pierce the frosty fog. It is like walking through cobwebs jeweled with dew. Women swirl past, deeply wrapped in their saris and shawls. Dressed in rags, a boy and girl—five or six years old—scurry through the streets. They carry a large metal pot. They stop at a crossroad, set the pot in a crude wooden sling, and peer into its depths. They poke and stir. Are they making food? I wonder. Suddenly, flames leap from the cauldron and people stop to hold out their hands. The children are selling heat.

Sherpas, with sure silent strides, appear from the fog with startling nearness. They glide into my perceptual field like visions: magnificent with their long, glistening braids, their heavy turquoise jewelry, their rustling magenta robes. They are gone in an instant, leaving in their wake the high sharp scent of yak butter.

I enter a large cobbled square and plunge into the sixteenth century. Around me rise a multitude of brick pagodas, their orange tiled roofs supported by ancient timbers carved with doves and erotic scenes, with peacocks and deities and little laughing skulls. Vegetable vendors and curio sellers jam the lower steps, spreading their displays in the morning mist. Side by side lie: chiles, betel nuts, dried fish, votive powders, khukri daggers, and Buddhist prayer wheels. Pigeons swoop from deep within the distant rafters to steal small rice offerings. Incense fills the air.

In a golden shrine, Ganesh, the elephant-headed son of Shiva and Parvati, rides a tiny shrew and receives a steady stream of worshippers. One is a small boy in traditional garb who lovingly anoints, with a streak of the god's red resin, the object he wants blessed. It is a chartreuse, plastic water pistol.

"Boom . . . Boom . . . Boom."

The earth trembles with an eerie, thunderous cadence. I scramble to the side of the road, wondering in stupid terror, Is this an earthquake; are we being bombed?

"Boom . . . Boom . . . Boom."

From the mist emerges an elephant on the run. Its sides are painted with red and white symbols. Two men ride behind its head. Just past me, the elephant slows and stops. It stretches its trunk and plucks a bolt of fabric from the window of a second-story shop. The fabric is passed to the riders, and payment is extended by trunk. A crowd gathers. People bow and throw coins. For surely this is Ganesh, here to bestow fortune on the day.

On my first day in Nepal, at 11 A.M., I join Pam and my fellow travelers at a small booking office in the courtyard of the Kathmandu Guest House. We are making arrangements to stay at a small naturalist camp in Chitwan Royal Wildlife Preserve. The owners of this camp are Major Rai and his "cousin-brother."

Major Rai is a retired Gurkha officer. In his late sixties, he calls to mind the symphony conductor Leonard Bernstein: the dignified bearing, the silvered hair, the magnificent discipline. But Major Rai is a modest man. He does no preening. His words are few and gentle.

It is not easy to become a Gurkha soldier. For generations, village boys have walked days to reach the recruitment sites. From hundreds of applicants, only a few are selected; of these, only a small percent will complete the arduous training. In the British Army during the turbulent colonial era, Major Rai earned his rank.

In his retirement, Major Rai has not been content to draw his pension. He has made no retreat from life. He is a poet. He was a leader during the 1951 uprising against the Rana prime ministers and again during the 1980 struggle for a two-party system. He is a principled man who—in Malaya, Indonesia, Kashmir, and at home—has seen much of human behavior. Perhaps he has seen too much.

On my first day in Nepal, by 11 A.M., the morning mists have

evaporated and the sun's unrefracted rays have begun to parch the soil and burn the skin. The magical mood is gone. In the daylight, I can see erosion scarring the face of the deforested Mahabharat Hills. I can see children begging for cigarettes because tobacco dulls the pangs of hunger. I can see the Western hippies, languorous in their drugged stupors and cunning in their shoplifting. Major Rai gazes at this scene outside his booking office and I can see weariness in his eyes.

Cousin-brother is oblivious. He is a small exuberant man, as dapper and round in his custom-made, three-piece, pin-striped Hong Kong suit as Major Rai is elegant and lean in his well-worn careless tweeds. Cousin-brother revels in the camp's financial management. He efficiently punches prices, conversion rates, and percentages into a hand-held calculator. He enjoys talking about the details of running a business, about the pleasures of being a businessman. He speaks rapidly and laughs frequently, in short joyful bursts.

"I fly to Hong Kong, where we do our banking—more honest banks in Hong Kong. I also like to eat in the Hong Kong restaurants. Ha Ha Ha. Soon I will pop this vest. Ha Ha Ha. Do you not think?"

On my first day in Nepal, when I return to the Blue Diamond Hotel, I again see the stamina of the desk clerk as he rushes effortlessly down the stairs, toward a waiting taxi. From a fourth-story perch, workers pause to watch. They are two barefooted worn women lugging bricks in the folds of their saris. The desk clerk carries the unconscious body of a twenty-two-year-old West German tourist. In his huge, slack, pink nakedness, the tourist looks like a slaughtered hog. On holiday, he has overdosed on heroin.

Chitwan Royal Wildlife Preserve is located in the Terai, the central region of the border between Nepal and India. Until recently only the Tharu, a tribe with a natural immunity to malaria, could

live in the Terai; for its swampy lowland jungle, historically, was
more hospitable to the solitary tiger and the broad-headed alligator
than to man. Now, a sea of cultivated mustard flowers guards the
border between village and preserve. The delicate golden blossoms
nod and ripple in the breeze. They are as effective as an electric
fence. Their pungent scent causes the one-horned Rhinoceros to
sniff the air and to halt in displeasure and distrust. And always,
beyond the boundary of flowers, beyond the verdant jungle, two
hundred kilometers away, the jagged Himalayas reach with icy
hauteur to touch a cloudless sky.

Major Rai meets us at his camp. Here, he looks much younger. The
lines in his face have been eased. I stand in the enveloping vast-
ness of the Terai; I catch my breath with the sheer staggering scale
of its wild beauty, and think I understand.

Our passage to this place has not been simple. From bus to raft
to jeep to dugout canoe to foot. And with each transfer, I have felt
more rested. My urban urgency has slipped farther and farther
away.

"Why manage a wildlife camp?" Pam asks Major Rai.

"The beauty and unpredictability of the land and animals," he
says. "The wisdom that is found here. The gratitude I feel simply to
be in such a place."

There is no electricity at Major Rai's camp. Blocks of ice cool the
food. In the final hours of our stay, someone will forget to replace
the ice and the food will spoil.

"Oh the waste!" Major Rai will cry, thinking more of the hunger
in his country than of the cost to his business.

In the evenings, when we return from riding elephants through
grasslands and jungle forests filled with hidden eyes and sudden
monkey screams, a kerosene lamp glows outside the door of each
guest cottage. There are only six cottages. They are made of twigs
and straw. Each day, massive tubs built on high platforms are filled

with water for our gravitational plumbing system. For our hot showers, the water first is heated for hours over wood fires.

On a cold clear Christmas Eve, guests and staff gather before a crackling bonfire. Major Rai stands and speaks. "We are here to share a meal on a night that is called holy. We have come from Nepal and America and Japan and Singapore. We are Christian and Hindu and Buddhist and Muslim and Jew. We are surrounded by a jungle that is beautiful with animals and flowers. May the world know such peace."

That night, a crystal skin of ice forms in my pitcher of purified water as I sleep beneath layers of soft blanketing. Tiny mice feet scurry in the sweet-smelling grass on the thatched roof. A rhinoceros crosses the courtyard as a crescent moon hangs in the sky.

On the morning after the ice melted and the food was found rotting in the heat of the day, Major Rai hires a jeep and driver. We are returning to Kathmandu. As we approach the Siwalik Hills, an animal rushes across the road. Major Rai cries out and the driver hits the brakes. A small brown monkey looks back at us and shrieks with indignation. Suddenly, two more monkeys scurry across the road. Then they come in threes and fours: a band of over thirty monkeys, hurrying on their way. They scramble scratchily over the hood of the jeep and run unevenly across the roof, as if we are a log crossed in the forest. They pass in an instant, like a cloudburst. They leave behind a dry musty scent and a slow settling of dust.

A few kilometers later, the jeep breaks down. The driver has forgotten to put oil in the crankshaft. We flag down an overcrowded dilapidated bus and ride on its rooftop, with goats and packages and machine parts dripping with grease, with young boys and nursing mothers, and old women knitting wool sweaters.

"In my village, a man stole into my house. He took the asbestos pad from my kerosene lamp and ate it," says Pam. "I was heartbro-

ken and furious—this man will die from such a small stupid act—
but the man was happy. He knew the lamp had strong magic, and
now the magic was within him."

When I was a child, I wanted to join the Peace Corps. I wanted to
give the gift of knowledge to developing nations. But technology
does not always transfer smoothly. People often are spellbound by
the magic in an automobile, an ice box, a lamp. To them, the
notion that their own actions can affect the magic must seem like
absolute hubris. "How can something so miraculous fail due to
human error? It must be karma." Often the consequences are trag-
ic. Small aircraft crash: overloaded, poorly maintained. How can
you expect people to believe that a magnificent metal bird can be
felled by too many suitcases, by a worn washer, by things so puny?

Karma

 When I was in graduate school, the miniseries
Shogun was aired on television. And for a while
things Japanese became the national rage. For days, people arrived at
work talking about the characters: the proud noble shogun, the
brave beautiful interpreter, the handsome resourceful Englishman.
But when the series was over, people felt betrayed. "What kind of
ending was that?" they demanded of one another. "The lovers are
parted. The woman dies. The man spends his life in futility. After

we've invested all this time getting to know and care about them, what the hell kind of ending was that!"

That was what Asians call karma. What Turks call kismet. What we call fate. Often, it is not very satisfying.

Cultures make virtues out of necessities. Americans—immigrants from distant lands, fleeing the past, setting sail from the familiar, from the beloved—built a national ethos based on the future. Based on belief in the goodness of going it alone, on the need for an ultimate happy ending. But Nepalis live in a land-locked country. With mountain avalanches on one end and jungle tigers on the other. From poverty and sadness, they cannot sail away.

On Tuesdays, at Dakshinkali there are blood sacrifices to Kali, the mother goddess. Before dawn, families begin the climb through quiet forested hills, to a natural recess where rivers run between steep jagged mountains, to a place of extraordinary beauty. They carry an animal. Usually it is a chicken. If the family is wealthy enough or the prayer heartfelt enough, the sacrifice might be a goat. After the blood-letting, the carcasses are cleaned in the river. They will be cooked and eaten as a picnic or carried home to feed the family. By 10 A.M., the shallow river is pink. Women sell garlands of holy marigolds. Fallen petals mix with splattered blood forming a mosaic.

The Himalayas are called the abode of the gods and, in Nepal, their presence is potent. Here the sacred mingles with the mundane. But the Hindu gods do not end with lofty creator Brahma—who rides a swan and stays away from worldly affairs. Or with noble naughty Vishnu—whose duty is to preserve the world and whose incarnations include both Rama, the enduring husband, and Krishna, the inventive cowherd who once appeared to a group of girls in as many embodiments as there were women so that he could make love to each in the ways she most secretly desired. No,

the Hindu gods also include the destroyer, Shiva, and the blood-thirsty mother, Kali. And in Nepal, it is they who are most revered.

A parking lot overlooks ancient Dakshinkali. It is for tourist minivans. In the thin air of 7,000 feet, skirting the endless line of worshippers and their animals to get to the important spot—the killing spot—feeling the crush of blossoms under your feet while watching one man deftly slash the throat of animal after animal: the colors and sounds and scents begin to hang heavily. Tourists largely come for this experience. It produces a giddiness, a near nausea that many find exhilarating.

It is not death that is being worshipped. Asians do not rejoice in destruction. They believe that life, no matter how joyous, includes pain and loss and sorrow. From endings come beginnings. From separation comes joining. From wrenching pain comes fulfilling pleasure. Think of childbirth and perhaps you will understand.

Beyond the killing spot, down by the banks of the pink river, the atmosphere is very different. Adults clean the carcasses. Children play by their sides. Faced with the quiet dignity of people matter of factly performing their weekly tasks, most tourists hurry past. If you stop and search the scene for too long, you begin to feel intrusive—like a voyeur. The boundaries between which group is engaging in barbaric rituals and which is not begin to blur uncomfortably. The children pause in their play to gaze at the tourists with wonder. Their eyes are rimmed with kohl. Some tourists take pictures; but the parents do not glance up. They know kohl will protect their children from the evil eye.

On Tuesdays, there is a children's pilgrimage to the parking lot of Dakshinkali. The pilgrims are not the kohl-eyed children of the worshippers. They are children with the copper hair of malnutrition. They pertly greet each person disembarking from each van. The cutest, the luckiest, the most tenacious may earn a few rupees, a stick of gum, a cigarette. A man is trying to evade three of these

children. He plunges past me on his descent to the shrine. The birdlike children hop by his side. "Hullo, hullo," they chirp. They peer sideways up at him. "Hullo?" they inquire with hope.

The man does not look down at the children. The tension of remaining deliberately unmindful makes him clumsy. He takes the descent in long strides, each stride ending with a downward skid. Small avalanches of dust and stones radiate in his wake. A camera swings wildly from his neck and ricochets against his thorax. Thunk, thunk, thunk, thunk. The sound reminds me of a racing heart.

As the children try to meet his eyes, the man stares desperately ahead. It is painful to meet the gaze of a hungry child.

Then another man begins to lope easily down the trail. "Say," he calls, "what's the rush? We're on vacation!" It must be a friend, for the first man smiles in relief. With one hand, he stills the swinging camera; and in that moment an idea is formed.

Wordlessly, he transfers his camera to his friend. Slowly, he reaches into his coat pocket. Now the children and I are mesmerized. I am aware that it is strangely silent. Then, in a flash, something flicks from the pocket and is brandished in the air.

The man dances a few paces down the trail. Suddenly he is nimble. He holds the object aloft, posing like the Statue of Liberty with her torch. In a common instant, we all recognize it. It is a package of crackers. It is a waxed papered, half-eaten stack of Saltine crackers.

"Hullo!" The children are shrill. "Hullo, hullo!" They leap for the crackers. More children stampede down the trail. They rush the man. "Hullo, Hullo, Hullo!" Again and again, they leap for the crackers. The man laughs. Avoiding the eyes of the children, he beams into the eye of the camera.

"Click."

I think of Venice, of snapshots of feeding the pigeons in Piazza San Marco. The man drops the package and steps unnoticed from the scramble of children.

I board the van. I sit alone. I do not want to chat. Perhaps it is the altitude.

I am an American. I have no patience with fatalism, no regard for the gift of forbearance. Often Asia disconcerts me. She has lured me back. She has willed me into the investment of my time and caring. And again and again, she shows me scenes that I am powerless to change. I sit on the van and rail. What kind of ending is this? What the hell kind of ending is this?

An American Man

 When I taught in China, it was the summer of the Los Angeles Olympic Games. It was the first time that China was a participant. Each day, the Olympic schedule was published as front-page news.

Throughout China, knots of people sat on battered bamboo folding stools, on scarred wooden chairs that looked as if they had been salvaged from school fires. They squatted on teaming city sidewalks in front of understocked appliance stores. They sat on the ground in the dust of nameless communes. In groups of forty, sixty, entire villages, they stared with total absorption at tiny distant elevated television sets.

Frozen with tension, dressed in drab uniformity, and hoping with all their might, they were players in scenes where viewers and viewed seemed strangely reversed. Like a photographic negative.

For within the fifteen-inch television screens, tiny characters awash with vivid colors soared from the constraints of body and spirit: moved beyond the boundaries of politics and possibilities. And these Chinese—two inches tall and clad in crimson and gold like the sun at its waking and zenith—seemed like the *real* China. While the rest of the nation seemed like a still life, like a tableau within which the dynamism of the distant dwarfed figures—the secret heart of China—finally could be revealed.

When the Olympic Games began, my Chinese students and I had reached chapter eleven, present perfect with since and for, in our textbook.

"I have been studying the drawings in the textbook and I have a question to ask," said Dr. Auntie Liu. "Is Jane—who has been awaiting her new boyfriend *since* eight o'clock—is Jane a black woman?"

"Yes, I think so," I said.

"And is Felix Mendoza—who rides horses *for* Western movies—is Felix a Mexican man?"

"He is a Mexican American."

"And you, Dr. Lydia, you are Asian American. You are a..." she hesitated, "a Japanese American?"

"Yes."

"I see," she said and paused. "Dr. Lydia, have you familiarity with the small house of Uncle Tom?"

"In America, it is called *Uncle Tom's Cabin*."

"What?"

"Cabin: a cabin is a rustic, small house." Sometimes I could be hopelessly pedantic.

"In China, we all have read about this small cabin." She thought a while, then continued.

"Do you know, Dearest Teacher, that I have watched the Olympic Games, and I have seen many things. I have seen the athletes of all nations marching: tall, straight, orderly, and then I have

seen the Americans. They are looking around, waving, wearing foolish hats, talking to each other. At first, I think them childish. They have no discipline. But they *win*, and when they win, team-mates of all races jump and embrace, and when they lose, team-mates of all races give sympathy. I see, and I know this is not propaganda."

Dr. Auntie paused for a moment, then gave a smile. "And can you guess, Dearest Teacher, what else I see? I see *you*. I see that Dr. Lydia, a Japanese American, is sent as representative of American culture, as an equal to Mr. Stone, and when I see these things, I think. Perhaps small house, small *cabin* of Uncle Tom is true, but these other things, I know, also are true."

We sat in silence with our thoughts. Finally, a student spoke. "Olympic Games are most interesting; they are a way of travel. Small sights, gone so fast, and then you think."

"And then you change," said another.

America is about vitality, about heartiness, about great undaunted spectacle. America is the land of Niagara Falls and the Grand Canyon—not of the reflection of the moon upon a pool of water.

When Dr. Auntie Liu described American Olympians—waving, talking in line, sporting silly idiosyncratic headgear—she was talking about the American spirit. Irrepressible, irreverent, good-natured.

Once such unseemliness had embarrassed me, had caused me to blush when told that my laughter was readily recognizable as it came ripping (surely they meant rippling?) through the walls. But I watched Americans in Asia: loud, jocular, well-meaning Americans. I saw the broad waves of delight that they cast, like cement blocks hurled heavily into those moonlit pools of water. And, over time, I grew to claim them as my kin.

Hank was one of those Americans. In Nepal, where people scrutinize physiognomy, Hank created considerable effect. A large strong man, over six feet tall, over two hundred pounds, he was a

man from whom you would expect lumbering—a heavy shambling gait. Instead, Hank carried himself with surprising grace and with a military bearing suited to his role as an officer.

However, it was not only Hank's size that fascinated. The Nepali people have seen many large European men: climbers, trekkers, assorted adventurers. More strikingly, Hank was a red-head. He strode confidently through the sun's glare, clad in shorts, displaying pale pink skin mottled with freckles—some the size of dimes. His arms and legs were thickly covered with hair, which glinted like copper wire, and to add to his wondrousness, Hank was bald. Encircling his lavishly freckled, increasingly sun-burned bald spot was a thicket of bright red hair.

In the city of Kathmandu, I saw a ten-year-old beggar boy—reputed to be quite wealthy from his multilingual patter and his skillful performances of a consumptive cough and famished feeble-ness—suddenly halt in his begging. With swiftness and agility, the one-legged boy approached Hank and pointed to the mottled, peeling bald spot. "Oh, poor sir!" he cried in a clear, strong voice filled with sympathetic concern. "What has happened to your head?"

A divorced father who missed his ten-year-old daughter, Hank displayed determined goodwill toward the children and young mothers he unwittingly frightened with his appearance. On a riverbank, I watched a twelve-year-old girl and her seven-year-old brother as Hank approached with food and a toy whistle. The small boy pointed in delight. The girl stood rigidly, placing her body between Hank and the child, acting as a shield and as a restraint. Frozen and staring with the fascinated terror of one who has seen a grizzly bear suddenly stand and pirouette, she watched Hank's advance and thoughtfully, pointedly, turned a hunting knife in her hands.

Hank is an extrovert with a teasing, mischievous heartiness. A hale fellow, a jolly good sport, he is a favorite with men in the American and British diplomatic corps. Once, in Japan, he orga-

nized an interconsulate costumed relay race and thrilled local citizens by dashing madly through staid banks and crowded shopping malls, clad in an organdy wedding gown replete with a streaming veil.

Impulsive, imprudent, always in search of a dare, not all aspects of Hank are charming. "This is why we were in Vietnam," grumbled Pam one evening as Hank jeopardized self and others by jumping from the raft to dangle from a high and crumbling bridge—trying to cross hand over hand. "Cocky American bullheadedness." But beyond the bluster and buffoonery, there is a certain spiritedness that is difficult to dislike.

One evening in Kathmandu as we passed the children selling heat, and the meandering sacred cows, Hank stopped at a weather-beaten wooden tailor stall. The stall was about half the size of those found on the midway of American county fairs. Half the size of one of those places where you can pitch a baseball or shoot an air rifle in the hope of winning an oversized plush animal. Shirts, jackets, and trousers—in various grades of homespun cotton and various bizarre styles intended to lure Western hippies and hikers—were piled knee deep over the entire surface of the floor. Candles burned from precarious perches atop the stacks of clothing, leaning with each small draft to lick hungrily at every flammable surface. In one corner of the stall, from behind a concealing curtain, came the hiccuping laughter of a small child and the aroma of cooking curry.

A tattered shirt hung from the shutters of the tailor stall. It was unevenly bleached from too much and too varied exposure to the sun. It was worn along the shoulders from too many years on the hanger. It was missing buttons and was speckled with bird droppings.

The shirt was not intended for sale. Rather, it was intended to provide a muted suggestion of the kind of splendid tailoring available. Hank eagerly pounced.

"This is beautiful. How much?" he brightly asked, holding up the shirt.

"Sir?" The shopkeeper was confused and wary.

"May I try it on?" Hank pantomimed the shrugging on of a shirt.

"Oh…yes…yes." The shopkeeper searched his inventory for a similar shirt.

"No, no, *this* shirt. I want to try *this* one." Hank slipped the shirt on and thumped his substantial chest with satisfaction. "Nice, huh?" He turned back and forth, modeling.

The shopkeeper began to warm to the joke. "Oh, yes, the sir is quite handsome." He tugged on a sleeve, trying to cover Hank's large, dangling wrists. Instead, a button came off.

The shopkeeper began to giggle. "Come see the handsome sir," he called to his family.

A wife, brother, two little boys, came forward. Seeing Hank they began to titter.

Hank solemnly offered the shopkeeper some business advice. "If you laugh at your customer's appearance, then it is harder to make a sale."

"Oh, no, sir. No laughing. Just small cough, sir." The shopkeeper struggled to restrain himself.

"What about this spot here?" Hank pointed to a large calcified blotch on the collar.

"No spot, sir. Natural imperfection in the cloth. Linen, sir." The shopkeeper had regained his authority.

"I think it's bird shit. Come on now, it is, isn't it?" insisted Hank.

The shopkeeper took a closer look. "Absolutely not bird shit, sir. A high-quality shirt, sir."

"Then what *is* it?" pressed Hank.

The shopkeeper replied with the pride and confidence of a professional.

"Mouse shit."

. .

Even Hank joined the laughter and applause. He paid for the shirt. Everyone shook hands with everyone else. Wearing his new purchase, Hank strode manfully into the night. He carried a small paper bag. As a trophy of sportsmanship, the shopkeeper had presented him with the international symbol of fine tailoring: extra buttons.

The Road to Chericot

"Baden is the only Nepali I know who has a Type A personality," says Pam with affection.

Her statement is not fully accurate. Gentle and generous, slight and soft spoken, Baden completely lacks the anger and competitiveness associated with Type A personality. However, he *is* a worrier. He is a perfectionist; he has an ulcer.

When Baden was a young teenager, Pam spotted his conscientiousness and trained him to be her chief household manager. He became literate in Nepali and English. He learned organizational skills. Most importantly, he developed an understanding of how keenly Westerners value sanitation, time, and the meeting of their personal goals. In his twenties, he became an expedition manager.

Expedition managing is not easy work. Baden is hired to ensure that his patrons will stay well, reach the summit, and return to Kathmandu in time to meet their scheduled departure flights. It is work that requires great tact and constant vigilance as the skill and vanity of his employers are measured and balanced against the unpredictability of climate and terrain.

Baden is the oldest son in a family of eleven. His work brings him enough money to marry, to support children. But Baden has an expensive dream. He wants his fourteen-year-old brother to attend the university. When we visit Nepal, Pam establishes an education fund in support of the boy's schooling. In appreciation, Baden and his brother cook for us, an eight-course meal over a wood fire built on the dirt floor of their twelve-by-five-foot room.

Baden and his brother also lead us on a trek through the northeastern hills, beyond the stone and stick village of Jiri, along the way to Mt. Everest Base Camp. It is a rough and scenic trail, climbing steeply to an evergreen forest through grassy highlands filled with jagged outcroppings, grazing goats, occasional yaks, and isolated dwellings. We are awestruck and we are sick. Before coming to Nepal, we had received shots against cholera, tetanus, typhoid, hepatitis, and bubonic plague. We have been brushing our teeth with water boiled for twenty minutes; we have been traveling with three months' worth of medicines; but since our fourth day in Nepal, we all have been suffering from giardia. On the second day of the trek, Dot collapses, weak and weeping.

Pam shakes Dot by the shoulders. "You must calm yourself," she sternly commands. "We will take you to a doctor, but we cannot carry you." Dot hiccups with grief. Now she is shivering without control.

"I am worried," Pam confides. "If it is dysentery, she could die."

"I will leave our supplies," says Baden. He turns to Dot reassuringly. "I will carry you in a basket on my back." He gestures to a deep, cone-shaped handwoven basket that he carries by a strap around his forehead. "Do not worry. I have carried large explorer men many times before."

Dot stops in the midst of her weeping. "But I weigh more than you do!" she exclaims.

"Do not worry," Baden repeats. "I have carried very large American men, many many times."

"No, no, I can make it," Dot says. She stands up and takes a few deep breaths. "I'm so sorry to cause this trouble." Again her chin begins to tremble.

"Either start walking or get in the basket," Pam barks. Her Upward Bound training has begun to show.

We hurry down the mountain, passing a man whose goat—fearful of heights—has demanded that its owner carry it piggyback across his shoulders. The gentle goat herder sings a song to soothe his panicky passenger. Dot looks at the goat—its eyes rolling with stupid terror—squares her shoulders and strides more resolutely.

When we reach the logging route, we flag down a westbound lumber truck. Knowing she is on her way back to Kathmandu, Dot grows calm. "It is not dysentery; it is not giardia," she meekly confesses. "I am not accustomed to foreign foods. I have hardly eaten for days."

Pam is enraged. Her jaw grows tight. "I thought you understood what traveling conditions you could expect," she says coldly. But the day is so beautiful, the scenery so magnificent, that her anger cannot last.

We are balanced high atop piled rolling timbers in the back of the careening open-bedded truck. We are warmed by a sun-bright day. The narrow road winds along the edge of steep mountain terraces. Over the side of the truck, the world seems to drop away. Like swooping condors, we descend through canyons of blue pine and fir which turn, first, to shrubs and then to high rocky meadows dotted with colorful Buddhist prayer flags.

As we twist through the mountains, the snow-capped Himalayas play a game of hide and seek. They pop out from behind the nearer mountains, now to the left of us, now to the right. Shimmering with whiteness, veined with avalanche valleys, the Himalayas hover between the green undulating folds of the terraced fields and the thin blue atmosphere. They hang like a line of whitecaps from some supernatural tsunami, frozen just before it broke across the sleeping planet.

* * *

As evening falls, a wizened drunken witch doctor finds us trudging along the desolate road to Chericot. Dressed in the white robes of a holy man, shrunken with age, chanting and dancing in weaving circles, he leads us from the diesel-choked dirt road to the tidy hill-crest house of two Hindu widows.

Bent by calcium deficiency, the two tiny widows scurry nimbly through their two-room house of neatly piled stones. The ceilings are barely sixty inches high.

Because the rooms are too small to accommodate more than the two of them, the widows peer at us from perches by the earthen doorsill. Their dark, bright eyes gleam with curiosity. They remind me of small burrowing creatures peeking from their den.

Four girls board with the widows. Ranging in age from fifteen to seventeen, they have left their villages to go to school. Their new home is outdoors, on the hard clean clay of the widows' courtyard. That night, they offer the courtyard floor to us. Each day they walk twelve rugged kilometers across the rocky hills to their school-house. They are accompanied by their twenty-four-year-old Bangladesh schoolmaster, who lives a few hundred feet away. It is the only other dwelling for dozens and dozens of miles.

On the night we are to sleep in the widows' courtyard, the schoolmaster's brother is visiting from the university. As the young women listen—bending their heads and gently fingering the folds of their gauzy saris—the schoolmaster and his brother speak in confident English. They are slim, handsome, and bursting with earnestness.

"Are you married?" I ask the teacher.

"Oh yes, of course." He answers with off-handed self-assurance.

"Do you have any children?" asks Dot.

The young man blushes. "Well, actually, I have been married only four months," he confesses.

"Newlyweds," teases his brother.

"Let me bring my wife to you," says the schoolmaster with sud-

den eagerness. He runs down the hill to his house. In a minute he returns with his bride.

The young wife is achingly lovely, with wide brown eyes and smooth tawny skin. She stands beside a rambling garden fence of neatly placed rocks and earth. She shrinks modestly amidst some potato plants and lentil beans. In the next month, she will graduate from her husband's high school.

"She is studying for the university entrance," her husband says with pride.

The bride blushes under our gaze.

"These young women, all are so beautiful!" I exclaim, not knowing if they will understand.

In a shared instant, five veils are drawn across their faces, five giggles escape into the twilight.

"No, no, no," they protest in unison.

The evening ripens to darkness. We build a fire in the courtyard. Light, and warmth, and wood aroma lick at our faces but will stretch no farther. On top of a barren hillside, in a quiet clay courtyard, we sit hunched in a tiny wavering spotlight.

A perfect half moon tiptoes across a constellation-strewn sky. Below us, a dark distant planet slopes away in a smooth cool curve. Around us hovers the endless airless universe. Earth seems more distant than the stars.

Bob takes out his harmonica and we sing. "Oh, my darling, oh, my darling, oh, my darling Clementine..." This was a song sung for solace by miners, we explain.

In tenor voices, with a harmony that makes me shiver, the brothers sing a protest song against the landlord system of Nepal. When they are finished, there is a soft silky rustling as the young women whisper behind their hands. "We will sing," announces the teacher's eighteen-year-old wife. "But we cannot look at you."

Too shy to face us, the young women rise and huddle in a circle. They hold one another's hands and gaze at their pretty bare feet

with quiet modest grace. In the firelight, the hems of their saris spark and shadow: emerald, violet, crimson, saffron, and sapphire. Moon and stars glow against their hair and faces. Their clear soprano voices pierce the stillness and resonate into eternity. They sing a song of women's liberation. A song of strength and heart.

The old widows nod in affirmation. A star falls from the sky.

Once and continuously, in the world of fiction, in the India of Salman Rushdie, Doctor Aadam Aziz falls in love through a crudely cut hole, perhaps seven inches in diameter, in the middle of a hanging bedsheet. Each week, through the rippling keyhole a modest patient presents Dr. Aziz with a different aspect of her anatomy that requires his professional attention. Glimpse by glimpse, an oddly jumbled impressionistic collage is assembled: its illness of fit only adding to its fascination. The young doctor really has no choice. He falls in love with this enigma.

One distant winter—when the world was wavering before my gaze, when my certainties were rippling and shifting like sand upon the ocean's floor—I spent a month in the Himalayan kingdom of Nepal. Veiled by mountain mists, cloaked by early nightfall, shadowed by clouds that brushed across the moon, Nepal could be glimpsed only through a clumsy tear in the curtain concealing a country from her tourists. She hid in the dust of villages, nestled in treeless hills, at distances of a day's walk. Like Dr. Aziz, I could not stay unchanged.

VII.

The

Journey

Home

Dim Sum

"Have some tea," says Richard Lin.
He fills my cup with the steaming liquid.

I reach for the cup.

"Too hot, too hot," he scolds, "you will harm your mouth." Carefully, repeatedly, he pours the tea from my cup into another and back again. Finally, he pauses to test a drop on the back of his wrist—like a parent testing his infant's formula. "Now," he says, "let me tell you about the miai."

I have stopped in Hong Kong on my return from Nepal. We are eating dim sum in a cavernous, clamorous restaurant. A hundred white-skirted tables are packed together in a huge dining room. A dozen white-shirted waiters are scurrying, this way and that, pushing tipsy tea trolleys brimming with small steamed delectables. Four hundred hungry patrons are disappearing behind fortifications built from precarious piles of empty dishes.

"I don't know about this miai business," I laugh, shouting above the clatter. "I really am not one for an arranged marriage."

"I know, I know," chuckles Mr. Lin. His freckled hands vibrate on the ample expanse of his vest front. "It would not be a serious miai, not a serious meeting of prospective bride and groom. It would be a gesture."

"A gesture?"

"I need to prove I am unsuitable as a go-between." He leans forward conspiratorially, "I do not think the young man will be an easy husband. He is spoiled. The family has had great difficulty finding a match. It is in desperation that they turn to me. I am an outsider and for a Japanese family to ask a Chinese to be the go-between...Ai ya." He sucks his breath for emphasis, "Indeed, they must be desperate."

"But why me?" I ask.

"I am a family man. What do I know of marriageable women? But I have been asked. I cannot refuse. I must make a gesture, and you are not an insulting choice. You have Japanese blood, you have never married, you are educated, and you have the too-skinny look that the young man favors." He pauses and passes me a bamboo basket of steamed shrimp dumplings. "But do not fear. You are totally unsuitable as a wife."

"This is not entirely flattering," I laugh.

Mr. Lin pours more tea into my cup. Again he cools it like an indulgent parent. "The father is a wealthy industrialist. Initially, the son made a love match. In college he fell in love and the girl loved him in return. She was the daughter of another wealthy family. Hand in hand, they went to their parents." Mr. Lin sighs, "It would have been a good match but the girl was an only child. Her family wanted a son-in-law to take the family name. The boy is an only son. So, of course, this was not acceptable. The match was refused. The couple was forbidden further communication."

"And then?" I offer Mr. Lin the bamboo basket.

Mr. Lin plucks a dumpling from the pot and plunks it on my plate. "These are modern times. Perhaps it is not good to force traditional ways. The boy had no choice in his career. He will inherit the family factory. When he was denied his choice of bride, the young man grew dissolute. He became sullen and spoiled. He spent much money on automobiles and unsuitable women. Once, I visited the family at their home. The mother is a Japanese beauty:

timid and generous. The young man barked orders. His mother scurried to obey. I thought of my own wife and daughter: a Chinese woman would not allow such a thing." He shook his head at the shame of it, "A gentle mother bowing before her arrogant boy."

"And you want me to attend a miai with that arrogant boy?"

"Oh, he is good to his girlfriends," says Mr. Lin with earnestness. "He purchases many fur coats from my store." Then he realizes that I am teasing. He gives me a sly smile, "And you have nothing to fear," he says, "You are totally unsuitable. Go to the miai, eat good food. It will be an interesting experience, and you can be assured no match will be made."

Mr. Lin is a furrier. Two years earlier, on my first visit to Okinawa, we met on an airplane. Since then, whenever I am in Hong Kong or he is in Japan, we meet and share a meal. This time I shake my head.

"I do not think I should fly to Tokyo on this family's expense simply to present myself as an unacceptable choice."

"As you wish," sighs Mr. Lin. He clucks his tongue. "Resistant," he mutters, "like my daughter."

"How so?"

"My daughter has opened her own fur store—in competition with her father," Mr. Lin puffs with pride. "She does not do it for money. She could inherit my store. She does it to determine her own life; and she will not take my help. Sometimes I worry. I go to her store, and a sign says she will return in one hour. Customers do not like that. They like regular hours. A store cannot operate at its owner's convenience; but she is a headstrong one. All my children do as they wish."

He sits in silence, counting his children and their headstrong ways. Then he peers at my plate and frowns. "Noodles," he says, "you must eat some noodles." Against my protests he arrests a waiter, midflight, and places an order.

"Perhaps my daughter is right," he says, "I have been poor and I have been rich. Businesses have come and businesses have gone.

Indeed, so have empires. It does no good to fret about security. Take a risk. All you own is in your heart."

We sit and watch the lunchtime bustle. The waiter brings the noodles. Beyond the restaurant spreads Kowloon's Golden Mile: palaces of commerce filled with elegant marbled stores, cool quiet grand hotels impeccable with British service, the world's finest in foods, furs, jewels, antiques, and electronics.

"What was Hong Kong like before all this?" I ask. "What was it like when the empires came and went?"

Mr. Lin smiles. "This is why we are friends," he says. "Children are impatient with the rambling of a parent, but you are eager for an old man's tales." He busies himself with serving.

"I was born in Shanghai," begins Mr. Lin, "One more child in a large and hungry family. The Imperial Dynasty had fallen, warlords struggled for control. When I was still a boy, I set out on foot. I walked for weeks. Finally I made my way to Hong Kong." He sweeps an encompassing arm across the table and beyond. "None of this was here. Hong Kong was an outpost, a hot and hated exile filled with merchants and his majesty's civil servants."

"What did you do? How did you survive?"

"The British are a meticulous lot: fastidious and controlled. They could not control the climate. They could not control their careers. They fell upon their conventions with adherence close to passion." He breaks off and looks at me shrewdly, "Have you ever wondered why so many Chinese are tailors and launderers? *That* is how I survived. I learned what the conquerors craved: silent, invisible valets. I learned to shine shoes, to mend, to sew, and later to make gentlemen's wear. I learned that when an Englishman is properly attired, he will feel secure. Sometimes he will be generous."

He bends and tastes the noodles. "Too greasy?" he worries, "Shall I order something else for you?"

"Just fine, delicious." I slurp with noisy gusto.

Mr. Lin watches me with satisfaction. "Gradually, I grew prosperous," he says, "I learned to speak and then to read. I learned the English ways. Most importantly, I learned to ingratiate. I had my own tailoring business by the time I was twenty, but then there was war." He pauses for a moment. "Have some pepper sauce with that."

"Mmmmmm, thank you. What happened during the war?"

"I was taken prisoner by the Japanese. But I had learned well. The Japanese were lonely and homesick. Most were barely out of childhood. I learned to speak their language. I learned to sing their sentimental songs. One night, a guard deliberately let me escape."

"But where could you go?"

"I crawled and froze, crawled and froze, until I was far from camp. Then I stood and ran. I found my wife and our little son. I took them to the harbor. I bribed a man. We hid in the bottom of his junk and slowly moved across the water. Some sort of battle was in progress. It was a moonless, starless night but now and again the sky would flare with thunder and light. We glided to Kowloon and ran into the dark."

I give a slight shiver.

Mr. Lin shoots me a sharp look. "Life is not so frightening," he scolds. "What you must do is trust and risk. Find your freedom, make your fortune, let your children fly away." He leans forward intently, "Everything, *everything* of value, begins with trust and risk!"

The dining room is almost empty. Mr. Lin signals for the check.

Trust and risk. This has been the dilemma in my life. Kiotsukete and gambatte. Cautiousness and boldness. I am a curious creature—half mole, half bird—a burrowing being constantly lured aloft by glimpses of the sky.

Before I left America, I had visited my friends Sam and Angelita. They are reassuring people: solid and mature. We sat in their

apartment, in graduate student housing, where posters of Martin Luther King and Mohammed Ali looked—one with benevolence and one with pugnacity—over secondhand furniture, a three-speed bicycle, and stacks and stacks of books. Ambivalent about my approaching departure, I babbled nervously about trivial topics. Gradually, Sam grew remote.

"I envy you," he suddenly interjected.

"I guess it will be fun. Kind of like a paid vacation."

"It's not that," Sam shook his head once, hard, like a waking man clears his mind. "I envy"—his face was grave—"that you know *where* to go."

"Japan?"

"Japan, Mexico, *anywhere*." He swatted at the air, driving away inconsequentials. "What I envy is a place. A knowing: my people came from there."

Hearing something in her husband's voice, Angelita drew closer to his chair. "A place," she murmured.

"And if you will it, you can go there. You can touch the ancient earth. You can feel the sun upon your back—the way your people did." Sam looked at me with intensity. "*You* have the opportunity to do these things, all it takes is an act of choice!"

We sat in silence.

"I have always taken pride," Sam reflected, "that I am no one's fool. I know that a black man's dreams—acceptance, trust, a simple scratching dignity—can be the givens in another man's life. But why waste my time in mourning for things that cannot be? I have a family, a career, a belief beyond myself."

He paused then and smiled, just a little. "Yet your talk has made me wistful. Here is a cost I simply had not reckoned."

Turning his hands palm up in his lap, Sam gazed upon their emptiness. "I wish there was a place," he said, "that I could name and know. *Here* is where I come from. This place is part of me."

He lingered with the weight of his wistfulness only for a

moment or two. And when he was done, when regret had been transformed into some private resolve, he straightened and turned and smiled. "Yes," he said, "I can see why you are excited and scared."

And graciously Sam lent me a small part of his resolve; he urged me to trust and risk. He stood tall, suddenly. He extended his hand in congratulations. He forced me to rise as well. "But trust it, chance it, go and see," he cried, "Here is your chance to find home!"

Two years later I leave Mr. Lin and catch my flight from Hong Kong to Okinawa. But the transit is not easy. Shortly after takeoff a subtropical storm arises. In turbulent skies, our airplane tumbles and falls. It struggles upward only to fall again. "We will be landing in Taipei," says the pilot, "We will resume our flight to Naha after the storm has passed."

For three days the storm shows its ire. Captive in my concrete hotel, I watch from behind water-streaked windows as the few puny-engined automobiles that dare to defy the wind are spun sideways or buffeted backward. Slapping, slanting rain ricochets along the pavement.

On the third day, light breaks the rushing sky. With pale and yellow fingers, it strains toward the sodden earth. Huddled and blinking like shrews, we are led from refuge and shepherded onto airport buses.

A quick ascent, a short glide, and then the plane burrows. When it bursts from beneath its billowy blankets, I see Japan. So beautiful and familiar. In azure waters the Ryukyus rise like mossy mounds.

We land. Stairs are rolled to the plane. I nonchalantly gather my belongings and step to the cabin door. And my indifference is lost forever.

In the hurried clutch of a hot and humid embrace, I gasp. In the

dazzling whiteness of the light, I tear. In the confusion of a strange exultant thrill, I stumble.

So, this is what they feel, I think in a flood of astonished recognition. Those people you see in newsreels, staggering from some distant border to fall and kiss the earth.

I blink and laugh. "So this is Motherland!"

Keiko-Sensei

 I start to study ikebana—Japanese flower arranging. "Heaven. Earth. Mankind," says my sixty-year-old sensei. "All is harmony. Line. Space. Depth."

In her sturdy hands, she wields a budding peach branch. "*Saa neh, momoko-san,*" she wonders. "What is in your heart?" She feels its weight in a quick unconscious movement, like a fisherman testing his net. Then in a sudden movement she begins to twist and chop. It is sheer physical intelligence but I wince. It looks so brutal and fast.

In my fantasies, I had imagined a different kind of sensei: a willowy woman with delicate movements and barely perceptible sighs, a woman of aging elegance in severe yet supple kimonos, an aristocratic woman with a manner of mild melancholia. I had wanted a sensei who was so sensitive—to nature and beauty and sorrow—that her hands would pause and tremble before severing branch from limb.

But Keiko-sensei is no such woman. She beams with vitality and mirth. Short and stocky, she scuttles—rather than wafts—through the tatami-matted classroom. Bobbing her poodle-permed gray head in nods of infectious enthusiasm, she feigns no comely graces. She stabs the stems of delicate flowers into sharply spiked kenzan, without a hint of apology. Sometimes she even wears slacks.

In our class I am the youngest student and the only beginner. On my first day, Sensei gives me such an unrestrained hug of motherly welcome that I blush to the roots of my hair.

When I enter Sensei's class, I know neither flowers nor philosophy. I approach ikebana like a starlet who auditions for the role of a mother. She looks into the camera. She affects a tender pose. She handles the baby gingerly. "The neck, the neck, I'm supposed to support the damned neck," she mutters to herself. The infant, feeling her tension, knowing "I am not safe!" stiffens and wails. The starlet pouts. An illusion has been spoiled.

In my hands, branches splinter and stems snap. The Wa, the mood, everything is ruined, I silently anguish. Keiko-sensei only chuckles. She firmly pries my concealing fingers from around the broken bud. "Poor little flower-san," she croons patting me on the knee. "Let us find this flower-san a suitable place of beauty." Then—after a moment or two of inspired, savage hacking—a universe appears. Heaven, earth, and mankind stand in harmony and grace.

And gradually I learn that what seems like roughness instead is honest intimacy. A real mother does not do her caretaking through a series of artful poses. And eventually my flowers cease to cringe and crumple at my touch.

In the beginning, ours is not a tractable class. We are not philosopher-poets. Officers' wives scorn enlisted mens' wives and the Japanese snub the Koreans. Keiko-sensei sees it all. She prunes our status seekings and softens the shape of our arrogance. Under her knowing hand, even the most incorrigible grow girlish: approaching new learnings and new relationships with a shy

appealing awkwardness. I wonder at the power that Sensei holds—this modest Japanese widow of an American G.I.

One day in class, Keiko-sensei distributes mimeographed maps. "Won't you please consider attending," she gently pleads, "my sixty-first birthday party?"

On Keiko-sensei's birthday I wake, shower, and slip into shirt, slacks, and sandals. I think it will be the most modest of affairs. I follow the map and find myself outside a luxury hotel. It will be in a small private room, I conclude.

I ask at the desk and am directed down the hall. I stand in the doorway and reel. In the most grand of grand ballrooms, hundreds of people are swirling in subtle silks. Tuxedoed waiters glide to and fro replenishing a glittering buffet. The prefectural governor is in attendance as are the highest of American military brass. There is a sprinkling of Japanese National Living Treasures and the consul general and his wife. It takes me a moment before I realize: my sensei is a famous woman.

I am trying to slip away, to go home and change my clothes, when Keiko-sensei spots my skulking retreat. "Lee-dee-ah-chan," she calls in an arresting shriek. "Lee-dee-ah-chan come here!"

Keiko-sensei gives me one of her bone-crushing hugs and looks me over from head to toe. "Red and pink, how pretty," she says of my gaudy costume. "Is she not a pretty, pretty girl?"

And as it turns out, it is a modest affair: with amateur talent and dancing and singing, and Sensei in her prime. Of course, there is a touch of ceremony. An official reads a staggering list of accomplishments while Sensei stands and squirms. Of course, there is some posturing. But when one gentleman huffs too pompously, Keiko-sensei is prepared.

"May I introduce my special friend?" asks Sensei of the man. "A friend with wisdom in his soul?"

"Of course!" he blusters, perhaps expecting to meet a Living Treasure.

Sensei tugs upon the hand of her special friend, who turns and gladly smiles. He is an eight-year-old child.

And when the official portrait is taken, and wealthy art patrons jockey for position closest to The Great Woman, Sensei approaches the shy, shunned sister of one of her Korean students and sits her by her side.

Finally come farewells. Keiko-sensei stands to say her thanks.

"Ladies and gentlemen." The blood is hot in her cheeks. She never is confident about her use of English. "Thank you for my happiest birthday party." She takes a breath and continues. "I am so very, very gracious to you all."

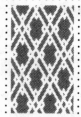

The End of the Road

I learn to snorkel. Three or four times a week, I ease into the warm emerald sea. I listen to my bubbling breath and drift above a coral forest. The fish are friendly. Curious colorful creatures swimming in shimmering schools or idling languidly in solitary insouciance. From wavering beds of anemone, clown fish defiantly peer. Sometimes I rise like an otter and float upon my back. Watching the seamless sea and sky, the verdant jungle at the shore, I never have known such peace.

I shop at the Japanese grocers: tiny, cool, dark recesses in a jumble of one-story shops, crammed with squid jerky and sweet potato donuts, and isotonic thirst quenchers that go by the name of Sweat. The shops whir with electric fans. They gently push the

humid air this way and that. Their heads slowly twist in unvarying pattern and path. Each is on its own unique rotation, like planets in a celestial scheme.

I purchase beautiful bento—artfully arranged box lunches of snowy steamed rice, bright pickled plums, and crispy fish tempura. The bento are made by local aunties who scurry to market in the cool mist of dawn, their aromatic offerings neatly stacked in huge mesh shopping bags, their backs bent with osteoporosis, their figures almost identical in gauzy print dresses of respectable navies and grays. In the early light, they move like elderly sprites: laughing, gossiping, surreptitiously pinch-testing fruit.

I browse through the Japanese malls. Those snaking corridors of commerce, often underground, always gleaming. Doors spring open as I approach triggering recorded messages of greeting and gratitude. I buy clothing off the rack and, for the first time, I need no alterations.

A new restaurateur, owner of Club Mickey—a tiny, immaculate diner painstakingly decorated with sweet Disney icons and standing in a cruel alley crowded with strip joints and pawnshops—calls upon me to taste her grand-opening creations. One, called the Mickey Roll after the famous mouse, is a peculiar kind of sushi. Rice, hot dog, and tomato catsup spaghetti are rolled into a thin sheet of scrambled egg and sliced. "Do you think Americans will like it?" worries the anxious inventor. "Delicious!" I proclaim, although silently I worry. But perhaps unsurprisingly she is very successful. Young soldiers head straight for her door. After midnight they crowd along the counter, like teenagers in their mother's kitchen, gobbling down Mickey Rolls, french fries, and Coke.

And everywhere I go, I see my students. Seventy students per term, five terms per year. They are rushing toward other classes—anthropology, physics, business administration—eyes shining with accomplishment. They are queuing in the commissary—waiting to buy their Thanksgiving turkeys. They are in the streets at Japanese

festivals—dancing with their children. In no time, I feel like Mr. Chips. I never have known such belonging.

My students enlisted for three main reasons: to pursue an education, to develop a career, to contribute in some way to their country. The recruitment research says it's so.

In Okinawa I could see them as their plans unfolded. I could see their pleasure and their pride. I could see them exploring new roles and places—clumsy and playful and endearing as puppies. And I thought I could see the poetry in their lives.

Much later, after I had returned to America, when my students were sent to the Persian Gulf, I realized there were things that I had refused to see. Even after China, I stayed blind. I had so wanted to believe that my students would always be carefree, that I could not see they were soldiers. I could not see them in peril. I could not see them at war.

Like a missionary, I was sent to light a candle deep in the wilderness. But the wilderness lit a candle deep in me.

In a hemisphere honoring tradition and faith, I was sent to educate: to advance progress and skepticism and debate.

I came armed with my ethical principles. Do no harm. Avoid dual relationships. Solid, external, impersonal: they were rules to base actions on. But I was disarmed by morality. With its rich and shining grace.

For everywhere I went there was goodness—in my students, my travels, my world. Time after time, there it was again: in courage and generosity, in wonder and simplicity, in a genuine gladness of heart. And, gently, I was educated. In time, I learned to see. Morality is a warm and breathing thing that dwells within the soul.

Yet despite all this happiness, in early March, I began to suffer from nightmares. I thought they were amoebic in origin. I had

returned from Nepal on a regime of arsenic, the dosages roughly calibrated to kill the parasites without killing me. Or perhaps, I reasoned, the nightmares were just a part of the wearing, wet weeks of winter. I was listless and saddened and knew no reason why.

One night I had a dream. I went down to the sea and slowly extended my arms. I rose into the sky. Then suddenly, like a bird within a hurricane, I was flung backward. The harder I tried to fly, the faster I was flung. I looked down in terror, and the East China Sea had vanished. Below me was Boston Harbor. Backward, I was beaten: past Beacon Hill and Brookline and beyond the Berkshire Mountains. East of Amherst, I landed with a thud. The year was 1912. Upon the grassy slope young women in summer whites were playing a game of croquet. "Who are you? Why are you here?" Their pretty brows creased with vexation. "You do not belong. You are spoiling our day. Please go back to where you have come!"

I awoke in a tangle: my bedding close and confining. For the first time, I understood my malaise. In June I would be leaving.

Change unnerves me. Behind every opportunity lurks the possibility of my undoing. Was I now Asian? Was I still American? Would I have to choose between the two?

While I had been living in Asia, Asia had begun living in me. She pulsed through my heart. She traveled through my bloodstream. She changed my perceptions, my thoughts, and my dreams. Like a mother who kisses her bruised daughter and shoos her back to play, Asia had transformed the ache of my lapsed career. But, O America—my stern, beloved fatherland—would I be worthy in your eyes?

When I was seven years old, I developed a mild school phobia. "I'm sick. I have a headache. My stomach hurts." For days I fooled my mother.

One afternoon she came to my bedside. I slouched beneath the bed covers and tried my hardest to look wan.

"You are a most healthy girl, Yuri-chan," she said crisply. "So tell me what is wrong."

"I hate them all; they all hate me …" I babbled on and on.

My mother sighed in sympathy.

"I never want to go back. You'll let me return to my old school, won't you?"

"Oh, no," said Okaa-chan, her voice prim. "You *will* go back. Yours is a very fine school. It will help you go to college."

"I don't want to go to college."

"Too sad for you. You are going."

"Too bad for you," I muttered.

" *Nani?* "

"Too *bad* for you," I sneered. "The saying is: too bad for you. You always get things wrong."

My mother did not blink.

"And everybody hates me." Thinking it perhaps unwise to antagonize the decision maker, I retreated to a more pitiable role.

"Everybody never all of one mind. You are a fine girl. You will make friends."

"They'll never be *my* friends!"

"Well, then." A smile crept onto my mother's mouth, "Just too sad for them."

In Asia I had found acceptance. But there were things that I wanted in America. Family. Work. To be a citizen once again. Trust and risk, I told myself. And when June came, I went home.

Epilogue

My uncle has spent years tracing the fate of his mother. As eldest son, it is he who travels again and again to Japan, who initiates family reunions, who has traced and located his long lost half-brother. In his seventies, his cancer in remission, my uncle travels to Japan to meet this half-brother. On his return, he flies to Albany. He arrives on my wedding day.

It has been two years since I returned to America. On this day I have married Robert Stone, the man with whom I taught in China and traveled in Nepal.

We have returned from the wedding luncheon and are sitting around the dining room table. The table is honey maple, Early American style. It looks odd against the Japanese shoji screens that separate dining from family room; but my parents are very proud. The table is a recent acquisition, purchased from a mail-order catalog. We sit at this new table, pouring over photographs of the mysterious brother.

"I have learned terrible secret," says my uncle to Okaa-chan. "Our mother tried to kill us."

Okaa-chan says nothing. She picks up a stack of travel snapshots and begins to shuffle them unseeingly.

"Forgive me," says my uncle, "Perhaps you would rather not know. You were only a toddler. Perhaps you have forgotten our mother."

Okaa-chan lays the photos aside. She gazes wistfully at the piles of my uncle's omiyage—specialties from here to take there—which are scattered across the table. Seaweed, forest mushrooms, tiny dried sardines. They smell sharp and salty, like a seaside memory. Strangely, she begins to sing.

"*Miyeko enkara ochite hana utsuna.*" Miyeko do not fall from the veranda, do not fall and bump your nose. She touches her nose and smiles. "Our mother used to sing this to me," she says, "a silly song, to commemorate some childhood mishap of mine. It was a game she played; the whole point was to kiss her baby's nose."

Okaa-chan absentmindedly fans herself with a cellophane bag of dried cuttlefish. "Oh, no," she says. "I have not forgotten."

"You never speak of her. You were close to our father. I was afraid I am asking for feelings you simply could not share," my uncle's voice cracks.

This is my beloved, gentle uncle—the tea master. A sentimental and contemplative man, he is mildly disappointed in himself. He lacks drive, rage, the sublime self-confidence of a samurai. It is his younger brother, Koji—the sword master, the No No Boy—who has inherited all the warrior bushido.

"Once, I recall awakening," muses Okaa-chan, "and I think the house is haunted. Through the cool tatami, echoing under polished wooden floors, comes the scent of incense and the sound of muffled sobbing."

"When Father demanded divorce," my uncle explains, "our mother went to the temple. She spent hours saying sutras. She was longing for some spiritual sign." He hesitates.

"Tell me," my mother's voice is calm and certain.

"On a night selected for auspiciousness," says my uncle, "Mother mixed rodent poisoning in a gruel of tea and rice. She could not bear separation from us and murder-suicide was considered an honorable act. She placed the gruel on the table and gathered us around her. A growing boy, Koji eagerly reached for the bowl."

My uncle pauses. He reaches for his tea. His elegant fingers cup

the base. His eyes close. His face disappears behind the earthen-
ware rim as he takes a long draft. I feel a twinge of fear.

"Perhaps the poisoning had a scent, perhaps a not natural
aroma. A willful child, Koji thrust the bowl away. He made a face
of disgust. In his roughness, the bowl overturned and the gruel
spread across the table. Mother sprang up and rushed us from the
room. It was as if the spill was fire."

"Do you remember this?" asks Okaa-chan.

"Perhaps a tremble in Mother's fingers, a muffled cry in her
throat. Perhaps a confusing rush from an innocent spill in a famil-
iar room. But no, I did not know she intended our deaths."

There is a silence. Misa and I hover like vapors, like forecast-
ings, at the end of the table. We are the future; we are not part of
this gathering of ghosts and elders. I look at Okaa-chan with
curiosity. I picture her as a little girl, in a summer kimono on an
ordinary night. Her singing mother has carefully plotted her mur-
der.

"Our half-brother says that Mother took it as a sign from Bud-
dha," continues my uncle. "She saw the spill as divine interven-
tion. Buddha told her to let us go. From that point on, she busied
herself with preparations. She stopped weeping and started to plan
for our futures."

We sit in stillness while, somewhere in the past, my grandmoth-
er packs her children's belongings.

"Our half-brother had a present for us," my uncle suddenly says.
"Something that Mother wanted us to have."

He rises and goes to the guest bedroom. Once, it was Misa's
teenaged home. Now, in the family room, Misa's children watch
television. Her youngest, her daughter, sits on my sleeping father's
lap. My husband sits by his side.

I finger my sleeve, stroking the rich wine-toned silk. I am wear-
ing my mother's kimono. Long ago, it had been a coming-of-age
gift from her father. All day, my mother and uncle have been star-

ing at me. They have been seeing her younger self. This gives me pleasure, knowing that I have my mother's face.

I look into my green tea. A stem floats perpendicularly. The Japanese say that this is an omen of luck.

My uncle returns with a gift. "I had copies made for each of us," he explains. The gift is an aging photograph tucked into a silver frame.

Okaa-chan holds the frame in both hands. "Ahhhh," she says. She bows her head.

Misa and I move forward. We peer over her shoulder at the picture. My young kimono-clad grandmother is in a photographer's studio. Around her are her children. Her sons are soldierly in their school uniforms. Her eldest daughter, poised on the brink of womanhood, is astonishingly lovely. Her youngest, my mother, slouches forlorn and pouting.

It is the first time I have seen the photograph but I recognize it immediately. "It's that time, before the parting, when you caught your mother crying into her kimono sleeve!"

Okaa-chan nods her head. "*Saa neh*," she murmurs. A tear slides down her cheek.

From the family room comes a roar of laughter. My father starts from his sleep. "What is it?" he cries, alarmed.

"It is us, Grandpa," reassures Misa's husband.

In the dining room Okaa-chan speaks. "Today is most joyous," she pronounces. "Today, I gain son and find half-brother."

She swallows and looks again at the photograph. "And here is my Okaa-chan," she proclaims almost fiercely, "come home to see it all!"

"*Neh, neh, honto neh*," croons my uncle's wife. Yes, yes, truly yes. She scatters soothing little syllables across the table, like a benediction.